GREAT BEAR WILD

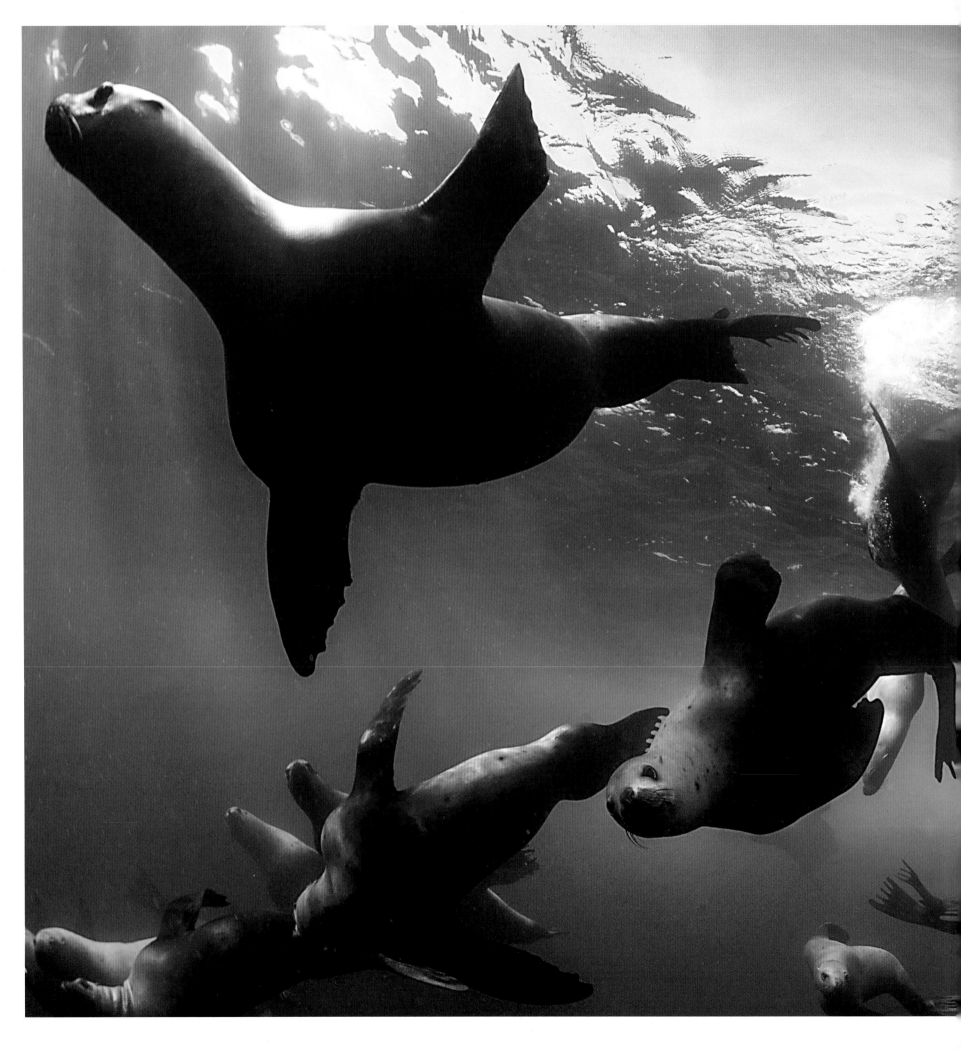

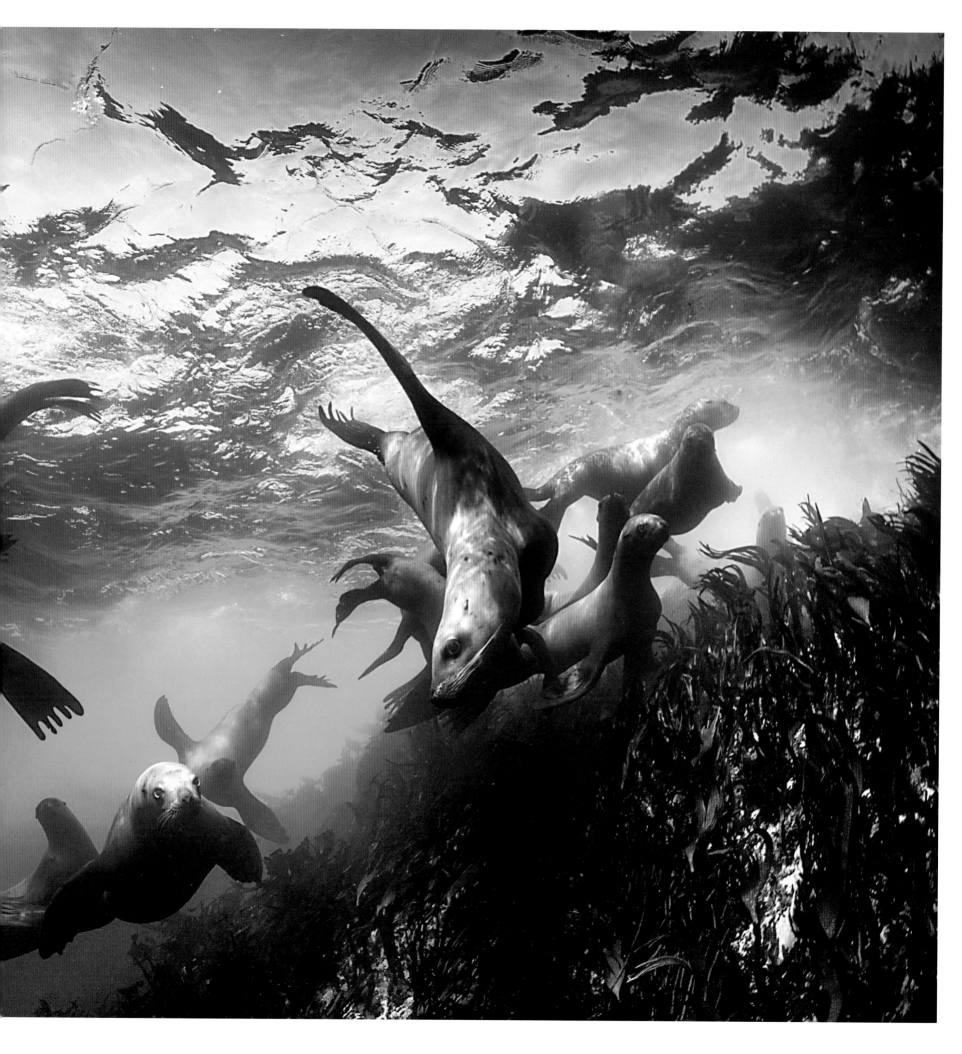

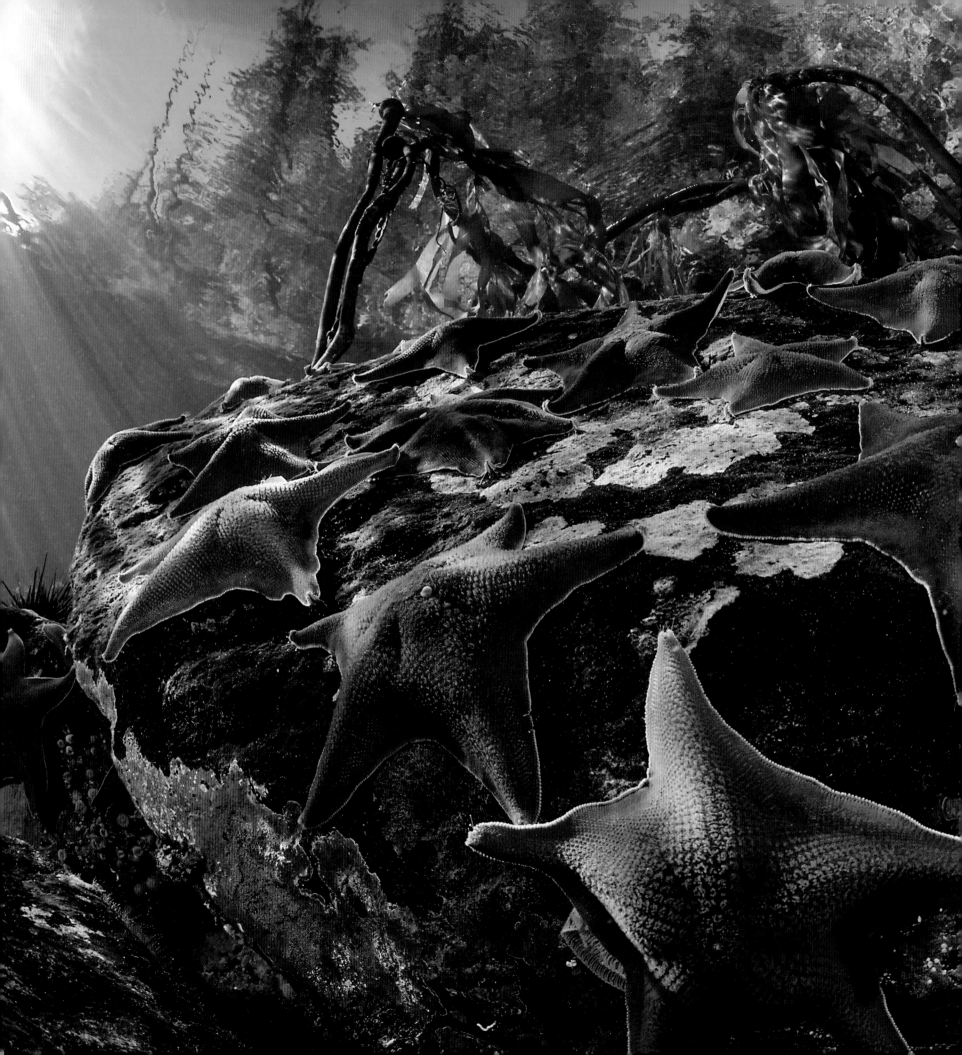

IAN McALLISTER

FOREWORD BY **Robert F. Kennedy Jr.**

GREAT BEAR WILD

Dispatches from a Northern Rainforest

GREYSTONE BOOKS

VANCOUVER

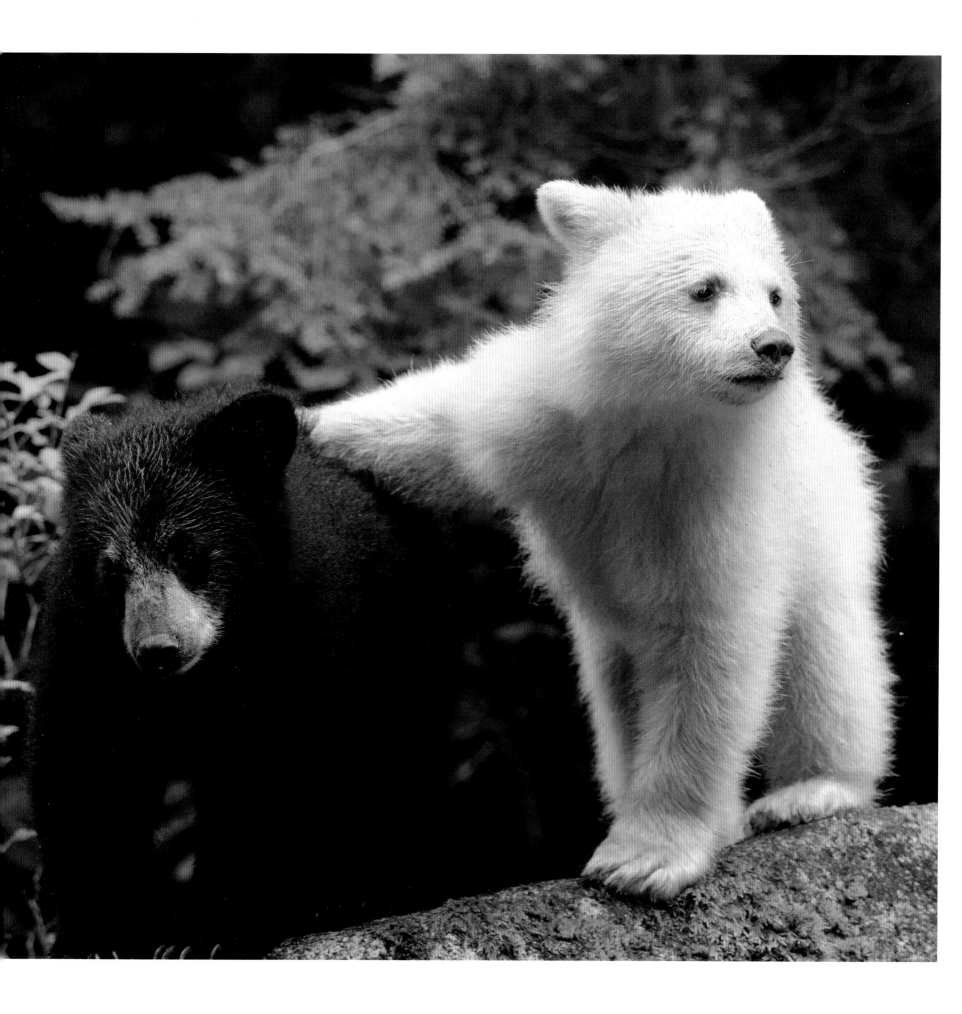

To the people of this coast who fight for home.

Greystone Books Ltd.
www.greystonebooks.com

Published in the United States of America by University of Washington Press

Cataloguing data available from Library and Archives Canada
ISBN 978-1-77164-045-9 (cloth)
ISBN 978-1-77164-046-6 (pdf)

Editing by Trena White
Copyediting by Lana Okerlund
Proofreading by Stefania Alexandru
Jacket and text design by Jessica Sullivan and Peter Cocking
Photography by Ian McAllister
Map by Eric Leinberger
Printed and bound in China by 1010 Printing International Ltd.

We gratefully acknowledge the financial support of the Canada Council for
the Arts, the British Columbia Arts Council, the Province of British Columbia
through the Book Publishing Tax Credit, and the Government of Canada
through the Canada Book Fund for our publishing activities.

Greystone Books is committed to reducing the consumption of old-growth
forests in the books it publishes. This book is one step toward that goal.

CONTENTS

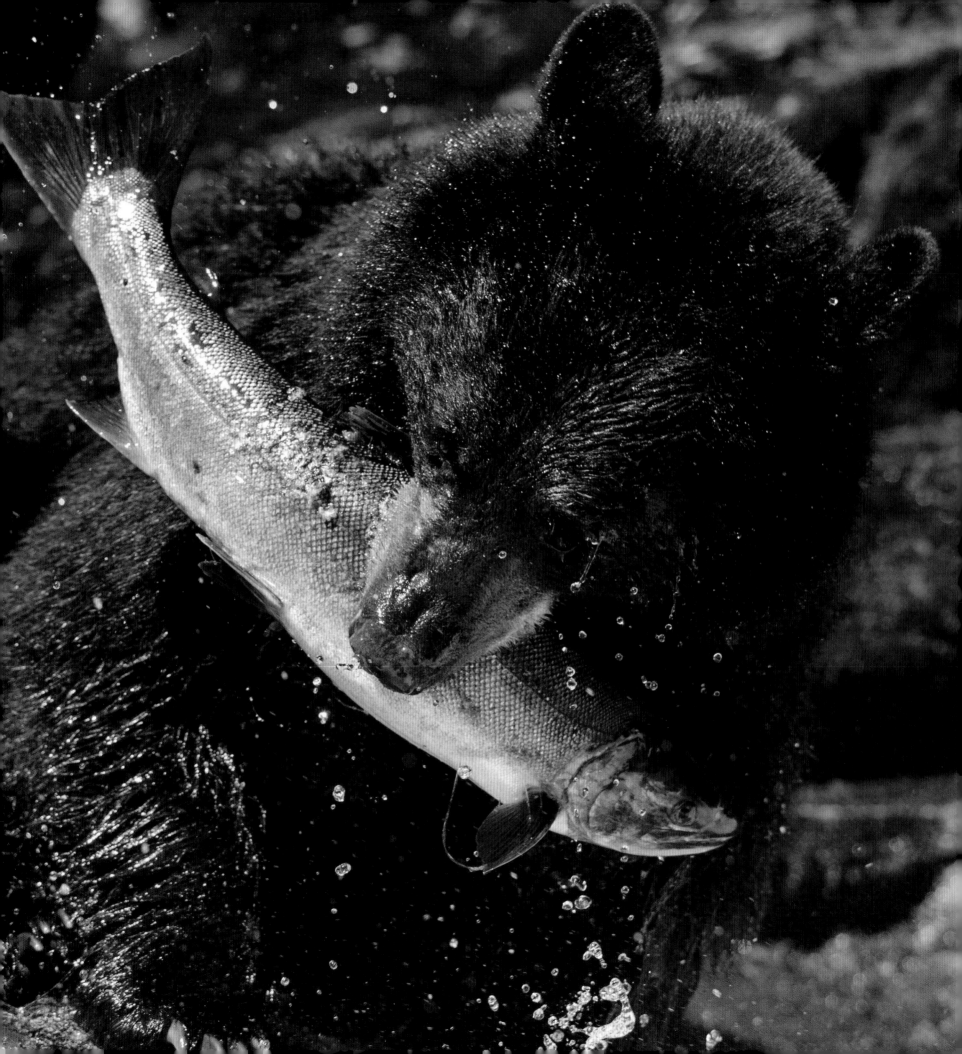

A black bear deftly
catching a coho salmon.

FOREWORD

ROBERT F. KENNEDY JR.
Senior Attorney, Natural Resources Defense Council

FIRST VISITED THE wild Canadian Pacific coast in 1993, when protesters in Clayoquot Sound on central Vancouver Island were making international headlines. Environmental and native groups were challenging MacMillan Bloedel, a large timber corporation that was illegally logging native lands, clear-cutting the last of the island's untouched coastal rainforest. Some of the area's ancient trees—towering ninety meters (three hundred feet) with a girth of ten meters (thirty feet) at the base—had been seedlings when Jesus walked the earth. MacMillan Bloedel was converting them to paper and boards. Anyone who'd witnessed the spectacular beauty of that BC coastal wilderness would have felt compelled to join a fistfight to save it. Predictably, a mass protest sprang up.

Government enforcers arrested eight hundred people engaged in peaceful protests, three hundred alone on one notorious August day in 1993. The Nuu-chah-nulth people who'd lived there for thousands of years banded with environmental organizations to raise international awareness about the logging.

The battle to save Vancouver Island's remaining old growth soon moved to boardrooms. The Natural Resources Defense Council and other environmental organizations began pressuring high-profile customers of MacMillan Bloedel, including phone book publishers and the *New York Times*, to stop buying its newsprint.

The protests were, in many ways, successful. In 2000 UNESCO designated large parts of Clayoquot Sound an international biosphere reserve. Much of the area is a protected

haven for tourists and boaters wanting to experience the incomparable majesty of the Vancouver Island wilderness.

Twenty years later that battle is being reenacted in the vast and spectacular Great Bear Rainforest region of BC's north coast.

Roughly 70,000 square kilometers (27,000 square miles)—about the size of West Virginia—the Great Bear is home to thousand-year-old trees, about ten different First Nations who have lived there for many thousands of years, and globally unique subspecies, including a rare white coastal black bear called the *kermodei*, or "spirit bear." I visited the Great Bear in 2000 for a longhouse opening near Hartley Bay, home of the Gitga'at people, where much of Ian McAllister's story takes place.

Talk to anyone in the Great Bear about wildlife and eventually Ian's name will come up. His life's work has been documenting the region's astonishing biodiversity through award-winning photographs in an undaunting campaign to protect the region he calls home. The co-founder of conservation organization Pacific Wild, Ian has spent twenty-five years crawling through thick underbrush, crouching under giant cedars in the driving rain, and sailing through every kind of ocean current to capture his subjects: wild wolves, orcas, grizzlies, and the fascinating underwater world. He knows as intimately as anyone the treasures of this region. And, like other locals, he knows the threat it is facing now from the ruthless and greedy energy titans.

Ian and I first met during the Clayoquot clashes. In 1997 I contributed a piece to his book *The Great Bear Rainforest*. Since those challenging and often combative days, we have seen remarkable, positive change.

Over the last decade the BC government has signed a series of conservation agreements committing to preserving over 30 percent of the area. These agreements have made the Great Bear Rainforest a template for responsible resource management and indigenous stewardship. The landmark settlement brought First Nations together as equals with the provincial government to plan local forestry in a way that respected First Nations cultures and title to the land, with the intention of promoting sustainable economic development for the region's inhabitants.

These coastal communities have been making a vital—and at times difficult—transition from economies based on industrial resource harvesting to sustainable practices. Tourists travel from all over the world to view bears and other wildlife in this pristine landscape, and expanding ecotourism has exposed the fallacy of the industry mantra that pits jobs against a wholesome environment.

But at a time when we should be celebrating the protection of one of the most significant stretches of forest on the planet, trouble is on the horizon. This time the issue is energy.

The Great Bear Rainforest sits between the world's second-largest known oil reserves, Alberta's infamous tar sands, and Asia's hungry oil markets. In between lies this rainforest of globally rare species and some of the world's most fiercely independent native people fighting for their way of life.

In 2013 a Canadian government–appointed panel recommended the approval of the Northern Gateway, a pipeline that would carry diluted bitumen from the tar sands to the coastal community of Kitimat, in the heart of the Great Bear. The petroleum moguls would then ship the bitumen down the coast in giant tankers—each hauling 2 million barrels—bound for the United States and Asia, traversing notoriously tempestuous Pacific waters important to many marine mammals, including the humpback whale.

Environment Canada ranks the tanker route among the most dangerous sea passages in the world, making navigation treacherous to behemoth tankers measuring three hundred meters (one thousand feet). Gales and hurricanes can drive wave heights upward of thirty meters (one hundred feet).

The pipeline is not the only peril. In 2012 the BC government, bargaining the future for the promise of immediate financial gain, announced the export of liquefied natural gas (LNG) to China as an economic priority. The greenhouse gases emitted by the LNG plants are comparable to that of the coal industry. Water contamination and other environmental impacts associated with the fracking process make LNG as dirty an option as the tar sands.

As they did in the 1990s, environmental groups, First Nations, and concerned citizens are mobilizing to fight these cataclysmic energy transport projects. Continued protests both in Canada and abroad against the Northern Gateway have resurrected passions of Clayoquot. Once again First Nations leaders are battling the provincial and federal governments over stewardship of their lands.

These aren't isolated issues, relevant only to small communities in northern Canada. They pose some of the most important questions Canadians have ever faced about their nation's economy, environment, moral authority, and once-vaunted role as a leading global citizen.

Will Canadians allow unbridled expansion of the world's dirtiest energy projects? Or will Canada reclaim its soul and show global leadership by choosing a path that helps the country make the transition to a clean energy future?

As Ian McAllister shows in this stunning book, through his photos and compelling narrative, this is a battle that pits apocalyptical forces of ignorance and greed against the welfare of our children and the rest of humankind. *Great Bear Wild* vividly demonstrates the high stakes in this battle.

ROBERT F. KENNEDY JR.

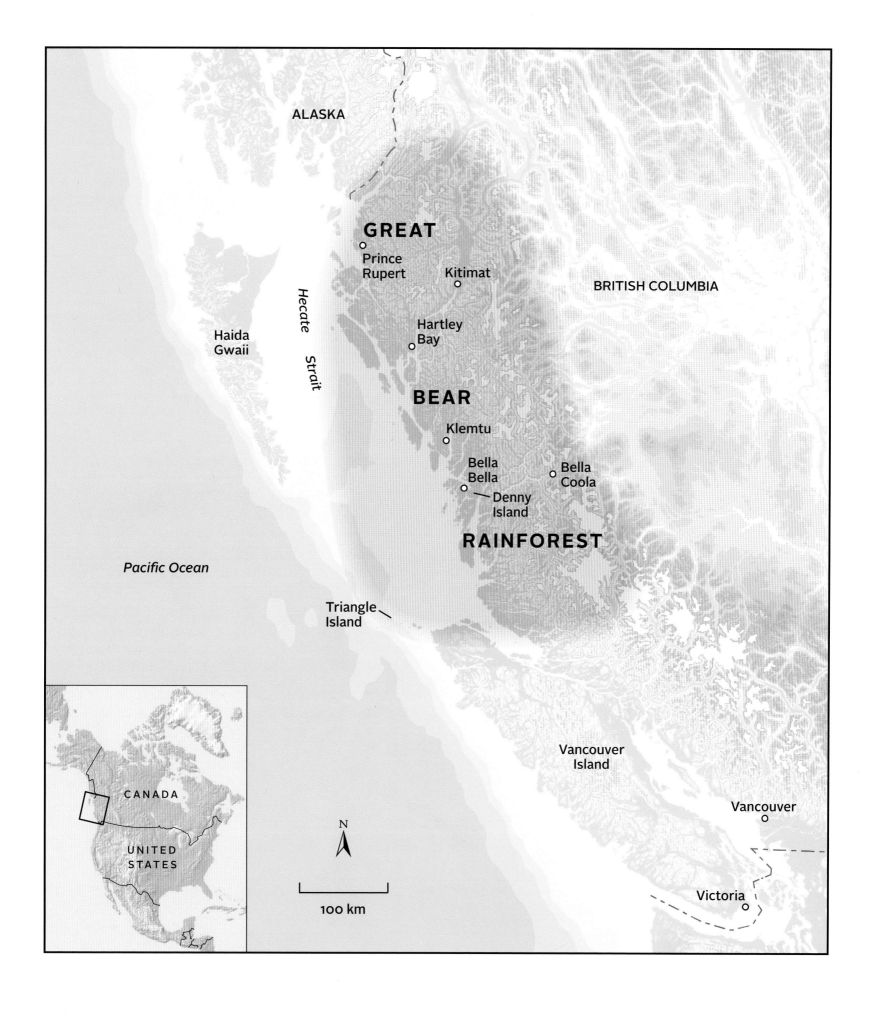

ALASKA

GREAT

Prince
Rupert

Kitimat

BRITISH COLUMBIA

Haida
Gwaii

Hecate

Hartley
Bay

Strait

BEAR

Klemtu

Bella
Bella

Bella
Coola

Denny
Island

Pacific Ocean

RAINFOREST

Triangle
Island

Vancouver
Island

Vancouver

CANADA

N

UNITED
STATES

Victoria

100 km

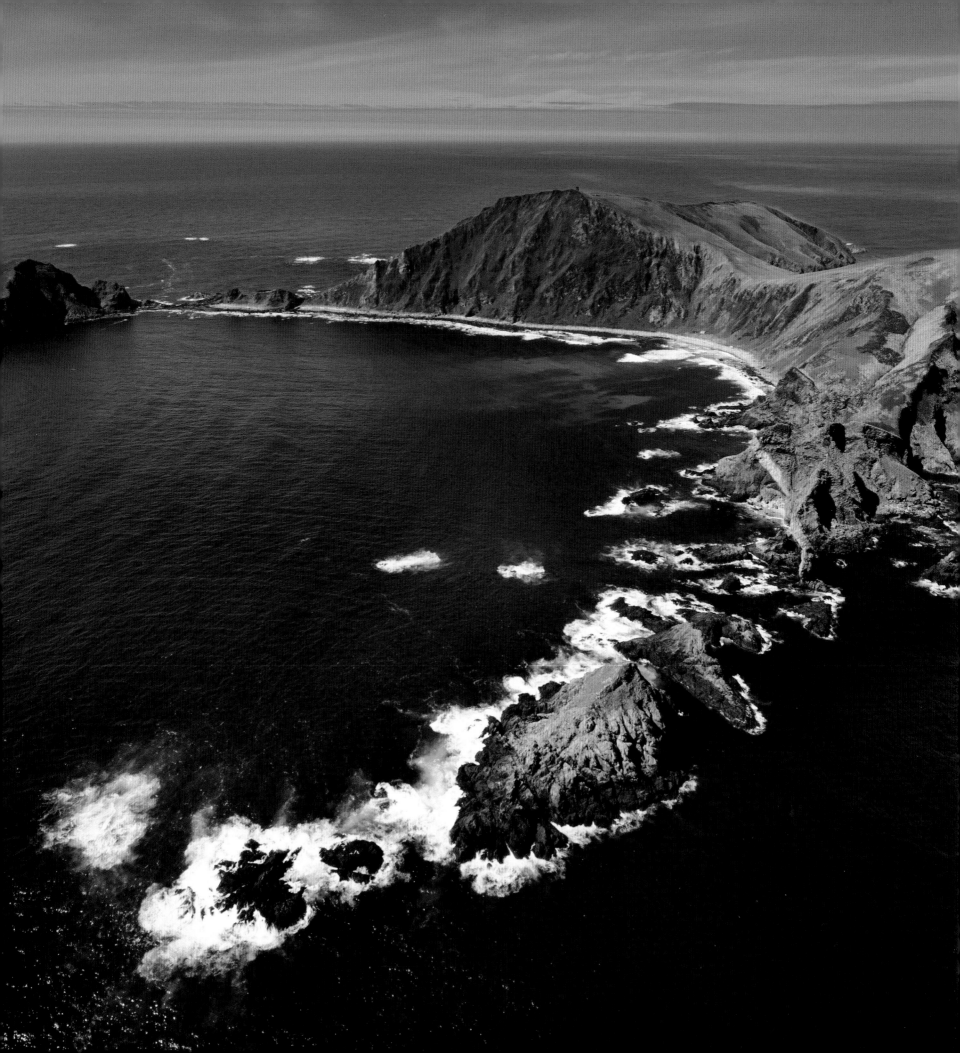

Looking north past ecological
powerhouse Triangle Island
into the heart of Canada's
Great Bear Rainforest.

THE BAY

THE WHITE SANDY beaches and rocky headlands of northern Vancouver Island
disappear behind my wake. Off to the east the Great Bear Rainforest's snowcapped
peaks are silhouetted against a darkening sky. Through the saltwater mist a chain of
serrated islets and islands appears.

These islands form part of the Great Bear's southern boundary, separating two worlds.
The one I'm heading toward is a lost world of kelp forests, rock, towering trees, and
ecological riches. South of here the forests have largely been converted to tree planta-
tions. Only a handful of river valleys remain intact between here and northern California,
wild salmon stocks have been assaulted, and humans rapidly encroach on the last
wilderness areas. When you consider all of that it soon becomes clear how unique this
northern rainforest is.

This paradise represents more than half of Canada's Pacific coast and much of the
world's remaining intact temperate rainforest. It constitutes over a thousand unin-
habited islands, two thousand river valleys hosting wild salmon, and one of the largest
unexplored, unprotected marine ecosystems on the planet. I'm traversing the wide-open
Hecate Basin, the body of water between Vancouver Island and Haida Gwaii and the
northern coast of mainland British Columbia. It remains as inspiring, fascinating, and
mysterious for me as it did when I first ventured here twenty-five years ago as part of a

1

research team assessing the region's endangered river valleys. Little did I know back then that this coastline would become home, and that exploration, discovery, and conservation would become obsessions—as would the challenges that come with them.

On days like today it is difficult to imagine living anywhere else. Some colleagues from Pacific Wild, the conservation group I founded with my wife, Karen, sailed with me to Vancouver Island on our fourteen-meter (forty-six-foot) catamaran *Habitat*, a fifteen-hour sail from my home on Denny Island, to pick up crew and supplies. Now a stable air mass is giving us a window of reasonable weather for a few weeks of underwater and offshore exploration. We will end up in Hartley Bay, the mainland home of the Gitga'at people about 320 kilometers (200 miles) to the north.

For sixty-five kilometers (forty miles), giant rocky outcroppings, epic in beauty and ecological riches, rise out of the broad oceanic shelf, giving a disproportionate foothold to countless pan-Pacific species that arrive here to exploit the water's riches. Thomas Peschak, a colleague and underwater photographer from South Africa, and I get our gear ready: scuba tanks are being filled, camera housings and strobes are being checked. Max Bakken, a mariner with Pacific Wild, steers us to an underwater pinnacle that rises nearly to the surface, one of many underwater features we plan on exploring while the weather holds. The anticipation of a new dive location never changes as we suit up and get ready to drop over the side.

Later in the day, after three separate dives, we sail farther west. As far as five kilometers (three miles) away we can hear above the ocean surf the deep roar of a thousand Steller's sea lions barricading the verdant slopes of honeycombed nesting burrows that rise into the clouds above one of the islands. I look to Thomas. We are both contemplating all that we have just observed on these dives. Thomas has dived professionally for *National Geographic* throughout most of the world's remote oceans.

"The best of the best, my friend," he says. I couldn't agree more.

Idling alongside one of the many islands that form this chain, we are visited by gangs of Steller's sea lions and an occasional California sea lion. Car-sized elephant seals bask on

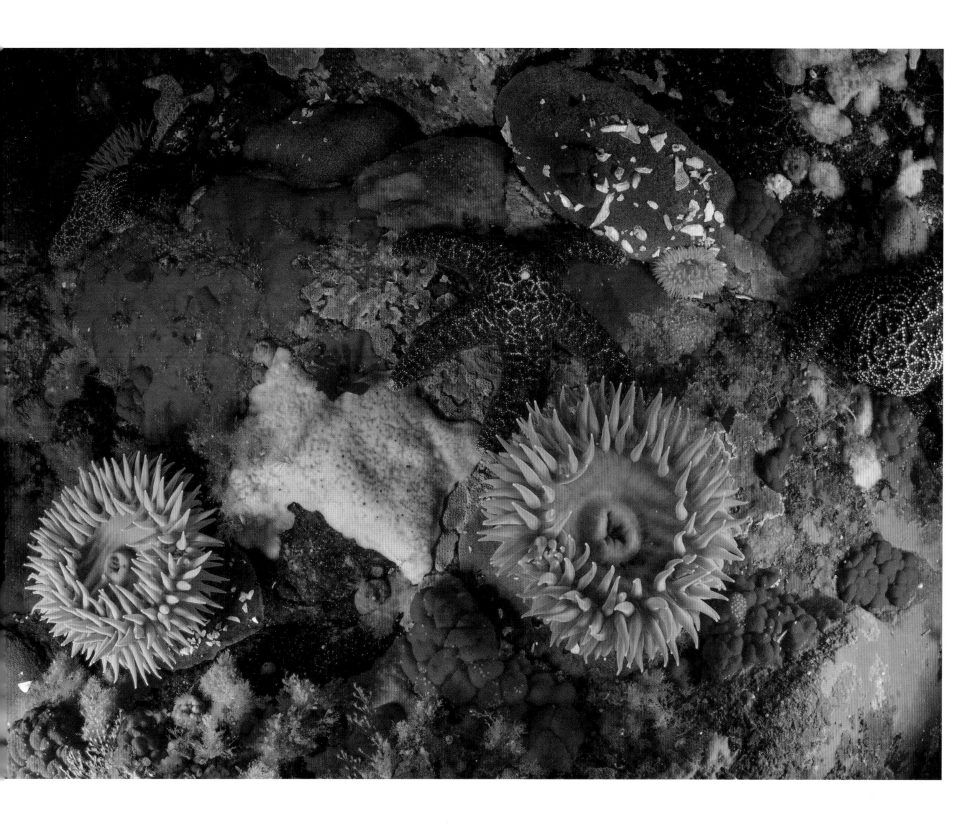

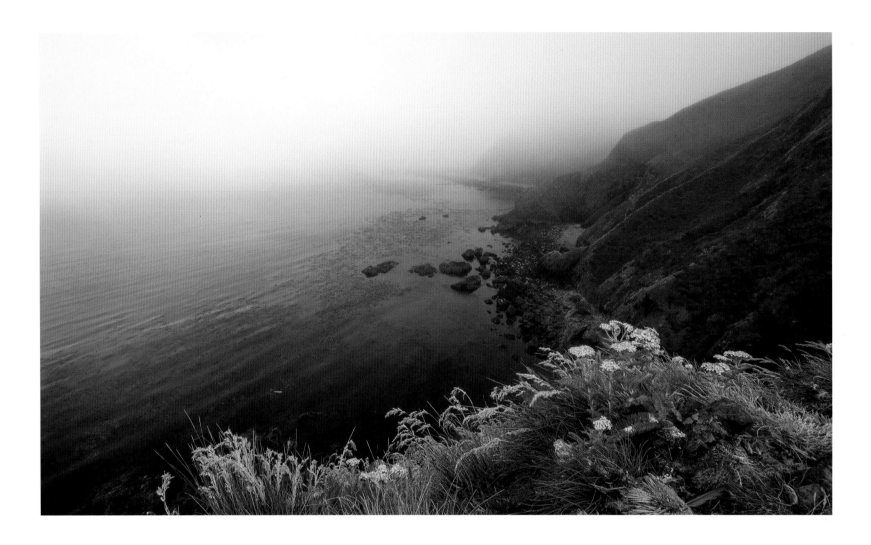

Known locally as the "Last Island," Triangle Island is a globally important seabird nesting island, home to approximately thirty thousand pairs of tufted puffins and half the world's Cassin's auklet population.

the few pockets of gravel found in isolated coves, harbor seals bob out of the water, and in each kelp bed sea otters drift on their backs. The air is filled with calls—shrieks, groans, barks, chirps, whistles. One large flock of rhinoceros auklets begins to dive below, forcing the schools of silvery sand lance to the surface. Hundreds of others swoop toward this new activity. The water is soon black with acres of surf scoters, and more keep coming in to feed. There is life simply everywhere.

These guano-covered islands are left from an ancient mountain range, the remnants of which also include Haida Gwaii, Vancouver Island, and the landlocked Olympic Mountains in Washington State. Tens of thousands of years of dramatic geological change, shifting sea levels, and icebound epochs have left a profound imprint.

Miraculously, during the ice ages, small ice-free islands existed here. Those refugia now connect us to an ancient world; genetically unique flora and fauna, remains of plant pollen, bones found sequestered in caves, and other evidence from earlier eras are slowly advancing our knowledge of the evolutionary history of the coast. At one time woolly mammoths trekked along the open ice fields that dominated this ancient mountain range's foreshore, the very place we sail through today. Ancient village sites built at the outlets of lakes long since flooded remain buried in the substrate well below present-day sea level.

This island chain saves the best for last: Triangle Island rises out of the slate-gray waters, supporting one of the greatest densities of bird and mammal life anywhere. I look up at tufted puffins perched in front of their individual burrows, their charcoal feathers and bright orange beaks giving them the look of tropical parrots. Popping in and out of their deep burrows, they look like trusting old men wobbling about before launching into the powerful updrafts coming off the ocean. Dropping like tubby torpedoes, their dead weight brings them precariously close to the rock below before their rapid little wings gain enough lift and they lumber off to sea.

Great gliders, puffins are not. They specialize in diving, having never evolved the longer wings that would allow for long-range foraging flights and effortless travel. Such specialization comes with risk. If warming currents such as the BC coast has been experiencing in recent years push sand lance and other important forage fish deeper or farther offshore, many of these birds will not have the range or the diving abilities to successfully locate, catch, and return food to the burrow for their chicks.

Puffins are not remotely elegant as they come hurtling out of the fog, bills full of needlefish, small webbed, bright orange feet splayed in front, offering steerage and drag in the absence of much of a tail or wingspan. Sometimes they land with a small bounce before entering their dark burrows; sometimes they do cartwheels—head over tail— through the grassy hummocks, knocking fellow puffins over like bowling pins.

Puffins don't seem to mind landing during daylight, but in hundreds of thousands of other neighboring burrows, tiny little Cassin's auklet chicks have to wait until dark for

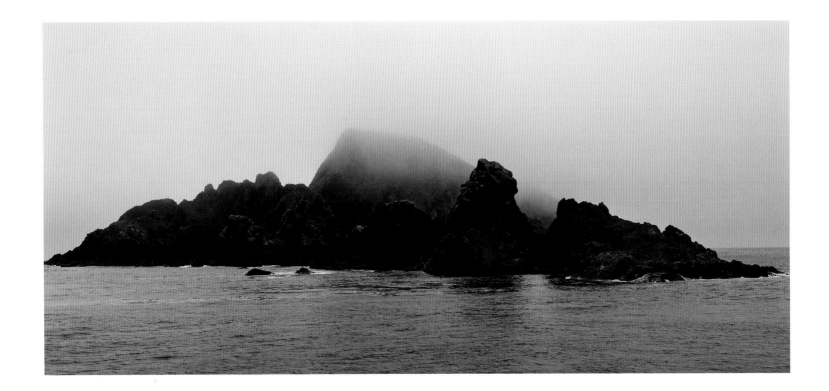

their parents. These small birds, estimated at over 500,000 breeding pairs on Triangle Island alone—or half the world's population—get fed at night. This is most likely a strategy to avoid the resident peregrine falcons, eagles, and other flying predators. But imagine hundreds of thousands of small black birds hurtling toward these steep cliffs in the dead of night, then successfully locating their individual burrows without colliding with one another.

Today a Peale's peregrine falcon visits. I can hear the wind whistling through its feathers before I see it. There may be only a hundred nesting pairs on the entire BC coast, and four pairs are nesting on this island alone. I have seen this far-roving subspecies over eighty kilometers (fifty miles) from land preying on seabirds. It must attack and consume its prey mid-flight because it is not capable of landing on water.

These birds have been lucky. A number of introduced mammal species such as rabbits have established themselves on Triangle Island, but so far they have not wreaked the devastation that carnivorous rats and raccoons, among others, bring to nesting islands. Fortunately rats can't swim for long in cold water, but a simple shipwreck or careless introduction and the fine balance of life on this island would change forever.

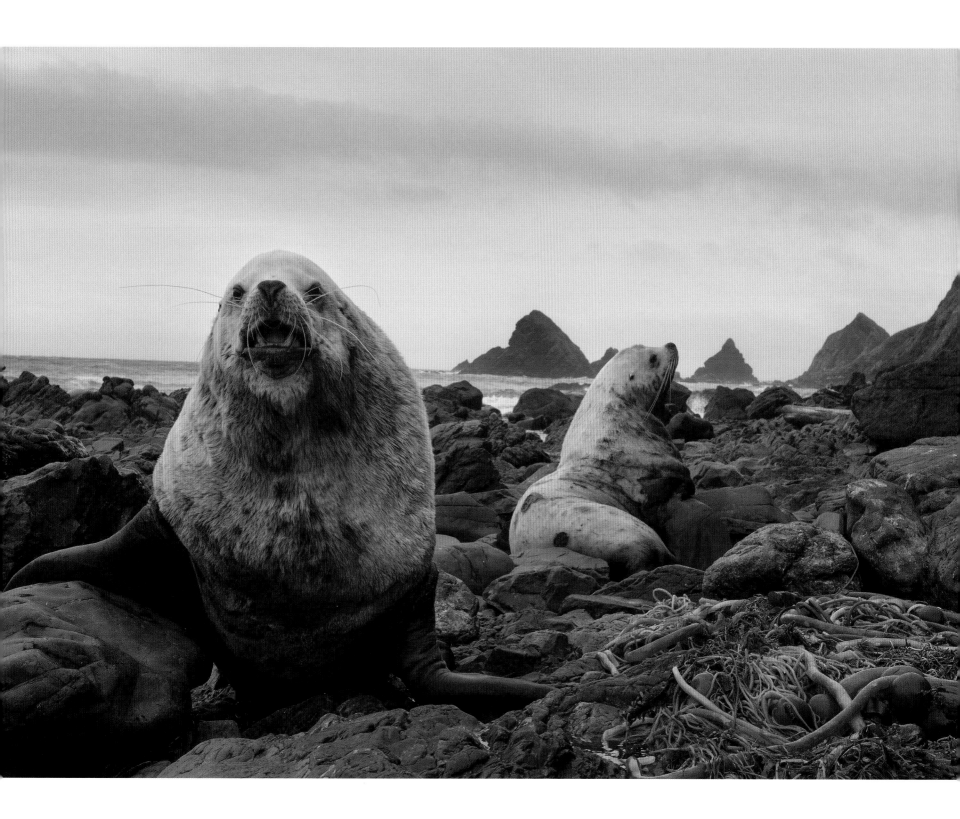

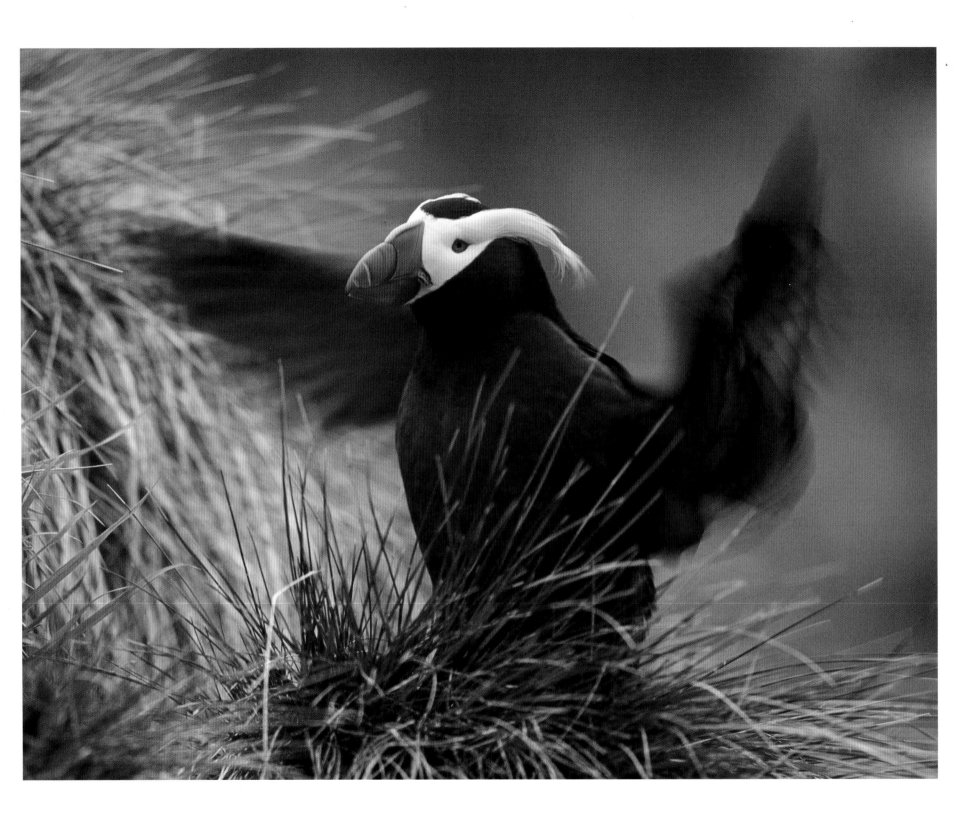

Strong southeast winds are being called for, and we know we are about to be blown off our precarious holding. As the sun drops we begin to lash gear down as we slowly steer out toward the open. By early morning we will be sailing along the edge of the continental shelf looking for birds and sharks, whales and other pelagic species. Only a few years ago researcher Dr. Rob Williams was conducting a series of line transects across Hecate Strait, mostly looking for whales, when he came across vast schools of sharks. Based on these observations he estimated ten thousand ocean-going salmon and blue sharks were congregating here in the summer, most likely intercepting southbound migrating salmon.

If the Great Bear could be broken up into different worlds this offshore realm would be one of them. The wind has pushed us north and we can see the snowcapped mountains above Douglas Channel as we enter Caamaño Sound. The sound's calmer waters are going to be a welcome change.

HARTLEY BAY APPEARS unhinged from the rest of the continent, isolated by mountains and an unbroken rainforest. There are no roads into the community, no airports, and no BC Ferries; unscheduled floatplanes and an occasional boat shuttle to Prince Rupert 145 kilometers (90 miles) away constitute the only public transportation. The Gitga'at community of 160 remains one of the more remote in the Great Bear Rainforest. Hidden behind Promise Island, the Bay, as it is known locally, is as picturesque and welcoming a community as you can find on this coast. Each home is connected by a wooden boardwalk, and only a handful of golf cart–like vehicles and ATVs operate on them; mostly they are for walking. There are no traffic or street signs; everyone knows one another.

Today there is silence in the Bay. Ninety-three-year-old Margaret Reece—known as "Goolie"—the elder matriarch in the village, has just been medevaced out. She recently fell and broke her hip, and complications forced her to leave Hartley Bay for the Prince Rupert hospital. There is fear she may never lay eyes on her village again, which has caused the abnormal calmness around the main pier, the community's commercial and

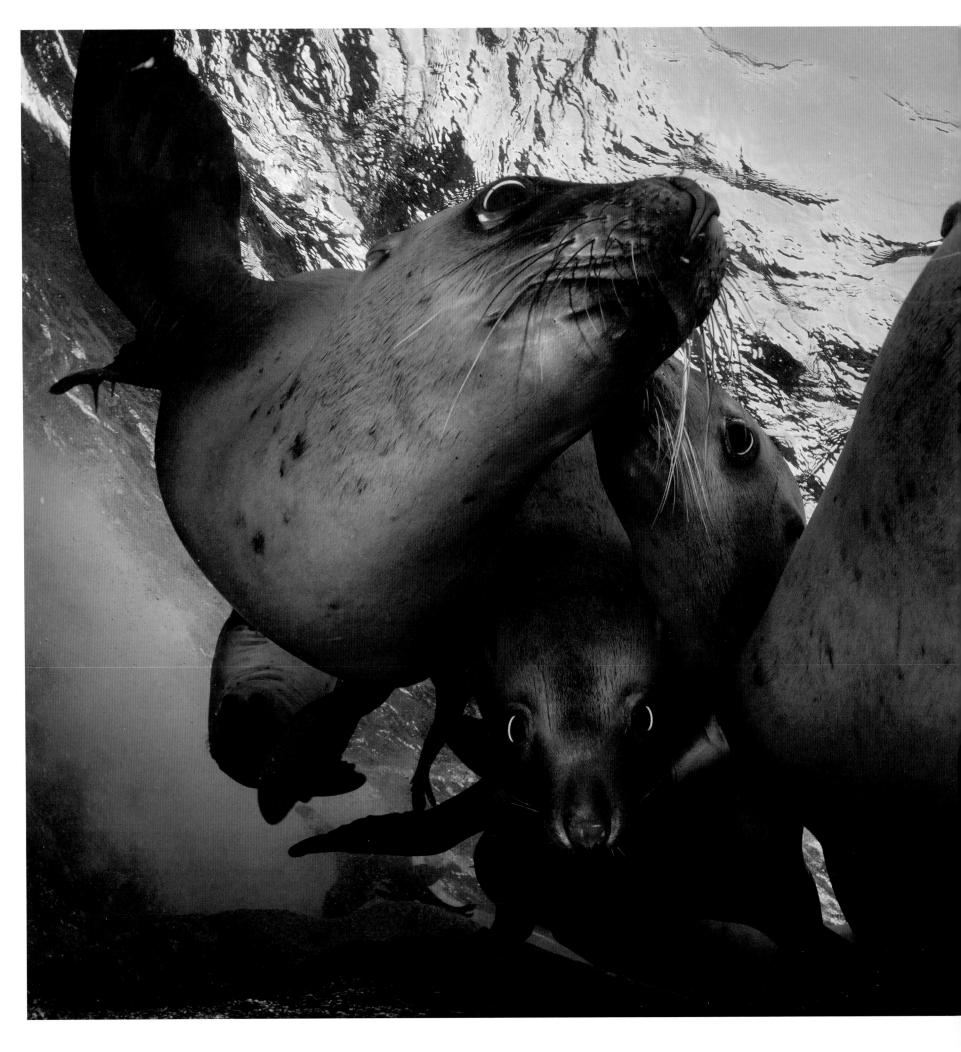

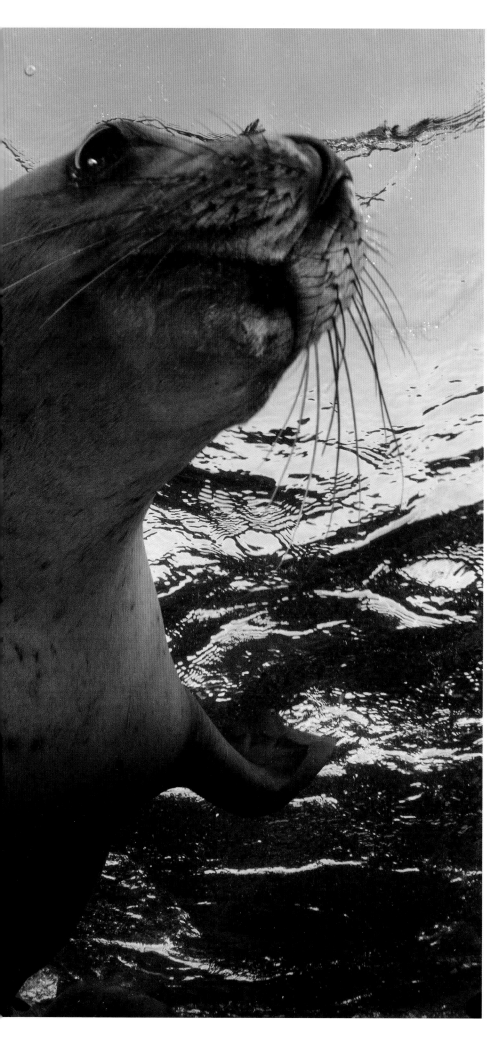

Over fifty species of prey have been identified in Steller's sea lions' diet, but the large pinnipeds mostly prefer small schooling fish, including herring, hake, and salmon. It is estimated that BC's sea lions consume over 100 million kilograms (220 million pounds) of seafood a year.

transportation heart. There are few boats coming or going on the protected side of the rock breakwater between the community's foreshore and the heaving and often tempestuous Douglas Channel.

Hartley Bay sits like a sentry over Douglas Channel and the neighboring islands of Gribbell, Hawkesbury, Princess Royal, and a host of others. Slightly hidden from the Inside Passage, the picturesque and proud community is defined by some of the most challenging weather on the coast. When it turns bad, people and supplies don't get in or out for days. It is during these times, especially, that the community relies on food gathered from the ocean, processed in many ways and eventually stored by jarring, drying, and freezing. My friend Cam Hill's family has a room in their house dedicated to three large deep freezers, each one storing countless preserved and well-organized ocean delicacies. From smoked oolichans to moose meat, there is serious biodiversity in Cam's freezers that can feed his extended family and others for a long time.

The weather system that tests people on this part of the coast, perhaps more than any other, is not the powerhouse southeasters that slam into the community with hurricane-force winds and torrential rain, occasionally ripping off roofs and felling telephone poles. No, these are the easier of the dominant wind patterns to contend with. These warm storms turn the sky black and the ocean white, but they do their damage and then eventually blow themselves out as the front moves north or dissipates.

The more challenging weather begins on a winter day with pale blue skies, when high pressure and wind from the province's icebound interior descend on the coast, eventually funneling down Douglas Channel. It is difficult to predict the strength and duration of these cold arctic outflows. Sometimes they reach only twenty knots and last a few days or a week, but other times they continue to build tirelessly through the day and night, increasing in strength, and the temperature drops as the wind builds. The problem with these winds is that they don't give in, like a train that just won't stop. There are no breaks. As each wave slams against a dock or the hull of a boat, another layer of ice is added. Ropes have to be found with sledgehammers and cut with chainsaws. The foreshore of

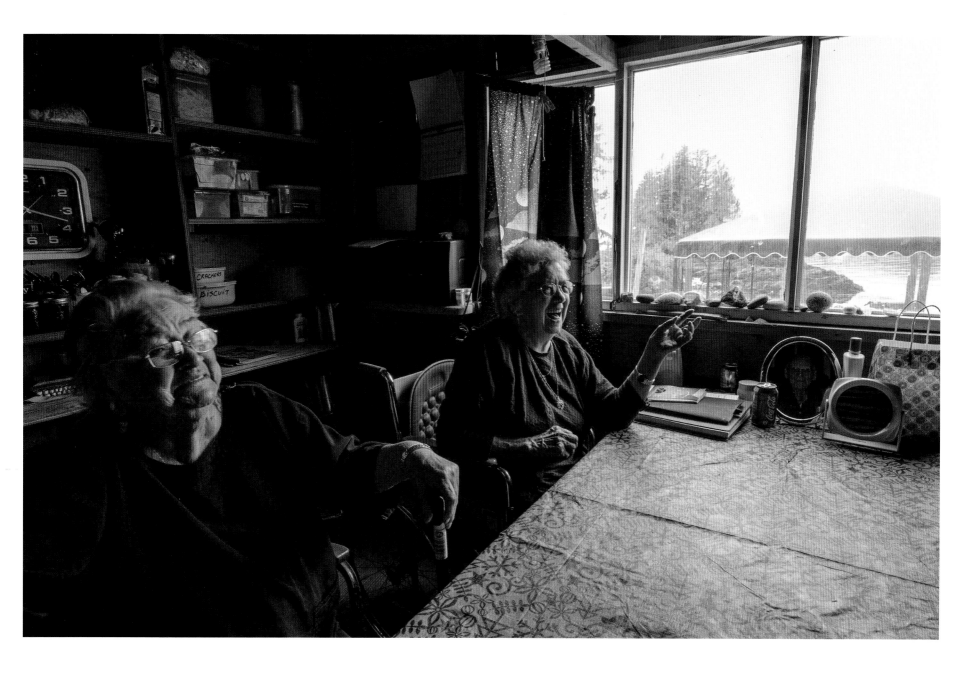

Hartley Bay, the waters surrounding the docks and boats, begins to freeze. Planes can't land and boats can't travel safely. Last year Hartley Bay received three and a half meters (twelve feet) of snow. This weather perhaps explains why the Gitga'at are among the most generous and welcoming people I have met, but equally resilient and fiercely independent. The strength of these communities is also found in the family bonds. The illness of an elder like Goolie, with her long line of great- and great-great-grandchildren, affects the entire community.

Gitga'at matriarchs Helen Clifton (*right*) and the late Margaret "Goolie" Reece share a laugh at Kiel after a day of halibut processing.

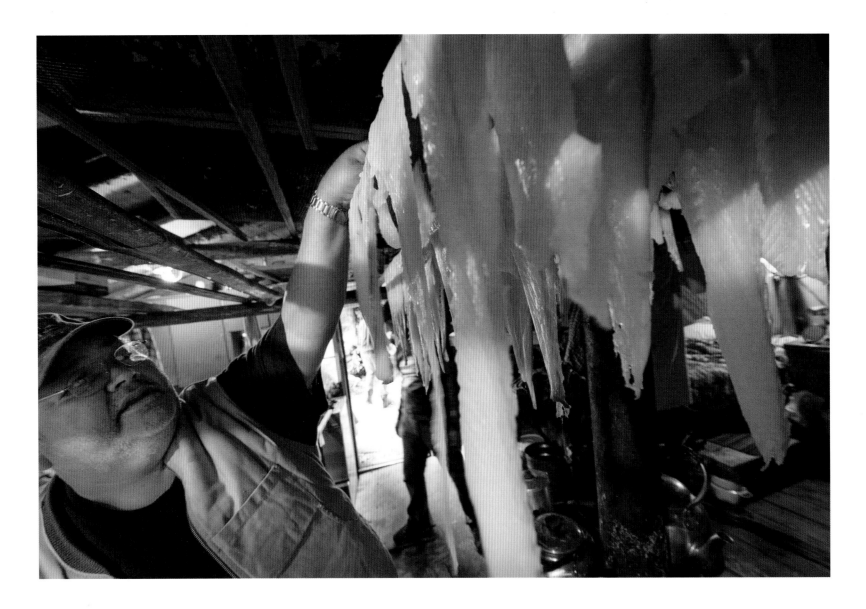

Gitga'at fisherman Tony Eaton drying halibut at the traditional harvesting camp at Kiel.

Git means people of, and *Ga'at* means cane. People of the cane. Gitga'at originally came from upper Skeena country across the mountains, to the north of here. They poled their canoes in the tributaries until they reached the deeper part of the river. So *cane* refers to these poles that helped move people and canoes. Present-day Hartley Bay was historically a seasonal village that the Gitga'at occupied permanently just 125 years ago.

Old Town, about twenty-five kilometers (fifteen miles) up Douglas Channel from Hartley Bay, was home to two of the Gitga'at's older village sites; one of them was situated in the middle of the Quaal River. It's also referred to as "man-made island," or *K'alahahaitk*. Its location was chosen because the river's flow and the tide's drop acted as a partial defense against warring tribes. When I first explored the Quaal, I remember passing by

the island and feeling that something was not right with the flatness and the tall spruce trees. Little did I know then that it once was covered with big houses and was a major village site, first excavated by archaeologists in 1938. Today it is slowly eroding from the mighty river's flow and the quiet surge of the tide coming in from Douglas Channel.

When Gitga'at speak about their history the conversation invariably starts with and cycles back to Old Town. Helen Clifton, one of the matriarchs of Hartley Bay, told me one day, "It's the canoe place, the smell of the river, the life cycle, human or fish. It is spiritual up in Old Town, the natural world in its glory."

Helen told me about an earlier village site that was at the headwaters of the Ecstall and Quaal Rivers. There an ancient overland trail—or "grease trail"—connected the Gitga'at with people from the Skeena River. *Grease* refers to the oolichan grease that would spill out of containers, staining the trail black, as this precious food commodity was traded between nations.

Helen also told me about how the Gitga'at moved far north to the community of a Christian minister, Father Duncan, near Prince Rupert during the smallpox epidemics of the nineteenth century. "Father Duncan was an Englishman and the first thing he did was learn the Tsimshian language. That was smart of him, but our people didn't flock to him because of Christianity, they went because he seemed to have some special power against the diseases. Our people already had belief in a higher power of this natural world, but the diseases were devastating." Many of the Gitga'at returned to the Douglas Channel area in the late 1880s.

Another heart of the community is Kiel, the spring-time Gitga'at seaweed and halibut camp on Princess Royal Island. The long winters of Hartley Bay are made bright by the anticipation of moving down to Kiel in early May. The view of the open ocean and the taste of the fresh food gathered each year have made this place a centerpiece of Gitga'at culture.

A few years ago I sat one evening with Helen and Goolie at Kiel while they talked about their history there. Looking out the saltwater-stained window bordered by old

Princess Royal Island. The interface of ocean and rainforest define the ecological richness of the Great Bear Rainforest. The sunflower sea star is the largest of its type in the world.

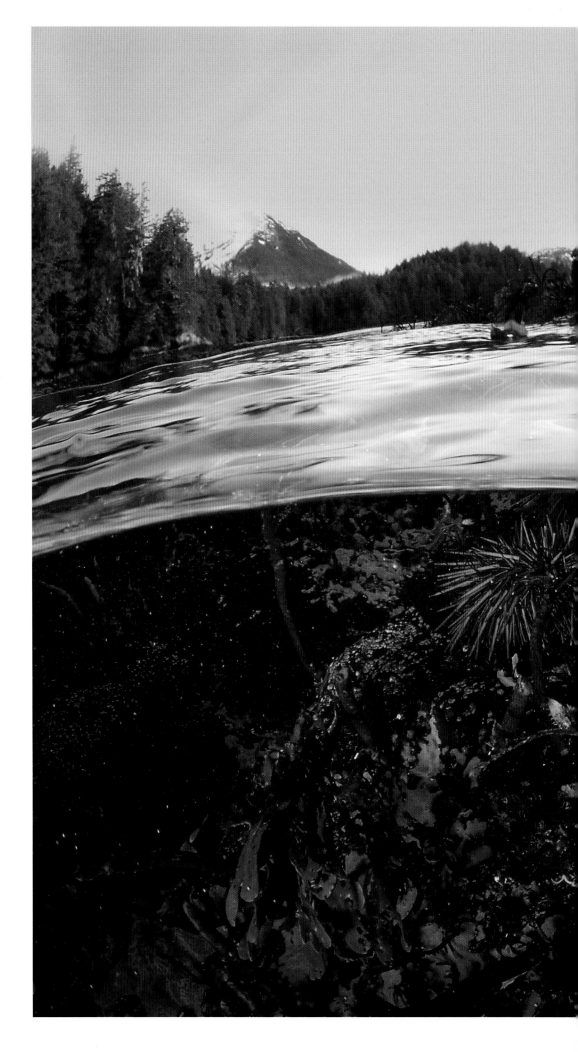

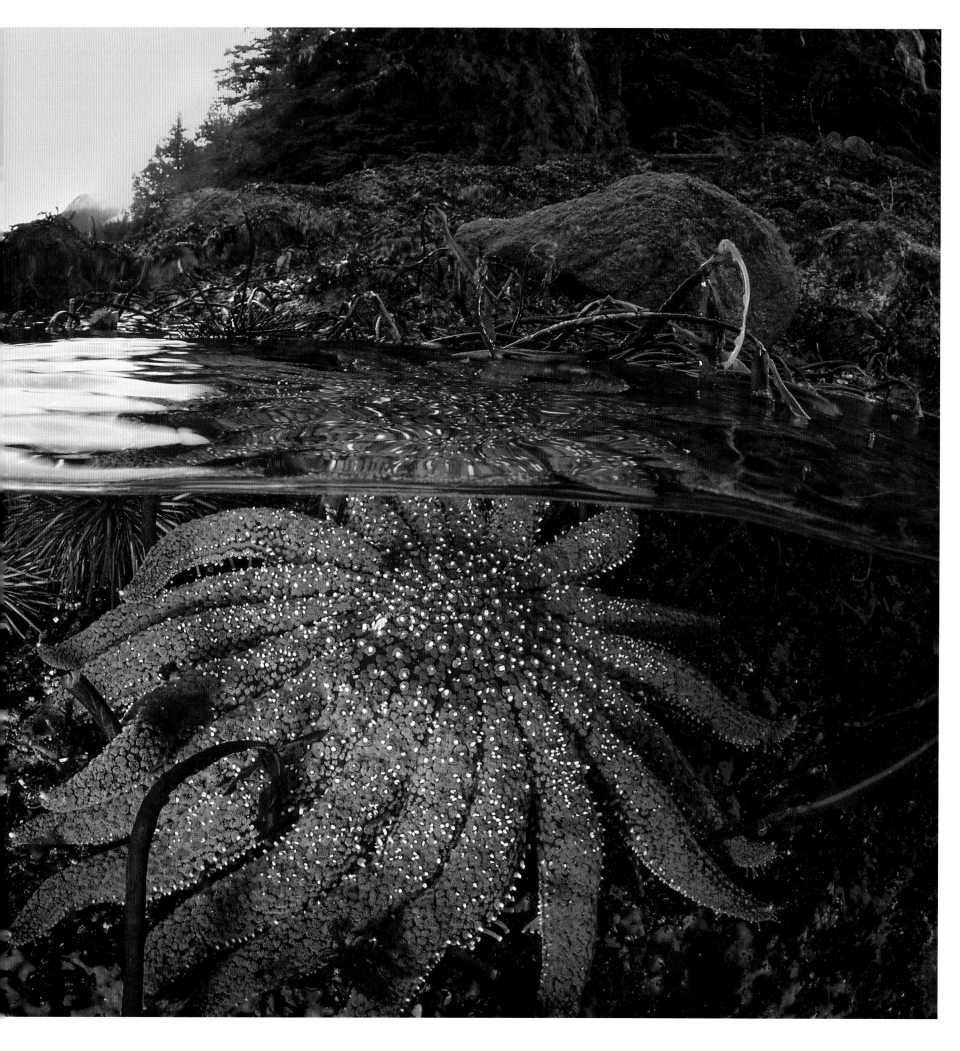

coffee tins and a picture of Helen's deceased husband, the revered Tsimshian chief Johnny Clifton, I felt fortunate to listen to these two matriarchs laughing and reminiscing—between them they represent a span of at least six generations. "Yesterday the killer whales moved inside. They passed right by Ashdown without having a look at all those sea lions," Helen said. "It means the weather is going to turn, so our fishermen won't be going out so far tomorrow."

The two talked about the weather, about the amount of halibut left to dry, and a lot about the quality and amount of seaweed they had collected earlier. I noted the number of bags already stacked in a corner. "One thing I will thank the white man for is ziplocks and zippers," Helen said. One of these women's seventy-odd grandchildren came running through the house. Helen smiled after him. "He loves this place. It is his," she said.

When Helen talks about abalone, it never fails to bring a twinkle to her eye. That day she said, "I remind our people that the stocks are not strong enough to harvest abalone. We need them to grow still. But the taste…" She laughed and then said, "Even just enough to tickle the tonsils." Fair enough; harvesting abalone is a right the Gitga'at and other coastal nations deserve. In 1990 they watched the Department of Fisheries and Oceans (DFO) blindly open a commercial abalone fishery, a species whose life cycle DFO knew nothing about. In a few short years, stocks of this prized delicacy collapsed.

Today DFO manages the sea cucumbers and other species they allow to be harvested commercially in the same way. Not one DFO scientist can state with confidence how long a sea cucumber can live or much about its reproductive life cycle, yet over 4,000 metric tons (4,400 US tons) are harvested each year. The same goes for urchins, geoduck clams, and a long list of other species that are showing signs of overharvesting.

Not a lot has changed at Kiel since the first steam engines plied this coast. The original dirt and cockleshell floors remain in many of the family-owned cabins. Candles and oil lights have largely been replaced by bare lightbulbs hanging from the ceilings; a few small generators can be heard humming outside; and the odd broken-down, rusting appliance can be seen poking through the thick salmonberry bushes. But of course there are greater

changes: not all the young people come, and many don't stay as long as they used to. Faster boats now allow for more seafood to be transported back to the Bay and waiting freezers.

A stove full of burning driftwood remains standard heating not just for the Gitga'at but also for the food that hangs drying in the rafters and most other available space. Upon entering any of the cabins at Kiel it takes a moment to adjust your eyes, and then you see row upon row of overhead racks covered in black seaweed or thinly cut fish. Crossing the room, you have to duck down to avoid getting strands of hanging halibut entangled in your hair.

The prized fish is caught just off the beach here with long lines and hung to dry for twenty-four hours to bleed out. Then, if the weather is right, it is cut in slices and dried in the wind. Finally the ivory-colored fish, called *woks* when prepared this way, is gently softened with a yew wood mallet before it is put away for transport back to the Bay. Laundry is dried alongside the fish and seal meat.

Just across the channel from Kiel the tidal area has plenty of rocky relief, allowing for a bit of air to circulate between the loosely hanging seaweed when exposed at low tide. Here is a preferred place where elders and youth come to pick seaweed. Seaweed picking is an art form, and, like all traditional harvests, there are good reasons for doing things at the right time and in the right order.

To my eye most of the seaweed covering the rocks looks the same, but my Bella Bella neighbor Jordan Wilson taught me how wrong that is. A few years back, as we traveled along the seaweed grounds after the first flush of spring, his sharp eyes glanced over long stretches of new seaweed, looking for just the right patch. He explained that the best places were found where the surf rolls in not too hard, but gently caresses the new growth. After jumping ashore and inspecting a patch, he gave the go-ahead to harvest, first throwing a gumboot chiton into my sack for flavor, something he learned from his ancestors.

Seaweed picking is not as easy as it sounds. I slipped on the olive green strands that covered the rocks, and I marveled at how sure-footed the elder ladies from Kiel were

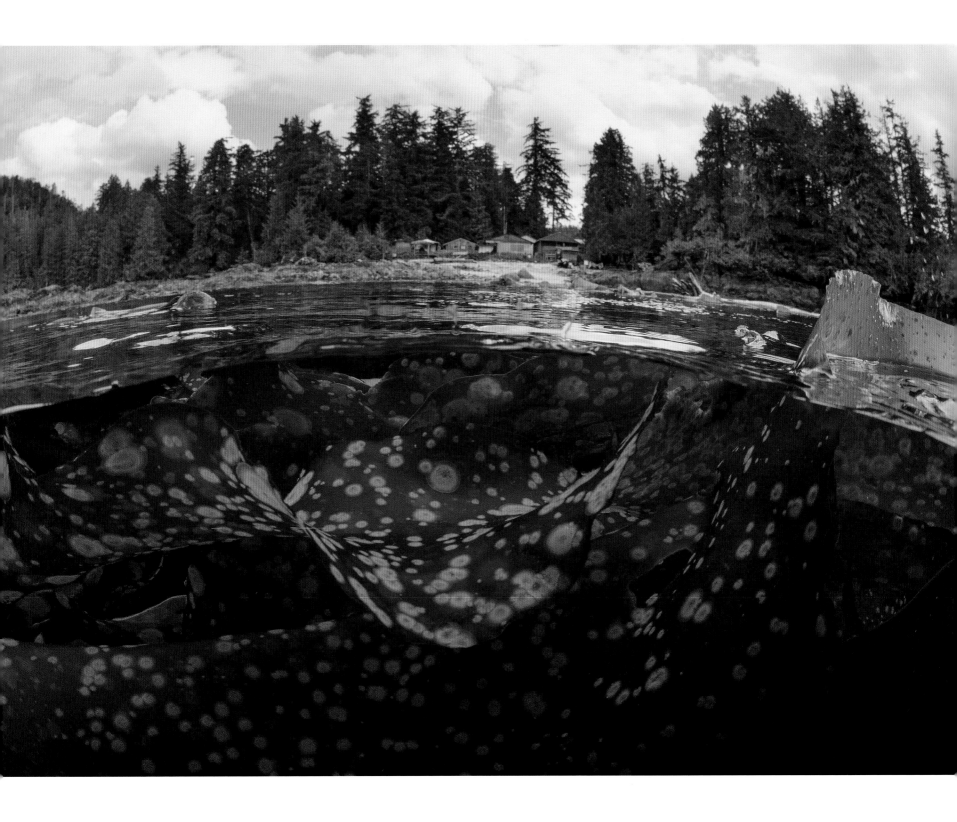

as they quickly and methodically filled their sacks with the cold leaves. Later, after it has dried in the sun, it is placed in buckets in a dark, cool place until it is added to soups, dipped in grease, fried in butter, traded as a commodity, or eaten raw as a snack. Once dried it will stay preserved for years.

So many of these important and historical food-gathering places are indistinguishable, at least to my eyes, from other parts of the coast. But they are often associated with intricate rock carvings; Gitga'at ancestors have left some of the greatest displays of petroglyphs on the Pacific coast.

Unlike culturally modified trees, which can be dated by coring and counting tree rings, petroglyphs—and the many stories they tell—are nearly impossible to date using modern methods. Their age can only be guessed. Petroglyphs are perhaps the oldest physical connection to Gitga'at ancestry that exist today, and some are likely older than the Dead Sea scrolls or the Bible.

Usually found near the tide line at old village sites, they are often visible only at low tide, and after hundreds and thousands of years of surf, waves, and rain, many have been lost to the ages. Others are found well above sea level covered in moss, trees, and roots. These are perhaps the lucky ones. They remain hidden while many other artifacts have been carved off or stolen, ending up in collections. Some of the early collectors came to Gitga'at territory and hauled off rocks covered in petroglyphs, some of which have since been recovered from the Kitimat Museum. I am amazed at how many people, when they come across a stone adze or other artifact at a midden or other old site, feel justified in keeping it. Just last year a number of burial boxes were broken into and artifacts were stolen from a remote site near Klemtu, the Kitasoo/Xai'xais village about a hundred kilometers (sixty miles) south of Hartley Bay.

Artifacts, masks, canoes, carved poles, and countless other cultural pieces taken, bought, traded, and stolen from this part of the coast since European contact lie in museums, universities, and private collections around the world. Many of these artifacts are stored in controlled environments where humidity and temperature are closely

monitored. When a First Nation repatriates, say, a totem pole, the natural thing to do is return it to its home, which usually means sticking it in the mud of an estuary or remote village site. It is appalling to the curators of these museums to see these ancient pieces of art returned to the mud or stored underneath the bed of a chief who rightly owns it. But from a First Nations perspective, art is not meant to last forever, and natural decay allows for a generation of carvers to create new work and continue their cultural ways. It is a living culture that will place a pole out in the rainforest of this coast.

I was invited to a historic event in Hartley Bay in 2012 at which the first repatriation of stolen petroglyphs was unveiled to the community. The ancient rock art was laid out in large wooden boxes on the community hall's cedar-planked floor. It was an emotional experience to be surrounded by the beautiful carved corner posts and raw red cedar planks that cover the hall's walls, to be part of a celebration that was not mourning the loss of culture or the natural world but celebrating the return of it. First Nations history is defined by oral teachings and stories, and surprisingly few physical objects survive the test of time on this coast. That is what makes petroglyphs like these that much more sacred and culturally important.

Not many First Nations on this coast have been successful in bringing their lost or stolen cultural treasures home, so that evening was especially important for the people of Hartley Bay. Tears flowed as community members passed slowly by the boxes, some gently touching the black rocks. There were tears of anger for the sacrilege perpetrated by the original collectors, and maybe shame that the Gitga'at had betrayed their ancestors by not protecting the petroglyphs, but mostly I think the tears were of joy and relief that they had made good with their ancestors by bringing these important cultural pieces back home.

SITTING ON MY boat tied up at the Hartley Bay dock, I watch Wally Bolton. Like clockwork he comes in from the open Douglas Channel in his tiny aluminum skiff, a routine that defines life on the Hartley Bay foreshore. I go out and meet him at his cleaning table near his parking spot on one of the small fingers that jut out from the main dock.

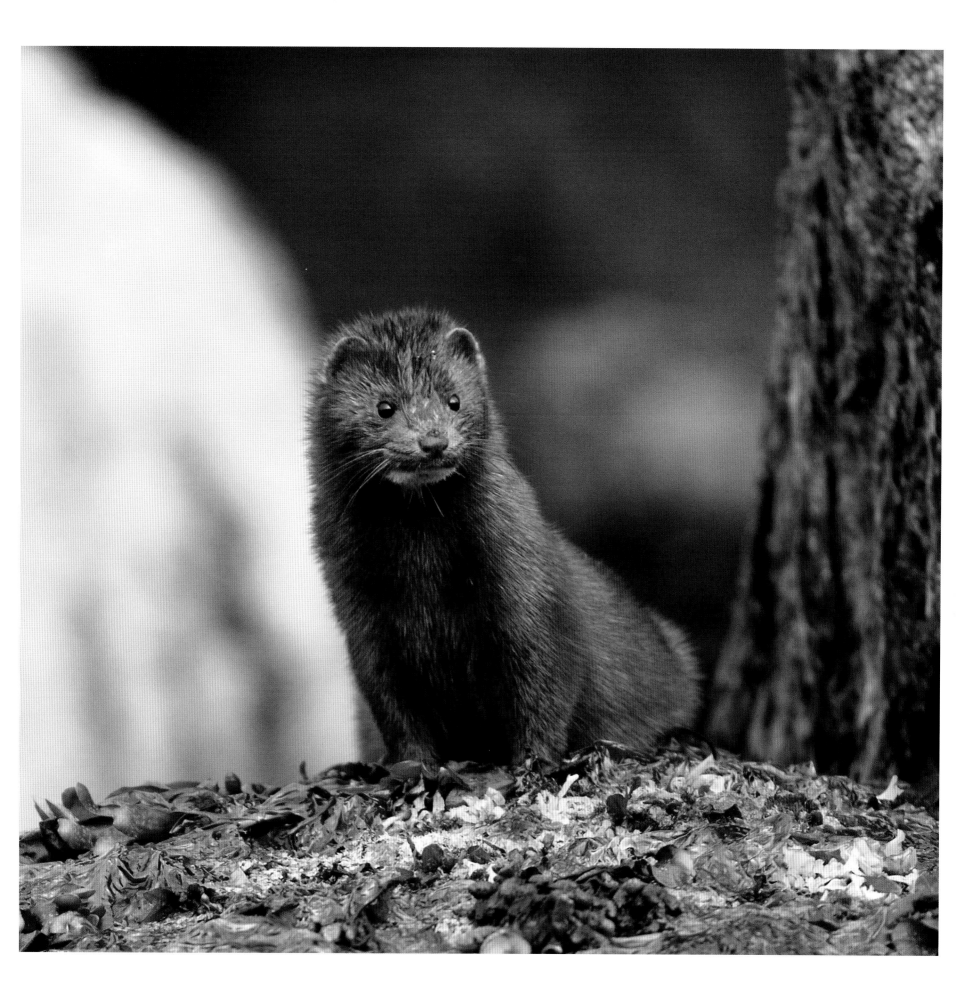

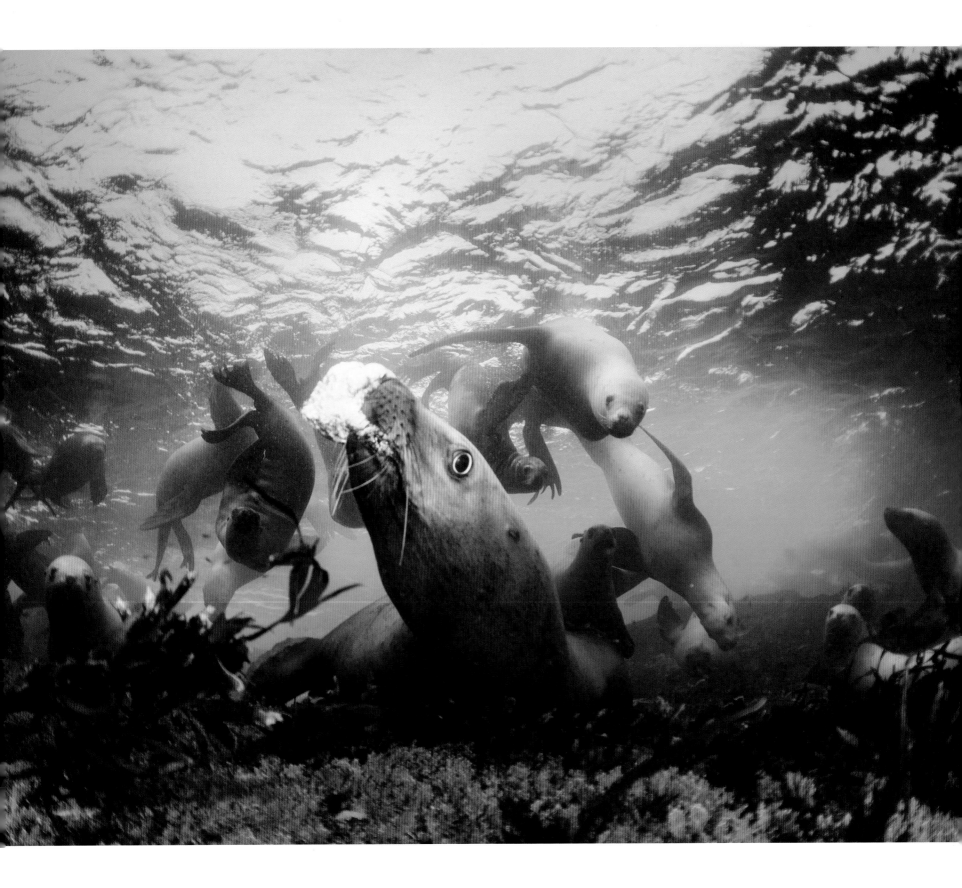

He follows my gaze into his boat and smiles: "Just the size I like." He has three halibut, each one beautiful and snow-white on its underbelly and in the fifteen-kilogram (thirty-pound) range. Soon he has one up on the table, and he deftly makes four cuts before dropping his blade into the fish point-first and feeling along the thick, strong bones, carving the flesh between each to ensure no meat is lost. The ivory flesh looks clean and healthy.

Wally is sixty-two years old and laid his first long line off of Hartley Bay when he was seventeen. He can tell you the heaviest halibut he ever caught, and the second, third, fourth, and so on. Wally is meticulous when it comes to fishing. In the early afternoon he comes down to the Hartley Bay dock where he stores his boat and baits each hook by hand, laying them out perfectly across the gunwale of a bucket, until eventually he has everything ready for the evening tide. I ask him why he always fishes right in front of the village and doesn't go farther afield. He smiles broadly, nodding his head across the break-water. "The fish come right around that island and through the pass on the way to the salmon rivers."

For more than forty years this man has been laying long lines with baited hooks, catching halibut and other bottom fish with precision. He describes how to bait the hook: not flesh first, but skin first, and not too much on the hook; it has to dangle. Halibut are scavengers and will grab almost anything, but the bait has to sit on these claw hooks just right. Laying and pulling these lines by hand puts him in amazing shape, and the size of his weathered hands shows the many years of hard work they have done.

He prepares his gear with the experience of a fisherman who knows that every small gesture increases the odds of success. Wally's boat is small, a lake boat really, and has a 20 hp engine on the back. It doesn't look particularly safe, but this man knows these waters as well as anyone here, and being close to the Bay, he can make calculated decisions on when to head out. He bought it for $500 and it's so old he doesn't know the year it was built. He is able to sustain himself, his family, and his extended family on the doorstep of his own village, which is remarkable. How many fishers on our planet's coastlines

can make their catch within a few kilometers of their community? It seems that in most coastal places I have been, the engines and boats are getting larger and the fishers have to travel farther and farther for smaller and smaller fish.

Looking at the huge coil of strong hemp-like three-strand line he is using, I ask him how deep he drops it, noting that he does not have any hydraulics or pulleys for mechanical assistance, and some of the line will have hundreds of pounds of halibut attached to it. "Sometimes two hundred," he says. I think, okay, that's not bad. I could probably do that. "Fathoms," he grins again. That's 365-plus meters (1,200-plus feet) of baited hooks with fish on them that he pulls up by hand, each day, in a boat slightly longer than a tub. Now I get why he looks as strong as a tree trunk.

DFO will not allow Wally to sell his catch commercially. Perhaps that is a sensible conservation policy, but on the other hand the Supreme Court continues to rule that if a First Nations person can prove that traditionally he harvested and sold specific marine species, he should have that same right today. This is the basis of the Gladstone decision, in which a Heiltsuk family won the right to sell herring roe, and other similar cases that have been fought and won over the years in the battle for Aboriginals here to sell marine products commercially. For now, though, in the absence of expensive lawyers and long, drawn-out court challenges, Wally's catch fills local freezers and is traded for other seafood specialties.

Later in the day, walking past the community center, I look back past the basketball court and fuel dock. Across the expanse of Douglas Channel, between the Bay and Gribbell Island, I can see only one little boat with a single figure slightly hunched near the bow. Wally is hauling in another line, going slowly I am sure, flaking the line in a neat coil on the bottom of the boat, the sting of lion's mane jellyfish on the back of his calloused hands. I bet he is smiling.

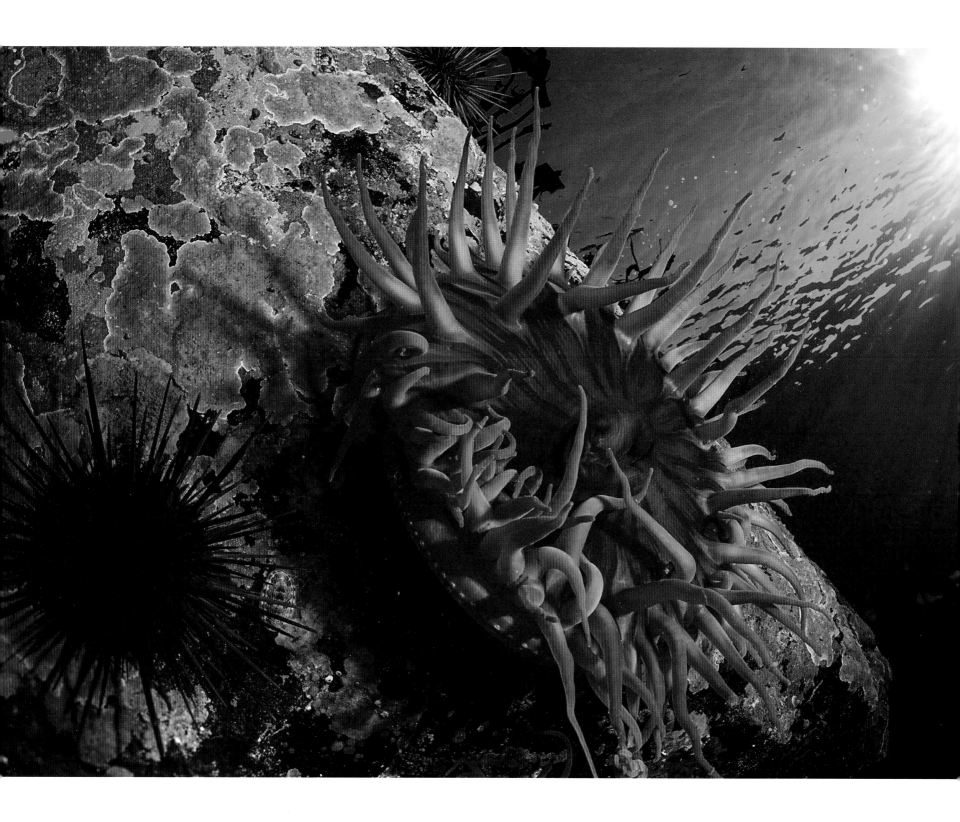

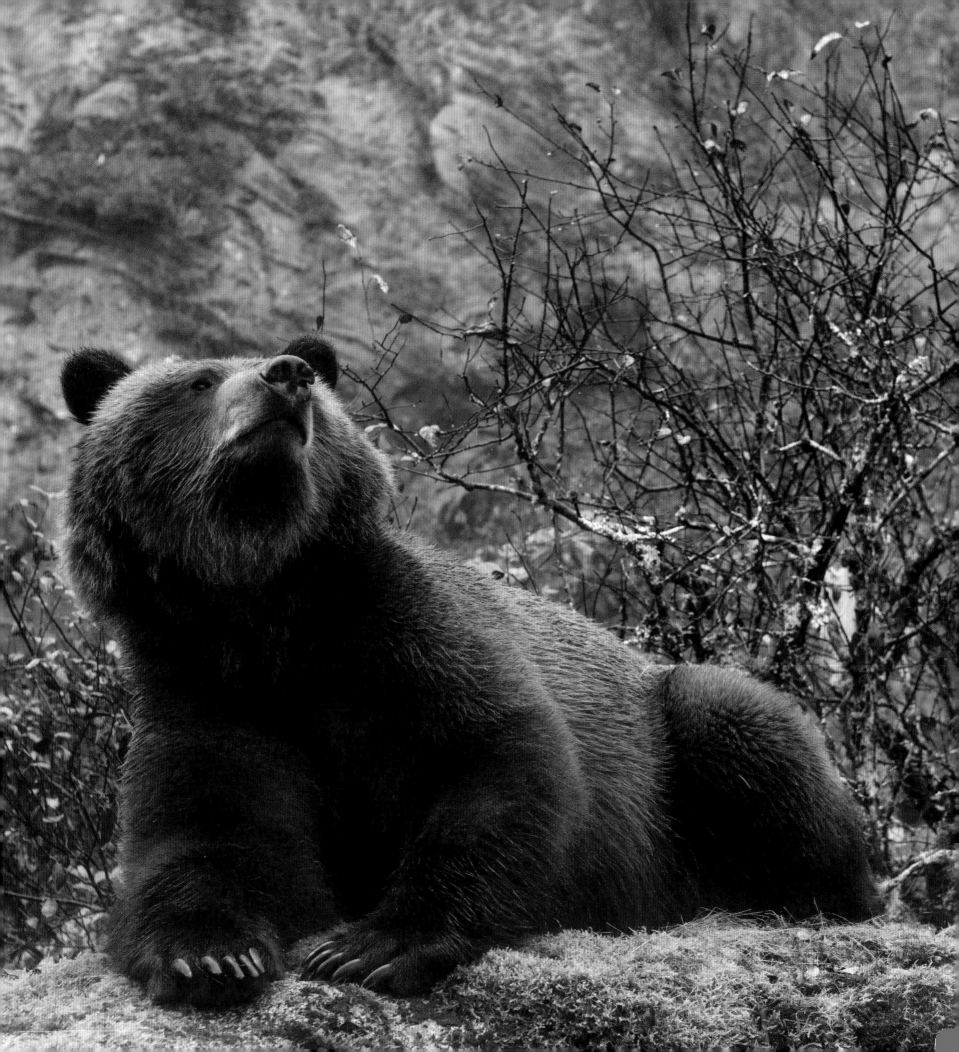

The monarch of the rainforest, grizzly bears in BC continue to be hunted for sport and trophy even in parks and protected areas.

RAINFORESTS OF HOME

ONLY A WEEK ago, the chatter of wrens, the rhapsodic thrushes, and the soft splash of a salmon tail were the ambient signatures of this rainforest alcove. Everything now is replaced by water—lots of water. A torrent falls from the sky, rushing across beds of moss as the river spills over and through the forest understory. Nothing escapes saturation.

Record-breaking rain hammers the coast. It is the end of September and already we have endured four separate storm events, characterized by winds exceeding sixty knots. Long-time mariners tell me they have recorded the strongest winds on their boats' anemometers in over fifty years. This kind of weather makes hard work for everyone, whether you're a bear fishing for salmon or a captain trying to keep your boat and crew safe.

The canyon has filled with spray and mist. The bears below are having a tough time keeping track of one another; normally scent is their navigation tool, but the pouring rains, unpredictable gusts, and loud rushing sound put them at a disadvantage. These bears couldn't even hear a shotgun blast from across the river. This is an old and well-established fishing spot, and for some of these bears, many of the most important days of their lives have been spent here.

Coming here feels like traveling back in time; all thoughts of oil pipelines and tankers that increasingly consume the coastal conversation these days seem distant. The fresh

29

smell of salmon, blood, and ripped flesh comes in chaotic waves with the mist, but I choose to stay higher up. The chance of disturbing a bear in the close confines of the canyon bottom is too great, so I wait above on the cliff's edge. Like the many carnivores around me I also feel sensory deprivation. The noise makes me feel like I'm underwater—there would be no warning of an animal's sudden appearance beside me.

When salmon return in strong numbers like this it has a calming effect on coastal inhabitants, human and non-human alike. A level of accommodation is being displayed between everyone in the canyon that normally would not be observed during other seasons. But the uncertainty of who, and what, is in the canyon, mixed in with my scent, creates a charged environment. There are only so many good fishing spots in these fast-moving island creeks, where bears, wolves, salmon, and a host of others are forced to meet.

Today is a day to be patient. If you are going to see things here you often have to wait quietly for quite a while and let things unfold in their own time. When I first arrived I didn't actually see any animals. But that's normal, and I suppose a bit like being in a seemingly empty neighborhood in an unfamiliar city. Minutes might go by in which nothing happens. If you leave, you might report that the place is void of life. But if you wait, a door might open, and people and their routines will soon become visible.

But bear signs are everywhere: The trees are worn, varnished from hundreds of generations of bears sliding up and down as their mothers fish for salmon, a kind of arboreal ursine daycare. Down below, the occasional coho has a deep red mark on its back, a badge of honor for having escaped a whale, bear, wolf, seal, or net, though there are many more mouths to avoid before this spawn has played out. The fish move through the river with heroic purpose, but the bears feel the anxiety of never knowing how large the salmon run will be and how long it will last. Bears furrow their brows like humans do when they are concerned.

Soon a bear comes out of a corner of the rapids, grabs a fish, and is replaced by another. Looking down through the occasional breaks in the spray and mist, I can see hundreds

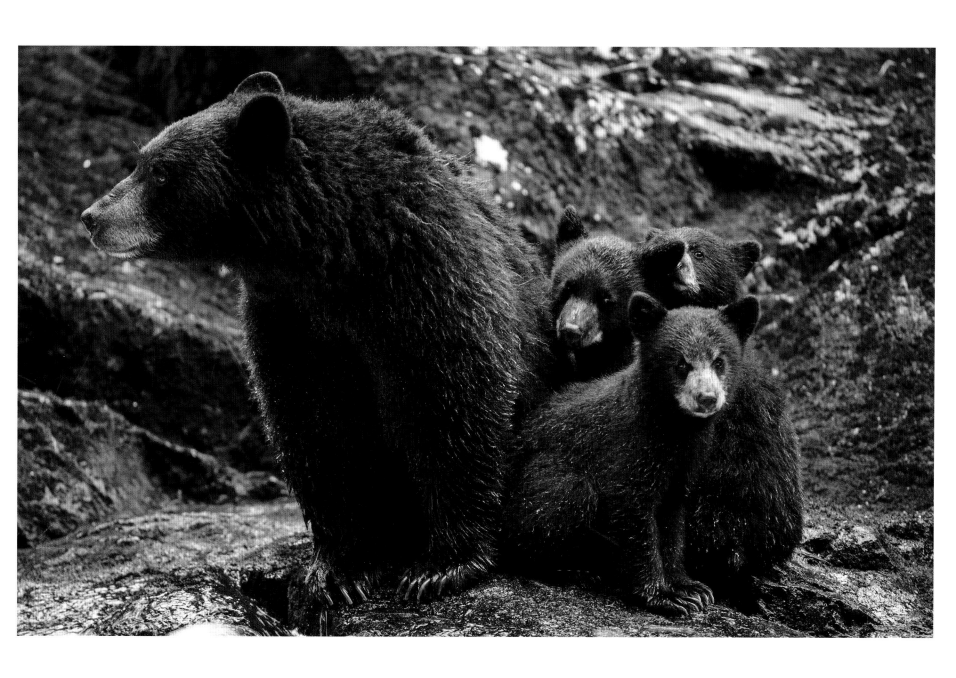

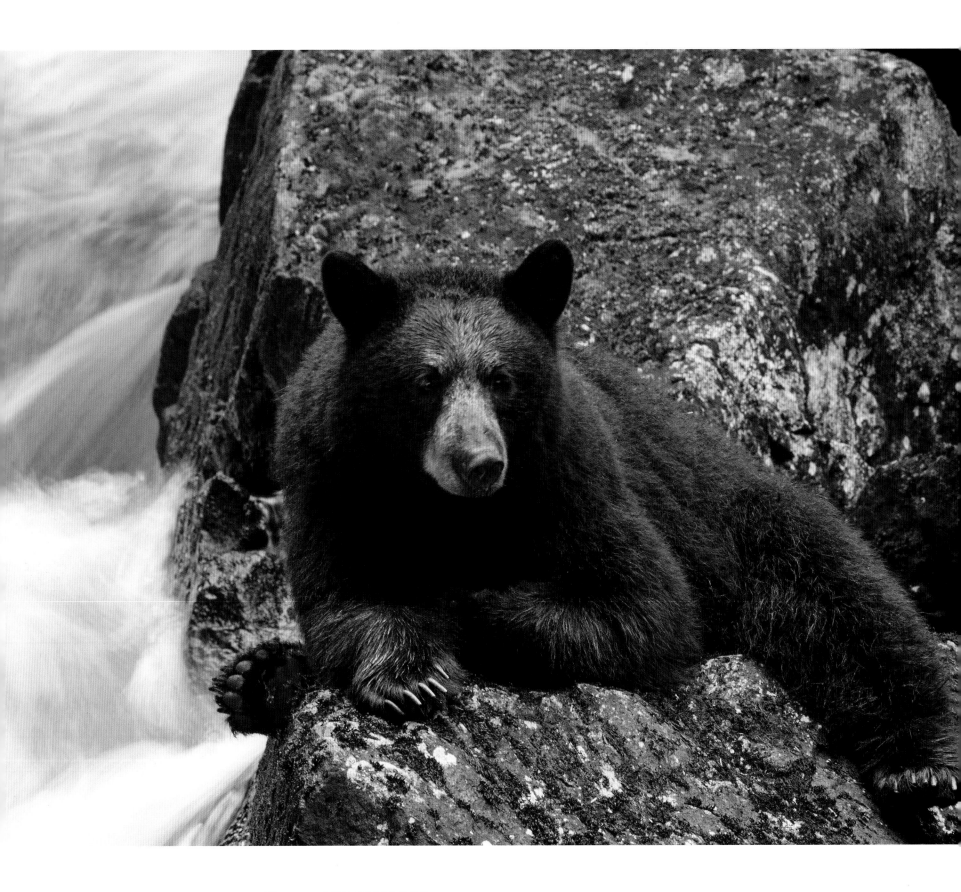

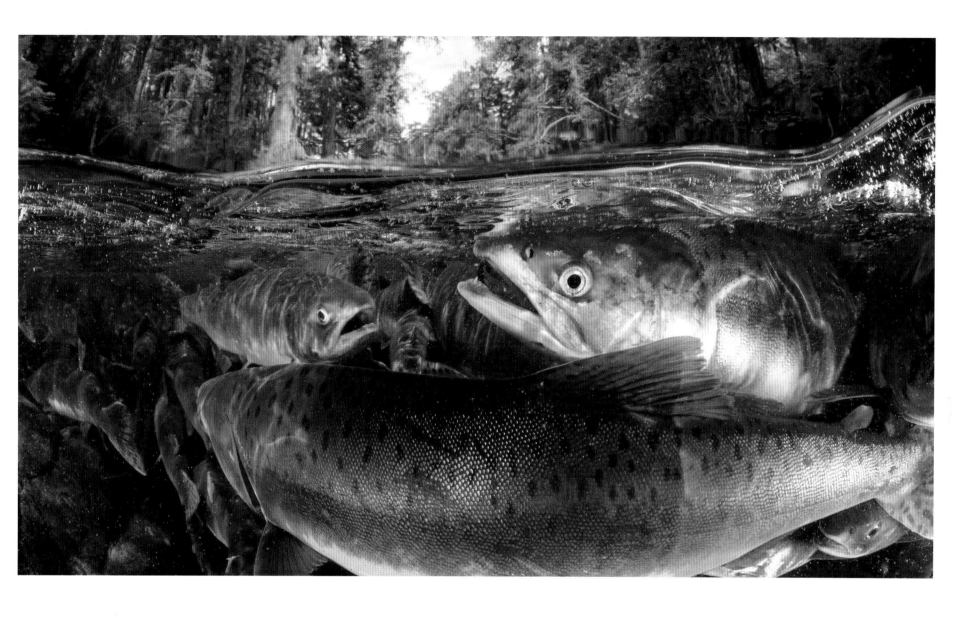

facing Well fed and secure for the time being, but as salmon decline along the neighboring mainland watersheds, grizzly bears are now swimming to traditional black bear islands, where they may displace or kill the resident black bears.

above Pink salmon. Born as orphans, these salmon will never meet their parents. Their multi-year heroic journey through the north Pacific, ultimately ending back in their natal stream, remains one of the planet's greatest migrations.

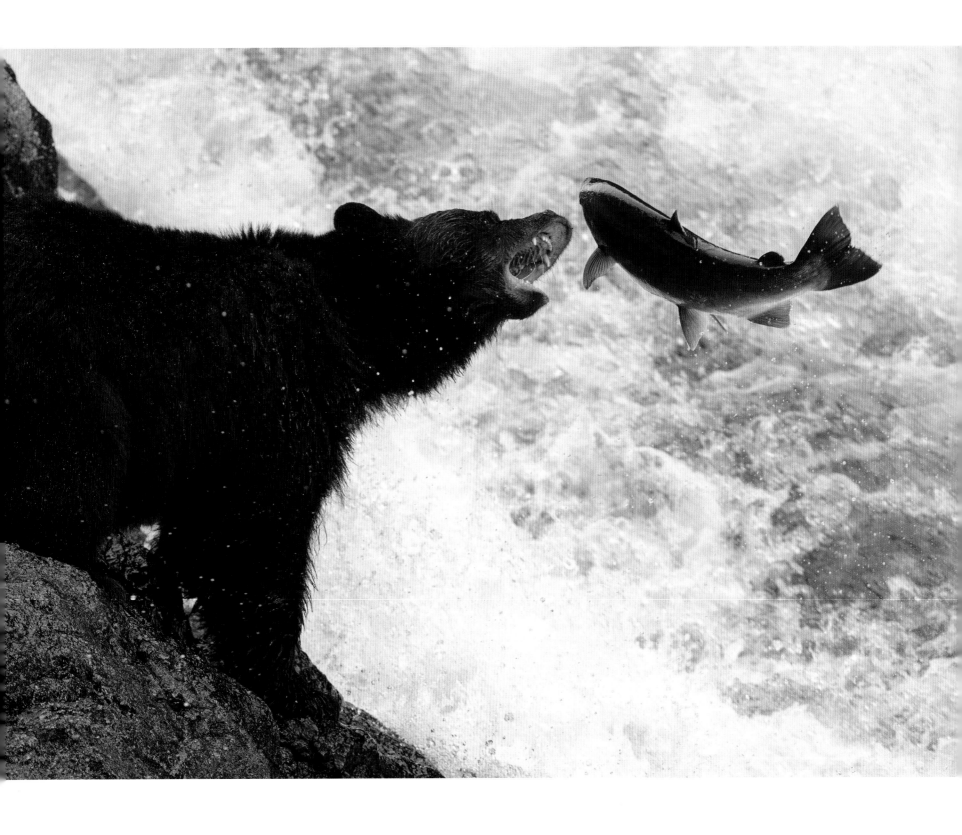

of black salmon heads and tails rising occasionally above the swirling foam. Large house-sized boulders fill the tight gorge, forcing salmon to swim through fast-moving tunnels below. It is a coho salmon bottleneck. A fishing derby is not far off. Downriver, the early run of pinks is mostly spawned out, and I see a small bear stand up on its hind legs to access some crabapples. The sharp tartness must be a nice respite from the decaying corpses floating downriver. When I passed those swimming carcasses earlier in the day some of them were moving and technically were alive, but their souls appeared to have since departed, their bodies unable to shut down after such a constant journey.

I first came to this spot over twenty years ago and have not missed a salmon season yet. Even by Great Bear Rainforest standards this place is remote, hidden among a sea of unbroken rainforest, wild creeks, islands, and mist-cloaked fjords. Down at the end of the main creekside bear trail, near the ocean, the entrance to this particular watershed is deceiving. It appears to be just like any one of the countless creeks emerging from the rainforest edge, but there is nothing typical or usual about this place. Being one of the few strong salmon runs for many kilometers, this river attracts a disproportionate amount of wildlife that come for the salmon, or predators that come for the salmon eaters.

Last year Karen and I brought our children here for the first time. It was a rich day, watching our small ones scampering about under such large and ancient trees, hearing their chatter and laughter as the ravens bounced along curiously above. I suspect that it had been many generations of ravens since the sound of young children's laughter had been heard so near the headwaters of this valley.

To get here involves bypassing a lower canyon by crossing over a saddle on the adjacent ridge that dissects the valley; then dropping back down to the river's edge and skirting two lakes, a stretch of open bog forest, and beaver-engineered wetlands; then scrambling up a steep, well-worn wolf/bear trail. The kids moved effortlessly.

A friend from Bella Bella, Larry Jorgenson, wrote that the only thing more beautiful than experiencing such rainforest paradise personally is to witness it through the glint and marvel of a child's eye. I understood what he meant on that day.

A mother bear successfully catches
a coho salmon while her cubs
encourage her from above. Salmon
may be the reason for the spirit
bear's evolutionary adaptation of a
white coat, as it acts as camouflage
against a bright sky.

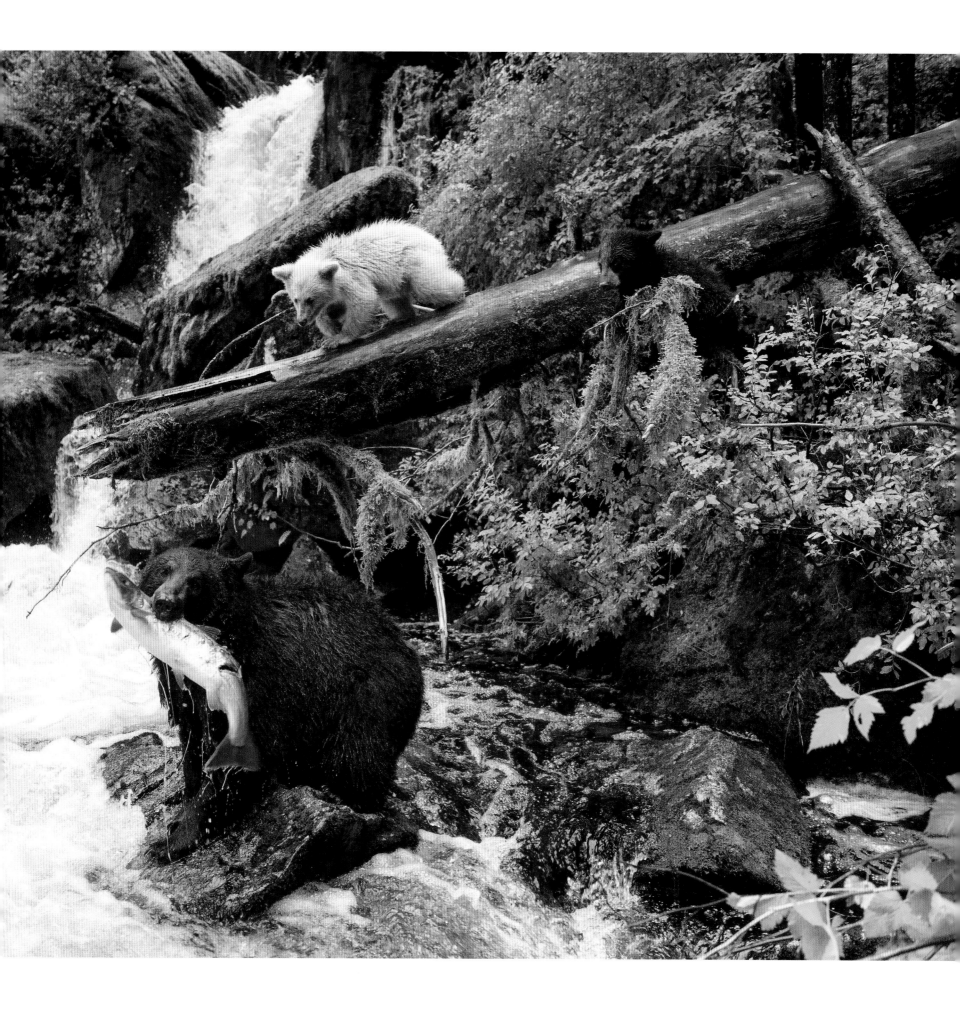

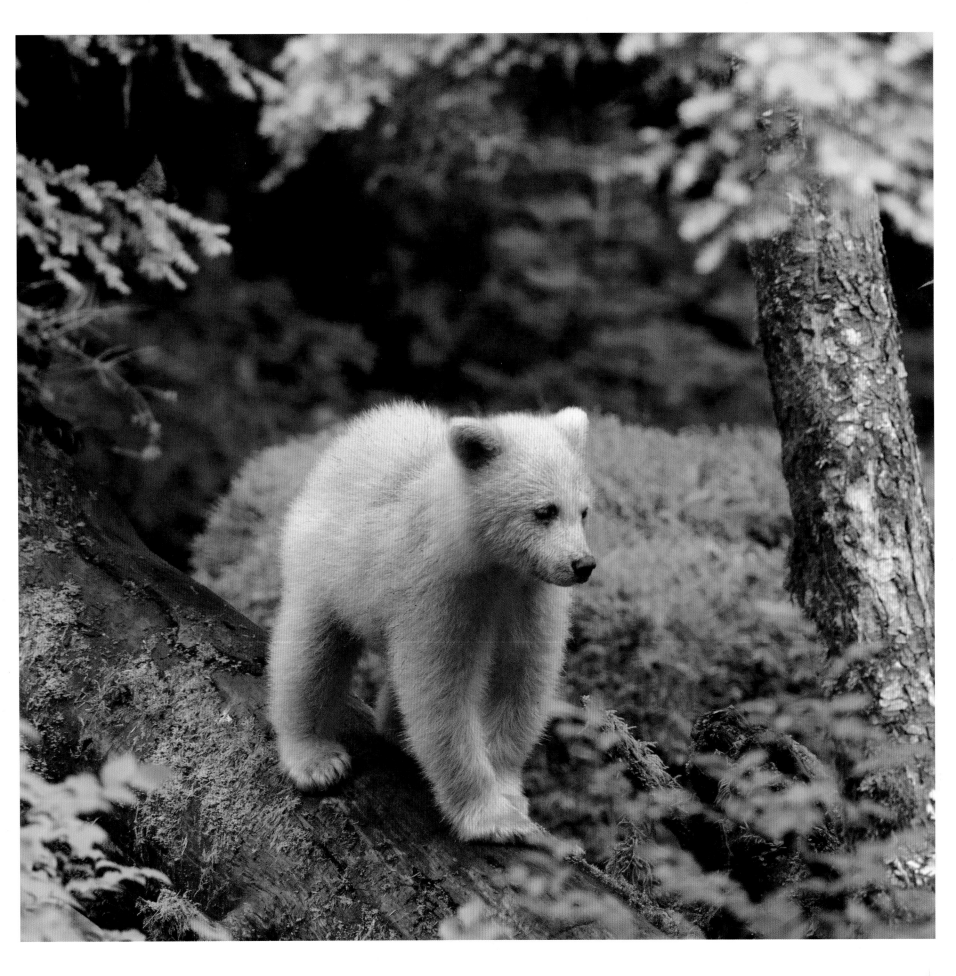

facing A spirit bear on Princess Royal Island. Every single intact river valley south of the Great Bear Rainforest to northern California— the southern extent of temperate rainforest in North America—has been logged, dammed, paved, or fragmented by humans.

Today, though, the occasional blasts of tannin-scented water mixed with the rich smell of dead and dying fish bring me back. Keeping an eye on the worn trails emerging from under the salal and salmonberry bushes, I try to settle in. As the day emerges and the light enters the dark corners of the forest, I can feel the gusts weaken, allowing tiny droplets to remain suspended in the air, floating softly through the columns of light. The mist curves past the soft woven bark of the red and yellow cedars, intersecting with glints of rainbows between the green boughs. Some of the individual trees within this forest have stood witness to a thousand spawning cycles such as this. The stories they could tell.

More birds arrive as the day awakes: Bonaparte, mew, glaucous-winged—they quietly come in from their resting spots in the inlet. Upriver they revolve, then drop down, head-first, wings folded back, and thrust their bodies into the water to grab an errant salmon egg bouncing along the bottom. The eggs are the size of a pea and nearly translucent. I stare and stare and can't see a single one, yet each bird rises out of the water, one after the other, with an egg in its beak.

Traces of salmon are stashed all over the forest floor. Even here, kilometers upriver, the migrating and spawning salmon dominate everyone's attention. From the largest animals of the rainforest to the smallest—a long list of over two hundred mammals, polli-nators, flying insects, and birds—they have all built their lives around the return of these salmon. And these are the species that directly consume salmon; the indirect species that rely on salmon are most likely measured in the thousands. Each year scientists add new species to the list.

Knowing the state of the once magnificent forests to the south, I find it hard to imagine a time when these ancient bear trails stretched along the mainland from northern California to western Alaska and down the Russian Far East, broken only by the Bering Sea. The trails, worn deep by generations of grizzly bears, once stretched 3,200 kilometers (2,000 miles) to the south of the Great Bear Rainforest, but today those old bear trails have long been dammed, logged, or buried under pavement, fields, and houses. Now the only wild coastal grizzly bear that can be found south of the Great

Bear is flapping on the California state flag. This fact alone should be enough for humans to want to save these last ancient trees, but in spite of significant efforts to preserve them they continue to fall at an unsustainable rate.

These conifer forests stretched across most of the planet 200 million years ago. But today they cling to the extremes—the edges of cool, wet coastlines. Now conifers like this are almost absent from the tropical world, where flowering plants dominate. High overhead in the canopy, thousands of insects—many undiscovered, named, or studied—live within layers of moss and epiphytes. A single silver spruce rising to the clouds hosts tens of millions of needles, and stored vertically in its trunk are thousands of liters of water.

The greatness of these trees comes thanks to the vast layers of mycelia, the vegetative part of a mushroom, which spreads for kilometers like an open web through thick layers of sphagnum moss. It is this fascinating relationship between mushrooms and tree roots that allows this forest to grow to great size and antiquity. These trees filter sunlight and process that energy into the roots and soil to feed the mycelia, which in turn alter the chemical balance, allowing these giants to exist in some of the most rain-leached soils on the planet. The moss is so thick that future generations of trees have no choice but to grow out of fallen logs, or what are called nurse trees.

As anthropologist Wade Davis describes, "They are called old-growth not because they are frail but because they shelter all of our history and embrace all of our dreams." Over 60 percent of these ancient temperate rainforests are now gone, and most of what still stands is found in these last river valleys.

One house-sized rock near the bears' fishing spot has the freshest trails along its mossy top; the rock is wet and raw, and small pieces of discarded salmon are strewn about. Ravens are hopping about gathering the pieces and flying off to cache them. It is a marvel how the soaked talons of cedar and hemlock gripping this rock, seemingly in the absence of any real soil, can produce such massive, old trees.

The gray granite slabs lining this river are periodically etched by white ones, marking where school bus–sized slabs calved off, succumbing to ice water and gravity. This

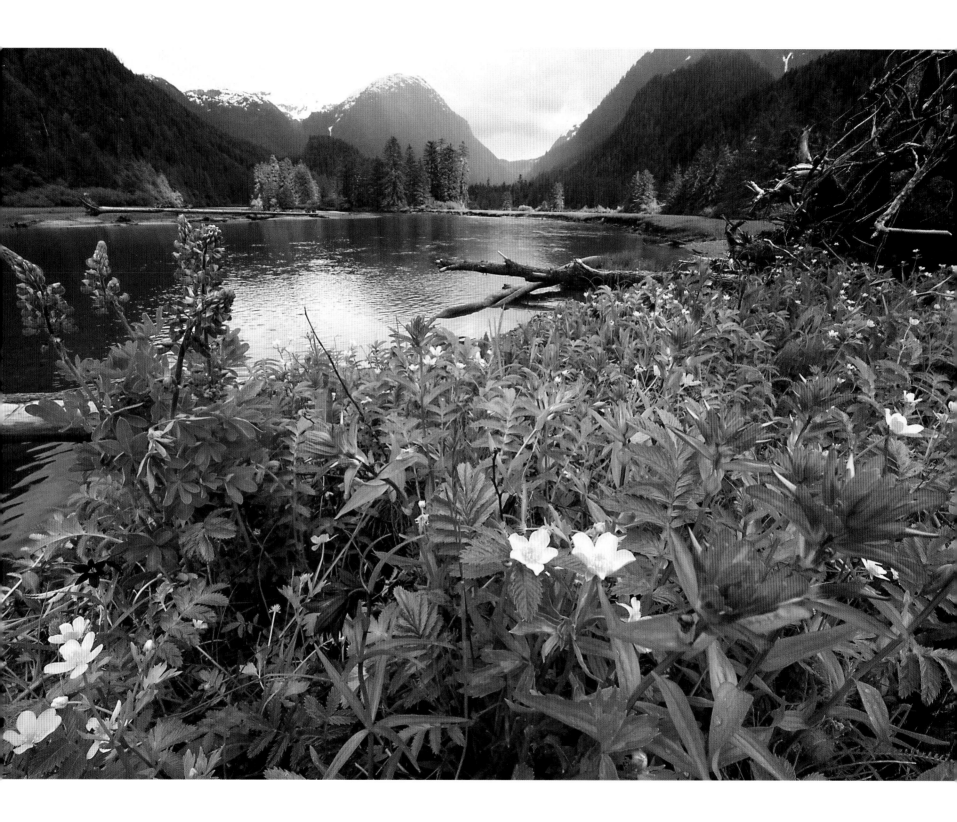

granite forms the backbone of the coast, running up from the Sierra Nevada of California through the Coast Mountains of British Columbia to Alaska. It separates this maritime world from the drier interior.

The return of coho on the north coast is better than expected this year—one of the species, at least locally, in these island creeks that continues to show signs of recovery, unlike chum, which continue on a downward trend. I visited recently with Doug Stewart on his boat the *Surfbird*. Doug, the DFO creekwalking veteran of this part of the coast, has spent nearly four decades counting fish, not missing a year and always counting in the same creeks. It didn't take him long to mention the decline of chum. These large, oily fish are less valuable to the sport and commercial industry than other salmon species, so their decline invariably receives the least attention. But people like Doug who remember distinctly what spawning rivers are supposed to look like, compared to how quiet they have become in recent years, don't miss a chance to bring it up. Doug knows this species is in trouble; the declining trend is not changing and his bosses aren't listening.

It's a common theme up here: too many boats catching too few fish. A few old-timers will say fishing is important because the fish will overspawn and compete for spawning gravel if we don't reduce their numbers, but the general consensus is that abundance— the kind of salmon abundance we once had before the canneries and the industrial fishing technology and the fish farms took over—is key not only to overall salmon health, but to the entire coastal ecosystem.

Creekwalkers like Doug sometimes send their pre-spawn fish counts to DFO with a recommendation to keep a fishery closed because of low numbers; DFO in turn typically ignores the recommendation and allows the net fishery to proceed, and one more year of declining stocks gets recorded. Not always and not for every species, but the prognosis for wild salmon, chum in particular, is not good. This is surprising, because chum are relatively ubiquitous to the coast, perhaps because of less specific habitat requirements than other species such as coho, sockeye, and chinook. It is common to see chum spawn in the high reaches of small creeks and in tidal water at the mouths of rivers.

The exploitation of salmon and the research and management dollars directed at this species over the last century, relative to most other fish, are remarkable. Yet salmon remain as mysterious as they are important to this place. And we are still taking them out of the ocean like they are inexhaustible. Over these last two weeks over 6 million pink salmon were taken out of a small part of Area 6, the fisheries management area around Hartley Bay. A couple of years before that nearly 10 million were taken in nets. Ten million pinks laid out head to tail would cover a distance of 6,000 kilometers (3,700 miles). And while some individual stocks may be able to absorb this high level of mortality, most natal rivers for which these fish were destined continue to support mere fragments of their former abundance.

Compounding DFO's refusal to consider broader ecosystem needs—such as allocating salmon for bears, whales, and birds, among other non-human species that we know suffer when salmon decline—is the "mixed stock" fisheries that don't just target specific healthy stocks but inevitably catch endangered ones as well. In one week of fishing in 2013, fifty seine boats discarded 300 metric tons (330 US tons) of non-target chum salmon in order to catch 600 metric tons (660 US tons) of pink salmon. Survival rates for discarded salmon are low, especially chum because they tend to dive to the bottom of the nets and get crushed. I often think of the frustration that must accompany a job like Doug Stewart's, given DFO's near abandonment of wild salmon research, monitoring, and conservation.

Doug has an indelible memory—not just for salmon, but for the larger trends and patterns that evolve around them. He can describe how the local black bear behavior changed when grizzlies started to show up in his creeks on Princess Royal Island, and he keeps detailed journals of countless other wildlife observations and trends. He also remembers when fishing and logging were the drivers of the coastal economy, unlike today, when the most likely encounter he might have with another human comes from a visiting yacht or a bear-viewing group out of Klemtu or Hartley Bay. I don't think Doug has a lot of time for the new bear-hugging ecotourists who are increasingly part

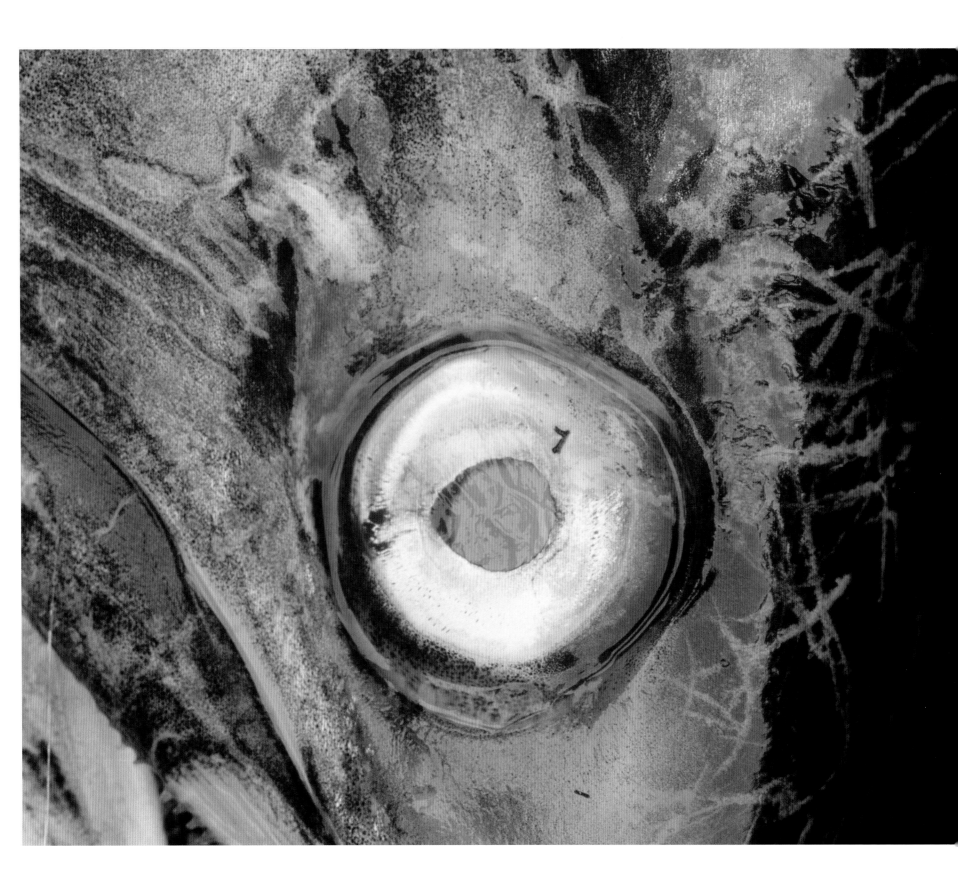

of the landscape here; I suspect he prefers days gone by when few people walked his creeks and rivers.

Doug is also a bit of a devil's advocate. If I ask him if he has seen a particular pack of wolves, he says they are eating too many salmon. If I ask him if he has seen a white bear, he says they are just black bears and can't understand what all the fuss is about. His role on the coast, and that of a few other remaining creekwalkers, like Stan and Karen Hutchings to the north, is nearing the end of an era; it can't be many more years before DFO will completely abandon any pretense of managing wild salmon stocks.

As I started my outboard and prepared to cast off from the *Surfbird*, I looked up at Doug. Our conversation had been more cynical than usual, and not surprisingly, given all the oil and liquefied natural gas (LNG) proposals destined to carve a tanker highway through the heart of his salmon-counting territory. If there is one person who has cause to be concerned about the future of wild salmon here, it is this man. As a parting gift he lightened up a bit, probably for my benefit, not his: "They are coming back—the salmon— if we could only give them some more time."

THE SALMON LIFE cycle is a gauntlet of variables and challenges, even in the absence of human-caused mortality. The fish below can't spawn when the water is this high. Their eggs get washed downstream instead of buried in the gravel. They have to hold on and wait for the rains to subside, but each day their reserves are depleted. In the meantime, seals and sea lions pick the salmon off down near the estuary, and these bears do their best upriver. In some years early winter floods scour the gravel, carrying away and killing the delicate eggs nestled below.

A landslide can do the same damage. They are common in these river systems because of the shallowness of the soil. Until seven or eight thousand years ago, ice fields dominated this coast; since then maybe a few centimeters of soil have emerged every thousand or so years, meaning some of the largest trees in the world grow in less than eight centimeters (three inches) of topsoil.

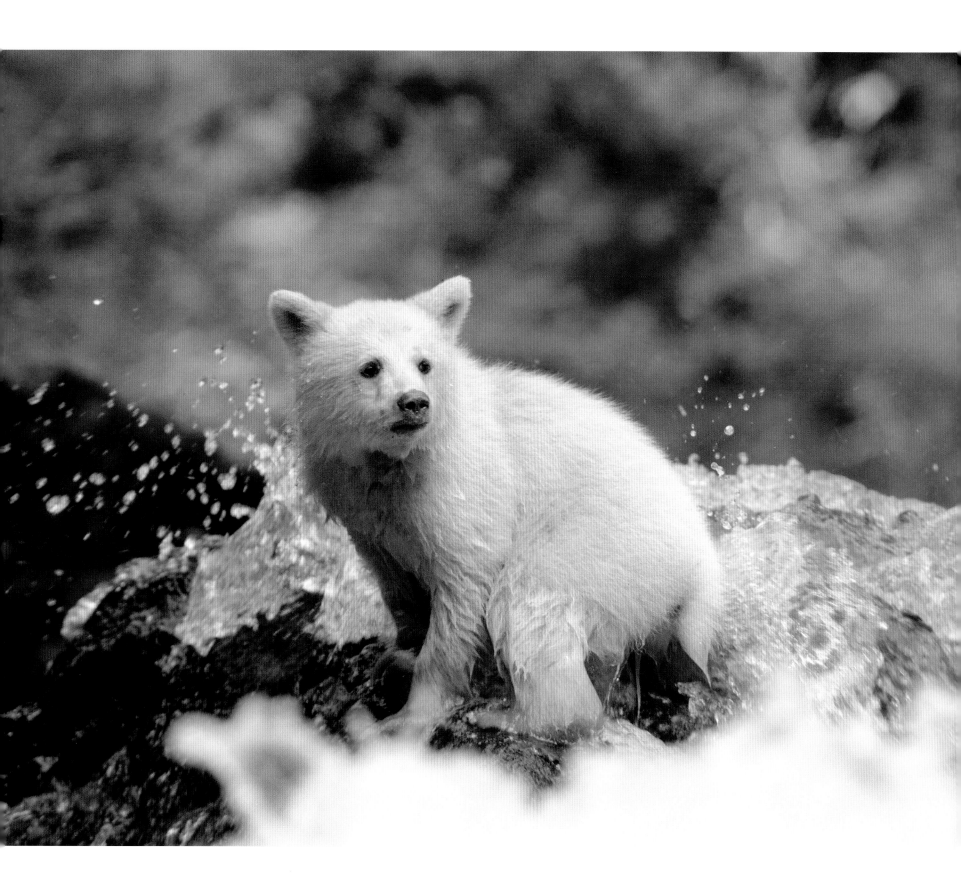

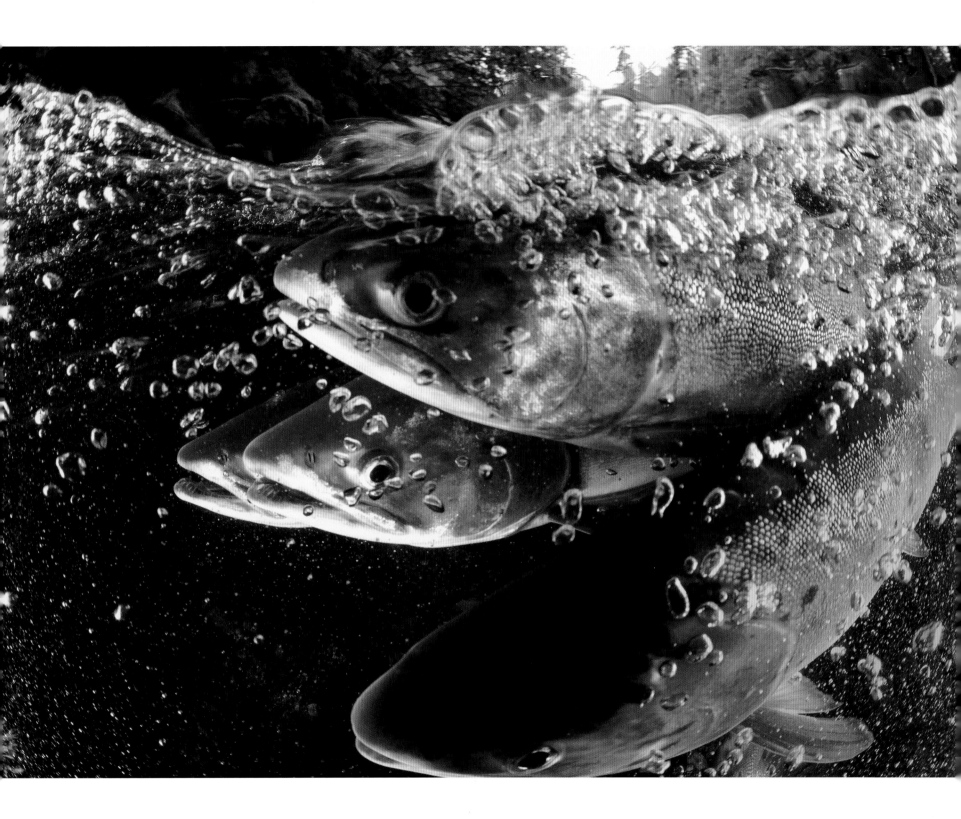

facing Waiting for rain, these pink
salmon are part of just one of over two
thousand distinct runs of wild salmon
found in the Great Bear Rainforest.
After spawning, their decaying bodies
will nourish their future offspring, the
forest itself, and over two hundred
species that rely on their return to the
rainforest each year.

This coast represents a fascinating juxtaposition of ancient and new. The actual
topography was physically shaped in relatively recent times, but the rich ocean and
rainforest habitat has attracted, and continues to attract, species that have evolved since
much more ancient times.

Two days ago I watched a pair of grizzly bear siblings digging for clams side by
side until the tide slowly covered the estuary. Then, without a thought, they deftly turned
to barnacles and mussels, and I was reminded of the ancient relationship between the
ocean and bears, dating back to the Miocene, when a bearlike creature called a *Kolponomos*,
or oyster bear, may have once called this same part of the coast home. It died off around
20 million years ago, but this distant relative also had a diet of mollusks and other marine
invertebrates, prying them off rocks with oversized incisors and canines. It was a terres-
trial animal that was a capable swimmer, just like the modern-day bears on this coast.

Looking at the deep pool below, I marvel at the rare sight of so many large and healthy
coho. The salmon launch from the pool's deep base, blasting through the thick layer of
foam and then catapulting through the air toward the waterfall. Like little missiles, some
hit the base of the falls headfirst, bouncing straight back into the pool; others, which will
pass on the strongest genetics, make the first jump over the first fall and immediately
move into a nosedive away from the surface foam. Using the soft river moss clinging to
the rock for traction, the salmon tails are a blur as they writhe their way upward. One
more makes it into the dark, slow-moving water above the falls where it will rest in the
cold water, below the thermocline, to wait out the final push into the tributaries above.

All salmon have the unfortunate distinction of being born orphans; they will never
meet their parents. But their parents do not abandon them; when they emerge months
later from their gravelly nests, they are armed with their parents' DNA and nutrition from
their dead bodies. This pulse of marine nitrogen feeds the river and provides strength,
persistence, and a genetic compass that allows for one of the most fascinating migrations
and life cycles of any species on the planet.

Before long a large brown-faced black bear emerges from the forest edge and ambles
straight for the fishing spot. By the end of the day I count nineteen individual bears.

facing Where the ocean flows through the rainforest, estuaries provide critical shelter and food for countless aquatic and terrestrial species.

Through daily observation over the week I will count twenty-seven in total, more than a third of them in family units, congregating at various times within 50 meters (165 feet) of this one fishing spot. Three of them are pure white.

One of the most striking examples of polymorphism in the animal world, the spirit bear, or *kermodei* bear, named after the museum curator Francis Kermode, is not an albino bear but a genetically distinct, pure-white black bear produced by a recessive gene. These archipelago-associated bears offer a fascinating entry to the study of population and quantitative genetics, and the obvious question is: why white? What possible evolutionary advantage would there be to turning white from black in a dark, shadowy rainforest environment?

According to Dr. Tom Reimchen from the University of Victoria, these coastal bears diverged from their interior relatives about 360,000 years ago, most likely during an ice-free refugium predating the Wisconsin glaciation about 100,000 years ago. So perhaps when the coast was dominated by snow and ice these bears evolved a color more suited to their environment; however, another University of Victoria researcher, Dan Klinka, looked at another possibility: that their color relates to these bears' main food source, salmon.

I remember Stan Hutchings, the DFO creekwalker for the area, raising his eyebrows about this research while he was on one of his salmon-counting trips and found Dan wandering about the salmon riffles covered in a white sheet. Dan was partway through his three-year research effort comparing the fishing success of a black bear to that of a white bear, the idea being that a white bear would blend in more with the sky. After three seasons of this work Dan was seeing a pattern emerge: yes, white bears were at a distinct advantage in fishing for salmon during daylight and crepuscular hours. By analyzing marine-based nitrogen in hair samples at the end of a salmon season, Dan discovered that white bears appear to consume more salmon over more days than black bears. Salmon are so important to this coast they may actually have changed the color of a bear.

Black bears are fascinating creatures, but because they are relatively common across North America, they tend to get overlooked in terms of their role within ecosystem

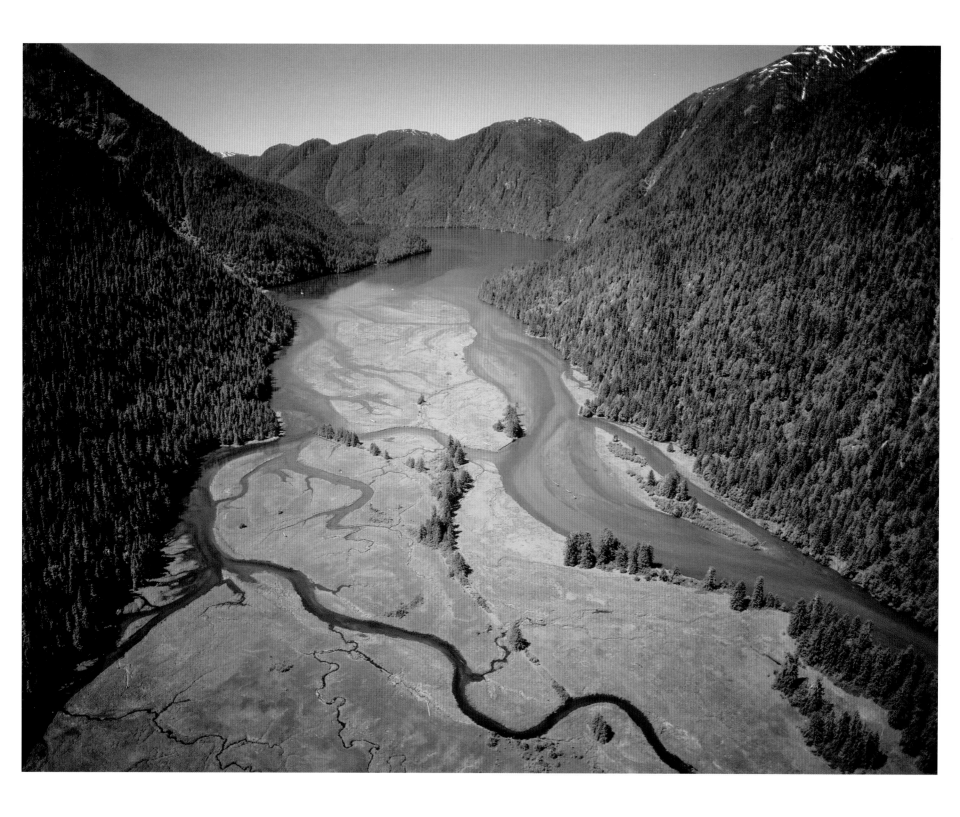

Spirit bears and grizzly bears alike take time away from salmon fishing to forage for crabapples in the fall.

function, their intelligence, their distinct behavior from other bear species, and their uncanny ability to adapt.

Compared to most other terrestrial mammal species found in this coastal rainforest, bears have been studied intensively and are the subject of ongoing research efforts. And for a species that is not exploited commercially as a human food source, that is rare; even in First Nations communities it is rare for a "non-consumptive" species to be the focus of such intensive research.

There are a number of reasons bears garner more attention than other terrestrial species. Recently, bear viewing has begun to create economic opportunities in the remote communities of the BC coast. Bears also have strong cultural associations with each First Nation in the Great Bear Rainforest. Yet with all the genetic, diet, telemetry, habitat mapping, and other research efforts that have increased our understanding of coastal bear ecology over recent years, the behavioral relationships that exist within the world of bears remain relatively unknown. Even less understood is how bears interact with other large carnivores such as wolves and cougars. Still, the BC coast is arguably one of the best locations in the world to study bears given their diversity, distribution, and abundance and the fact that the coast remains such an intact environment.

As far as anyone on this coast can remember, or that turn-of-the-century Hudson's Bay Company trapping records indicate, grizzly bears have historically avoided the outer islands of the Great Bear Rainforest. It has generally been presumed that their need for larger home range, plus the smaller estuaries, alluvial floodplains, avalanche chutes, and availability of salmon on the islands, would keep the bigger bears on the mainland. Denning opportunities are also fewer out on the islands, because during a mild winter the wet conditions of the high country mean bears can get rained out of their winter dens more often. Grizzlies usually den over three hundred meters (one thousand feet) above sea level, well protected under the roots of an old cedar tree, where the deep

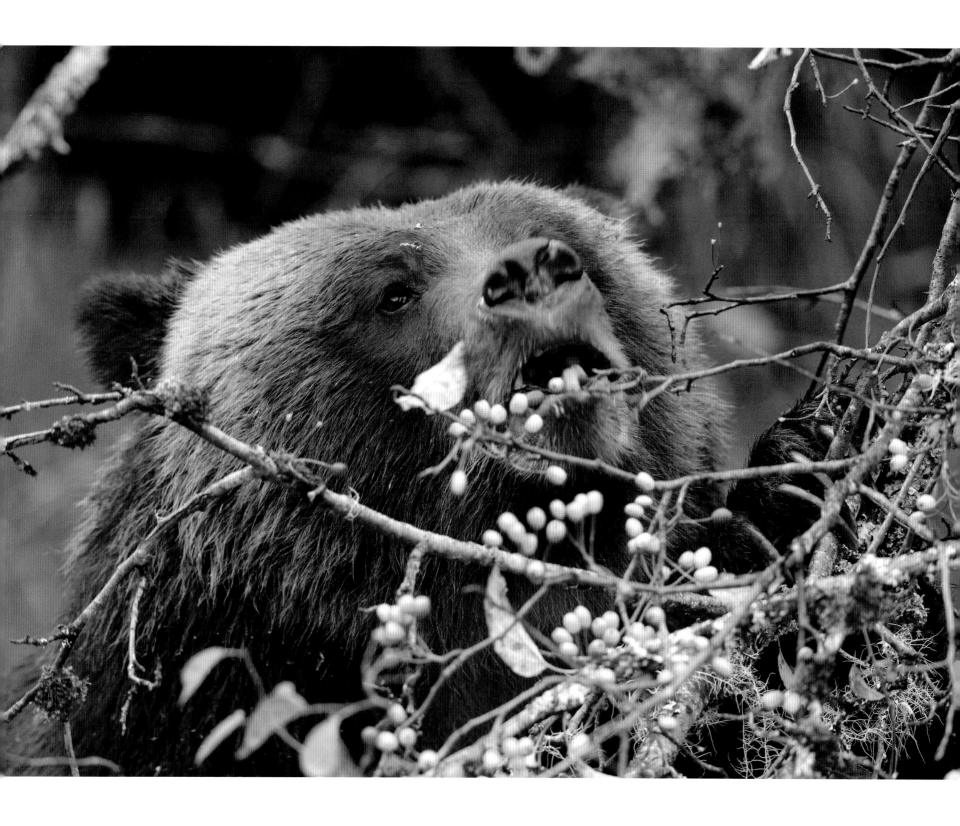

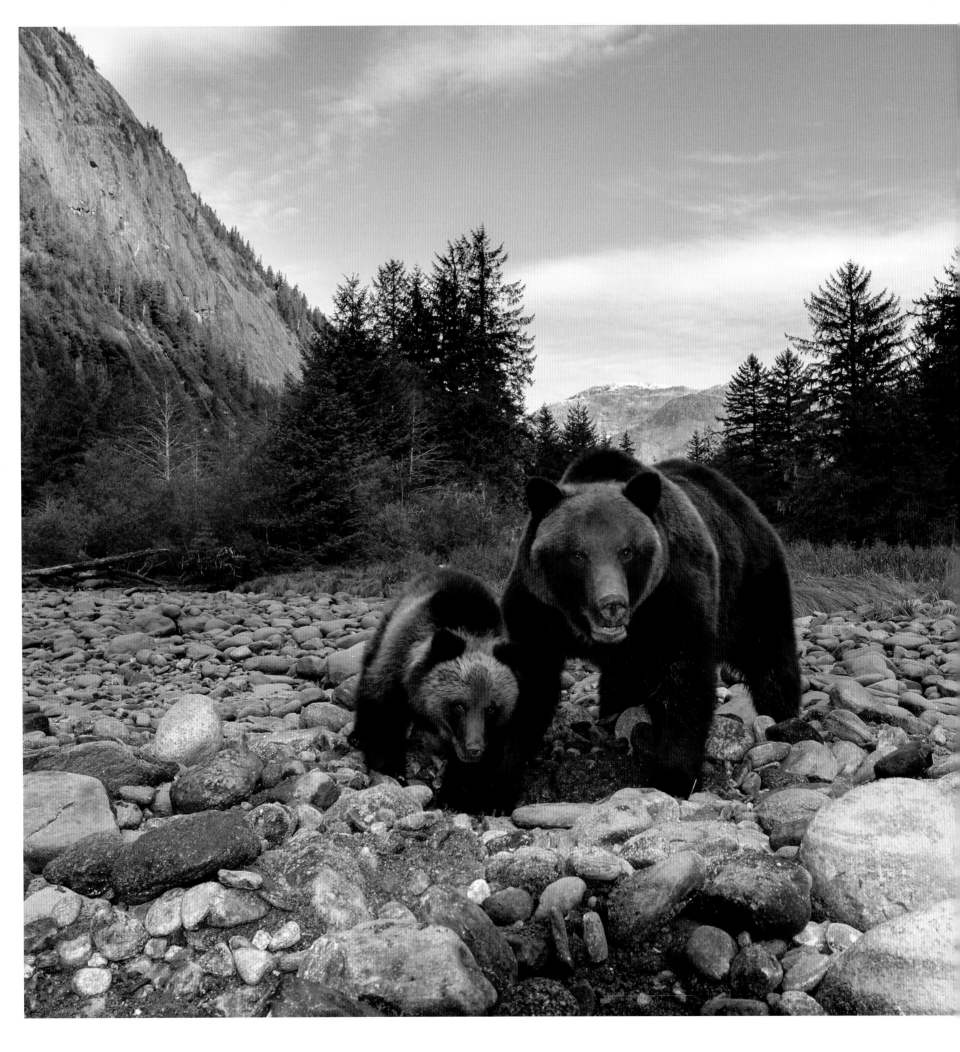

Now that the flood rains have receded and the river level has dropped, this mother grizzly and her cub focus on digging for salmon eggs buried deep in the gravel—a rich delicacy and preference for coastal bears.

snow insulates them over the winter. However, Doug Stewart recollects seeing his first grizzly on Princess Royal Island nearly twenty years ago, and I have been finding more and more of them in traditional black bear haunts. Grizzly bears are reproducing, denning, and increasingly expanding onto the islands, bringing significant uncertainty about the future of these traditional black bear strongholds. Grizzlies and black bears do not coexist comfortably.

Yesterday, in Hartley Bay, I heard Gitga'at local Marven Robinson talking on the radio to the captain of a US-based pocket cruiser who hoped to hire him to help find some bears. Marven sits on the Gitga'at Nation's elected band council, in addition to countless committees on land and marine use, and he has been at the forefront of much of the opposition to the various LNG and oil transport schemes knocking on Hartley Bay's door. He also is a boat captain, helps direct the Coastal Guardian Watchmen Network, and is an accomplished photographer. The list goes on. In his mid-forties, he is also the go-to person for most things involving bears in Gitga'at territory. For most people any one of these occupations would be full time. But in these small communities people inevitably wear many hats, and Marven is no exception. Still, I think if he had a choice he would choose his work as a bear guide over the others.

Marven is good at what he does. Every morning he is at the dock in Hartley Bay before daylight, organizing film crews and guests from each corner of the planet who have come to glimpse a white bear. His generous nature usually means there are more people heading out in one of the Gitga'at boats than were planned the evening before. He won't be back until late in the day, and then he does the rounds of the dock, chatting with passing boaters until well past dinnertime. His wife, Teri, is used to Marven coming home exhausted, falling asleep, and getting up a few hours later to head back for the dock. As tiring as it is, and as logistically challenging to sort out so many people who all want a piece of Marven, the seasonal employment of bear guiding offers a respite from the uncertain, challenging, and often combative days of government and industry negotiations that consume most of the winter months.

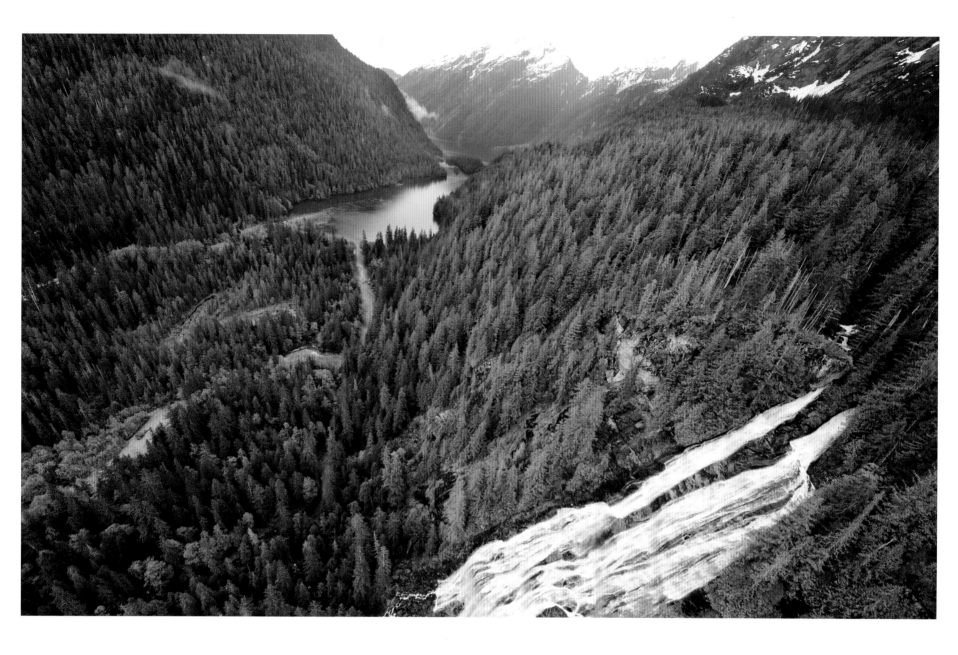

I could overhear Marven telling the captain about seeing grizzly bear tracks and the concern he feels for the resident white and black bears in the area around Hartley Bay where the community does most of its bear viewing. For most bear guides, finding a new set of grizzly bear tracks on a beach or riverbank would be positive. On these islands it is the opposite.

Studies in the Khutzeymateen River, just north of Prince Rupert, and Pacific Wild's remote camera work in other parts of the coast have shown that where grizzly and black bears overlap, black bears are subjugated to the less desirable habitats and become more

A waterfall drops into a vast stretch of rainforest near Dean Channel.

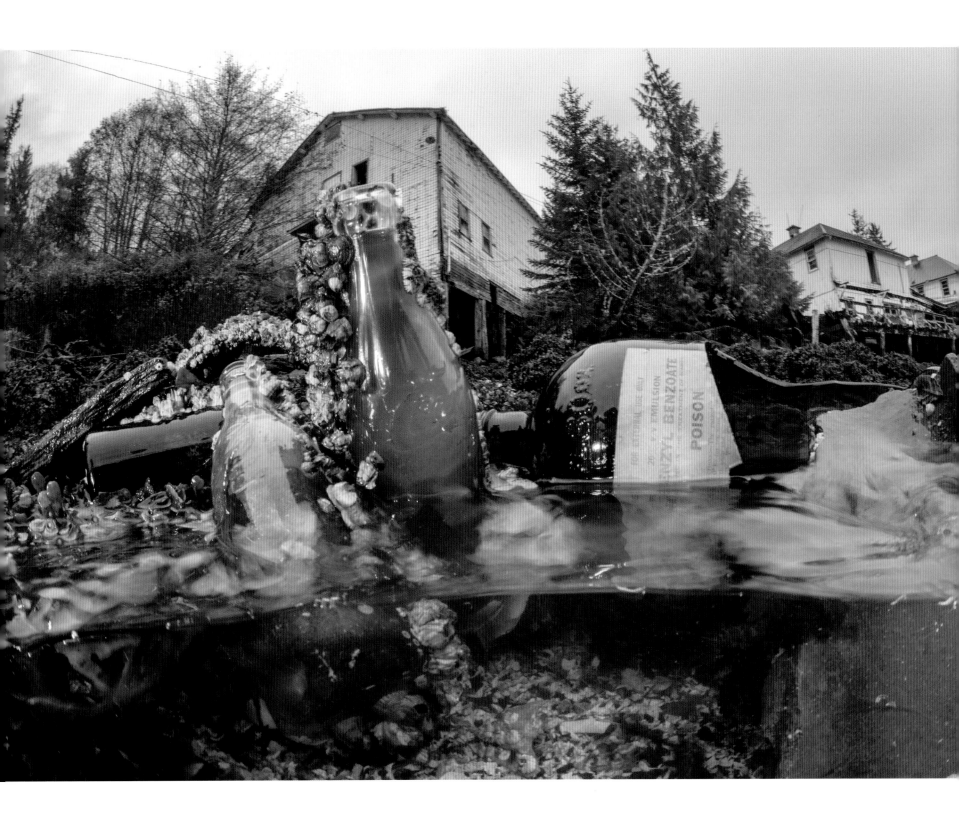

secretive and nocturnal. I have seen grizzly bears kill black bears. Sometimes they eat them and sometimes they don't, but whether they are killing for food or because of intolerance, the outcome is consistent.

On the mainland, where there are longer reaches of salmon-spawning habitat and more oxbow bends and riparian area, many more bears—both black and grizzly—can access fish without tripping over one another. But here on the islands the smaller and steeper creeks offer fewer spawning reaches, and even within them few locations that make for prime fishing spots. Gribbell Island has been described by veteran coastal bear biologist Wayne McCrory as the mother island for the spirit bear because of the inordinately high frequency of the recessive gene that allows for the pure-white bear. The mountainous island has only two main salmon-spawning creeks and both are relatively short. If grizzly bears move on to Gribbell—and given how many are on Princess Royal Island now, it is only a matter of time—the resident black and spirit bears will be displaced.

But why are grizzlies moving out here after such a long absence? Perhaps it was just a matter of time. Moose, for instance, are increasing their range to these outer coastal areas, as are foxes, cougars, and wolverines. But the migration may be precipitated by the serious decline in chum and other salmon runs on the mainland. Many grizzly bears have left their mainland rivers in search of more predictable salmon supplies. Mothers may also be looking for more secure places to raise their cubs away from male grizzly bears.

THIS COASTAL ECONOMY is benefiting from new industries like wildlife-based tourism, and now lodges are being built and guides are being trained. Marine, hospitality, and other skills are in demand. In the fall Hartley Bay, Klemtu, Bella Bella, Shearwater, and other small towns become busy places with community-run wildlife-viewing operations and charter boats disgorging their guests on docks, ready to be taken out by local guides. Boat-based charter companies are now a common sight in remote parts of the coast. Film crews, photographers—a couple on their trip of a lifetime—and countless

others pay many hundreds to thousands of dollars a day for the chance to go out and see a white bear or grizzly or wolf, to experience this rainforest while also learning about First Nations cultures.

Doug Neasloss, a member of the Kitasoo/Xai'xais First Nation, was a pioneer of community-based bear viewing in the Great Bear Rainforest, along with his Gitga'at counterpart Marven Robinson from Hartley Bay. These two have been guiding guests into the wilds of their respective territories for over a decade now. I caught up with Doug recently, and we reminisced about the early days of bear viewing on the coast. "Things have changed a bit," he chuckled.

I remember there was this young couple that booked a trip for their honeymoon. So we thought, to make it a special trip, I would take them out to one of our remote cabins, some fine food and bear viewing. We only had an open herring punt for transport and it started to pour rain on the way there. I remember passing by one of the charter boats and seeing everyone warm and happy inside the cabin. I looked up through the driving rain and the soaked couple were staring at the fish guts rolling around in the bottom of the herring punt with hoods over their heads hiding from the rain. I just kept thinking that if we can get to the cabin, get a fire going, everything would be all right. It was getting dark when we finally arrived, and it wasn't long before we realized that all the food got packed on the wrong boat. It was right about then that I thought that we either get serious about tourism or we pull the plug.

Today Klemtu Tourism operates a multi-million-dollar lodge-based bear-viewing operation and has become a major employer in the community with an expanding season and growing international client list.

My own affection for bears runs deep but is not shared by all. Over the years on my travels from western Alaska through the Great Bear Rainforest I have come into contact with more trophy hunters than I care to remember. It is a perplexing and frustrating

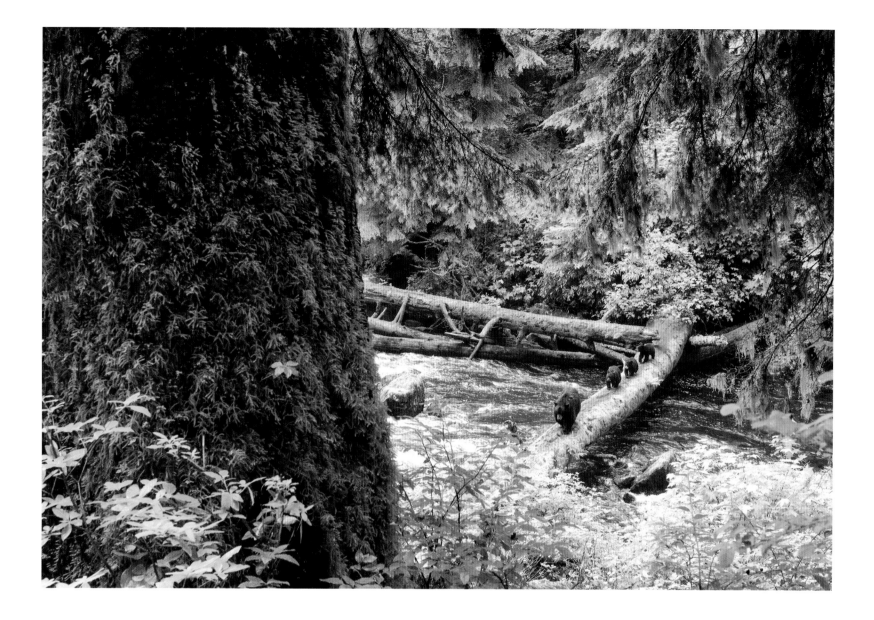

issue. The wilderness monarchs of North America continue to be hunted for sport or for a trophy on a wall, and even though public sentiment increasingly sides with bears, their future remains uncertain. It's not even illegal to kill a female grizzly bear, the second-slowest-reproducing land mammal in North America next to the polar bear.

A few years ago I was observing a spring grizzly bear through my camera viewfinder when the bear suddenly buckled, screaming as it fell to the ground, the rifle shot still echoing through the mountains. My heart pounding furiously, I stood beside the bear moments later as it shook out its last breath. The bear had just woken from her winter sleep, and this is what greeted her.

A mother black bear and her cubs walk across their favorite bridge, which takes them daily to the best fishing opportunities.

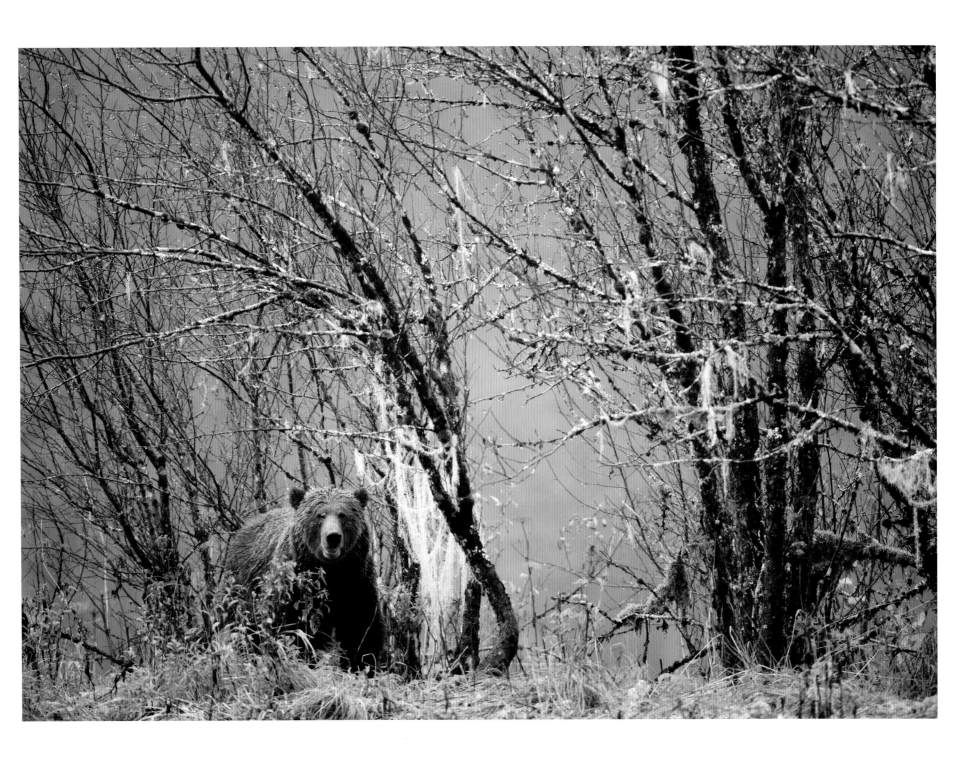

The guide and his sport-hunting client had no idea I was in the area until we met alongside the dying bear. The trophy hunter proclaimed her a nice-sized "boar," apparently echoing what he had just been told by his guide. I turned the rear leg over and showed them what a female bear looks like, and a young one at that. The bear was about five years old and had not yet reached reproductive age.

Trying to understand, I asked the usual question: "Why?"

"You wouldn't understand," said the guide.

"It's always been a dream of mine to kill a grizzly bear," said the client.

Ending the gratuitous trophy hunt of large carnivores like grizzly bears and wolves has consumed significant conservation energy here on the BC coast over the last twenty years or so. Some question the disproportionate amount of time being spent on the issue given the scarce resources for wildlife research, management, and education, but I believe it is justified.

We simply don't fully (or even partly) understand the ecological role that these great bears play in the rainforest. If we continue killing them as a legal form of sport we can't possibly continue building a basic level of respect with wildlife on this coast. The trophy hunt is anachronistic and based on a bankrupt set of ethical and scientific principles.

Over the years the ever-changing rationale that the provincial government puts forward to support the hunt has been flawed, outdated, and usually contradictory. First it was the jobs argument, but now that wildlife viewing has eclipsed trophy hunting in revenue and job creation, that argument has been dropped in favor of the hunt being "based on science"—as if science can somehow excuse unethical behavior.

Simply ending the trophy hunt is not without precedent or we would still be hunting sea lions, otters, whales, eagles, and countless other species once feared, hated, and killed indiscriminately—but now celebrated as icons of our natural heritage.

BEARS OFFER AS many personalities as I can find in my neighborhood, and on Denny Island, where I live, that is saying something. Back here in the canyon, size and even

gender do not necessarily determine who dominates the fishing spot below me. A large male sitting on the rocky outcropping waiting for the next salmon to launch itself at first seemed to go uncontested. But then late in the day I see a female with cubs of the year in tow heading purposefully along the rainforest trail toward the fishing hole. She appears on the edge, looking down for a moment. Without hesitation she and her little cubs walk straight down the rock slab. This might end up in a row. But the big old bear glances furtively at the water hole below, hoping for one last chance at a salmon, then realizing he isn't going to get it, bounds off, leaving the strategic podium to the mother. This bear is small and shaggy, like a cinnamon-colored woolly mammoth. She is a no-nonsense-looking bear with pudgy bowlegs and a broad face. For six hours not a single other bear, a number of them much larger than she is, comes close to her spot at the podium.

She sits on her hind legs with one arm outstretched on the rock and another held at a right angle ready to grab a fish. Slowly wagging her big round head back and forth, she waits with her arm cocked back like a baseball pitcher in mid-throw.

As the day winds down more bears show up. Across the river about 45 meters (150 feet) up into a grove of thin hemlock trees sit four black bear cubs and one spirit bear cub. The spirit bear has climbed up above its siblings and is rocking the tree back and forth. It looks to me like the little white bear is trying to shake its siblings out of the tree. Farther down the side creek I see more bear cubs up another tree. Again, here are cubs of the year waiting patiently in the safety of a hemlock tree while mother fishes below. The lower canyon is looking more and more like it has been decorated with Christmas trees with white and black bears and baldheaded eagles. In total there are ten cubs in the trees around the canyon and maybe a couple hundred bald eagles.

A few weeks from now wolves will focus on this area, knowing that the bears' annual hyperphagic descent and slowing metabolic rate in preparation for hibernation will leave them less equipped to ward off an attack or protect their cubs. The wolves are gaining peak strength because all members can now participate in the hunt; they are fueled by the anxiety of winter to come. The wolves also know that the bears will soon be gone for the

winter and they are at their very fattest. It is in this fall season more than any other that I find bear hair and meat in wolf scat.

Across on the mainland it is mostly the same story for wolves and bears. The only difference is that when the wolves have played their best hand at killing bears, the next hunting season begins; lowering snowpack means families of mountain goats drop down into their lower-elevation winter range. There are no goats out on these islands yet.

Judging from the tracks on this trail, I suspect a bear cub is just in front of me. How peculiar for a cub to be walking this trail on its own. I stop and stare at the track. It's not a bear track at all, but wolverine. The track has big claws and is the size of a small bear's, but it's rounder and the pad is a bit squarer. These salmon-eating giant weasels are found in low densities, and like cougars are rarely seen; however, they have a strong sense of home and there are a few river valleys where they dominate the riparian area and can be predictably observed year after year. I have found signs of cougars and wolverines in most river systems on this coast, and these two species also seem to have advanced on most of the large islands that support salmon-spawning systems.

Wolverines rely on old-growth forests to house and support their prey—namely, marten, mink, and salmon. I bet they also take down small deer, bear cubs, mountain goats, and, while I have not seen it, even young harbor seals or pups. Like wolves, eagles, otters, bears, and a host of other salmon predators, wolverines leave a clear and unique signature on their leftover carcasses. They also prefer the heads of salmon and they tear the flesh rather than bite it.

Making my way toward the ocean, I continue following the old bear trail. I find myself glancing aloft into trees more often than I used to, trying not to think of how many times a cougar watches these same trails from the forest canopy. Soon fresh tracks put a bear on the same route as mine, just minutes ahead.

At the ocean's edge I stop and see my boat anchored in the inlet. Looking down at the gray mud, I see tracks slowly filling with the rising tide. The long protruded claws. Another grizzly bear track.

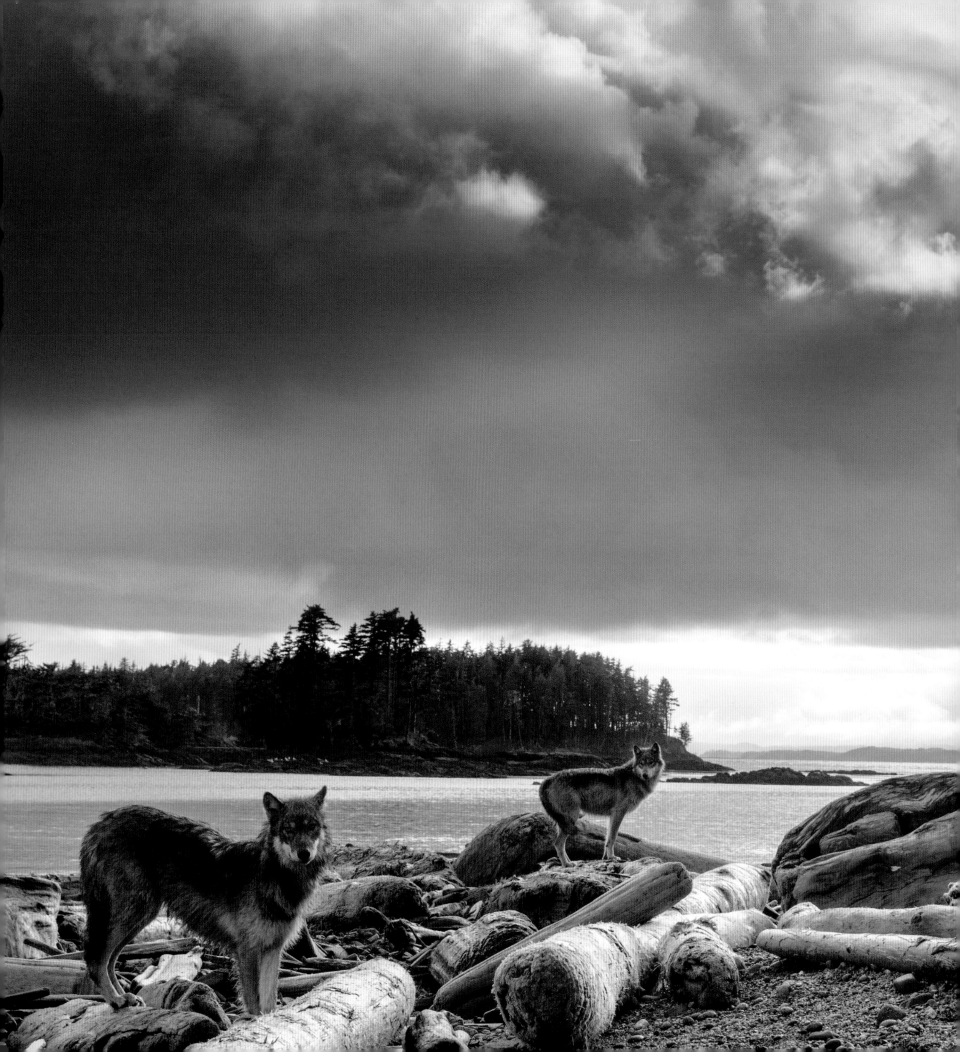

Wolves, the apex predator of the rainforest, have fully penetrated all environments along the mainland coast and adjacent islands but do not exist on the offshore archipelago of Haida Gwaii.

SEA WOLVES

NOT WANTING TO have to deal with my sailboat, *Habitat*, dragging itself to shore in strong winds, this winter morning I left it in all-weather anchorage and set up a remote camp on the surf side of the coast. I often come here to spend time with these fascinating maritime wolves. Almost a tribe of their own, they are one of the few packs that forge a living on the windswept and remote outer islands. It is comforting to be free of the boat, as I have almost lost it a few times in unpredictable storms—and myself with it. The downside of tent living in this environment is that it often feels like you're living in a wind tunnel or under a waterfall, but that beats the hell out of walking on the walls of a sailboat—at anchor—plus I don't have to worry about getting in and out of the surf zone in a small craft.

I spend a lot of time by myself out here, and the last few seasons I have spent more time with these wolves than I have with my own family. I miss them—my family—of course, but building trust with wolves requires a long-time commitment. While wolves' individual personalities remain predictable, the pack's personality often changes, so I don't want to parachute in and out too often.

My tent is situated on a rocky outcropping, slightly protected from the prevailing southeast wind. It has a decent vantage point of some of the wolves' main travel routes and allows me fairly easy access up the main salmon river where they spend most of

An early morning search for salmon. Some wolf packs begin feeding on salmon in early August and continue through October.

each day. Remote observation is best, because when one member of a wolf pack sees you, you can assume the entire pack knows you're there. Wolves have an uncanny ability to communicate among themselves even over distance. Sometimes they communicate my presence audibly, sometimes each wolf smells my tracks, and other times they communicate in mysterious ways created by their years of unfailing reliance on every member of the extended family.

One night I wake to a lone howl a few kilometers away. It has a sad touch to it, as though the wolf is unsure of itself. No one answers. I lie in my sleeping bag trying to interpret the howls. As the sun finally rises to the east, enlightening the gray rock along and above the surf zone, I see the pack running toward the opposite point of land that separates two large gravelly beaches. The lone wolf's howl this morning came from this location, so I figure they must be going to inspect a possible kill or marine mammal carcass that has washed up on the beach. I fully expect the pack's perfunctory tail wagging and high pawing with the subordinates crouching low, spinning around with tails between legs—the usual meet and greet between these wolves that I have witnessed hundreds of times over the years. But today I won't see any of that.

The pack bursts onto the narrow point, four members running low, single file along the water's edge, occasionally splashing through a few centimeters of tidal water, and three others bounding across the rocky outcroppings above the beach. I see a black-gray flash in front of them that must be prey. Instead, I'm surprised to see it is one of the gray siblings, the lone wolf that had been howling in the night, cowering low to the ground. This individual was a solid member born into this pack four years ago. And now his extended family is snarling, biting, and pushing him into the cold ocean. I hear yelps of pain. All members are laying into the poor wolf to the point that no escape is possible and he is forced to half dive, half lunge from the cliff into a kelp bed that is frothing white with incoming surf.

Despite having watched this close-knit family over the years, I cannot figure out what I am witnessing. This would seem a fair response if the gray was an unknown wolf

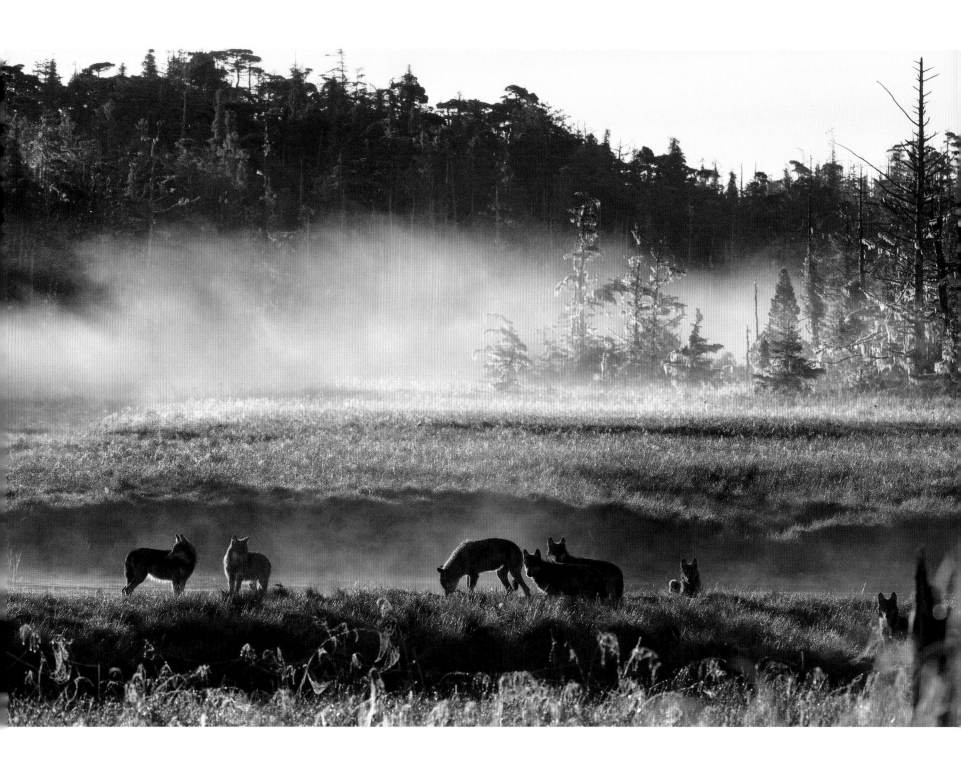

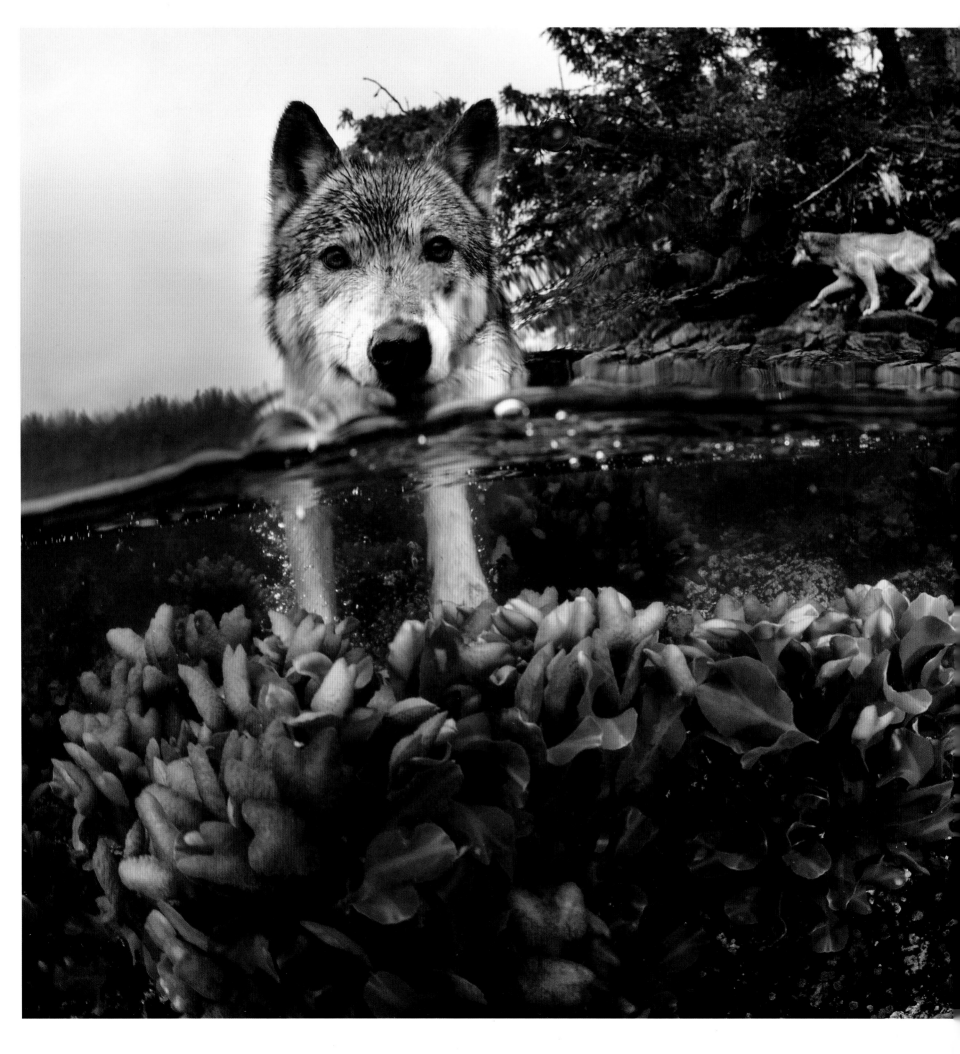

Sea wolves live almost exclusively on deer and what the ocean provides, unlike wolves closer to the mainland, who have access to mountain goats, deer, moose, and beaver. These wolves are eating herring eggs at low tide.

that had happened unannounced on their island territory, looking for a pack to join or unclaimed territory to start his own. But this one had loyally supported this pack since becoming an adult three years ago. For a wild wolf that is a long time. Almost half a lifetime.

The gray turns around with difficulty, as his long legs are entangled in the kelp and he is disoriented by the incoming surf. He tries to make a break back to land, but he is not welcome. His pack members—previous members—come to the water's edge with teeth bared and tails aloft. It is one of the most dramatic wolf events I have seen within a pack—and quite emotional, as I have watched this gray wolf since he was a pup.

The gray turns toward open ocean, pawing and lunging his way through the thick kelp bed. Once free of the entanglement and surf he swims through the choppy water. He is swimming on adrenaline—or fear—as his body is high out of the water. About 200 meters (650 feet) out is another low, wave-washed rock with a few seals on it. They quickly splash into the water as the wolf drags himself up onto the starfish, gooseneck barnacles, urchins, and rockweed. He shakes the saltwater off as he stumbles out of the surge.

About then it dawns on me that I am witnessing perhaps the most important and difficult decision that an alpha leader must make on behalf of his extended family. In all likelihood the pack had reached its carrying capacity and these islands could no longer support a pack of this size, especially as the pups would soon be near adult-sized and capable of joining the hunt. In wolf society the pack cannot live beyond its means: someone had to go. Pups are the future, so they are secure, for now. How this individual was chosen only the pack will ever know.

Back at the point the rest of the pack are splitting up. A few of them, the gray sibling and two of the ochre-brown three-year-olds, lie down on a green lichen-covered rock, each of their paws facing out toward the seal rock to which the gray has been subjugated.

I can see his silhouette glancing back and forth from the rest of the pack to the white-caps racing across the sound. He was born at the base of a large cedar tree not far up the

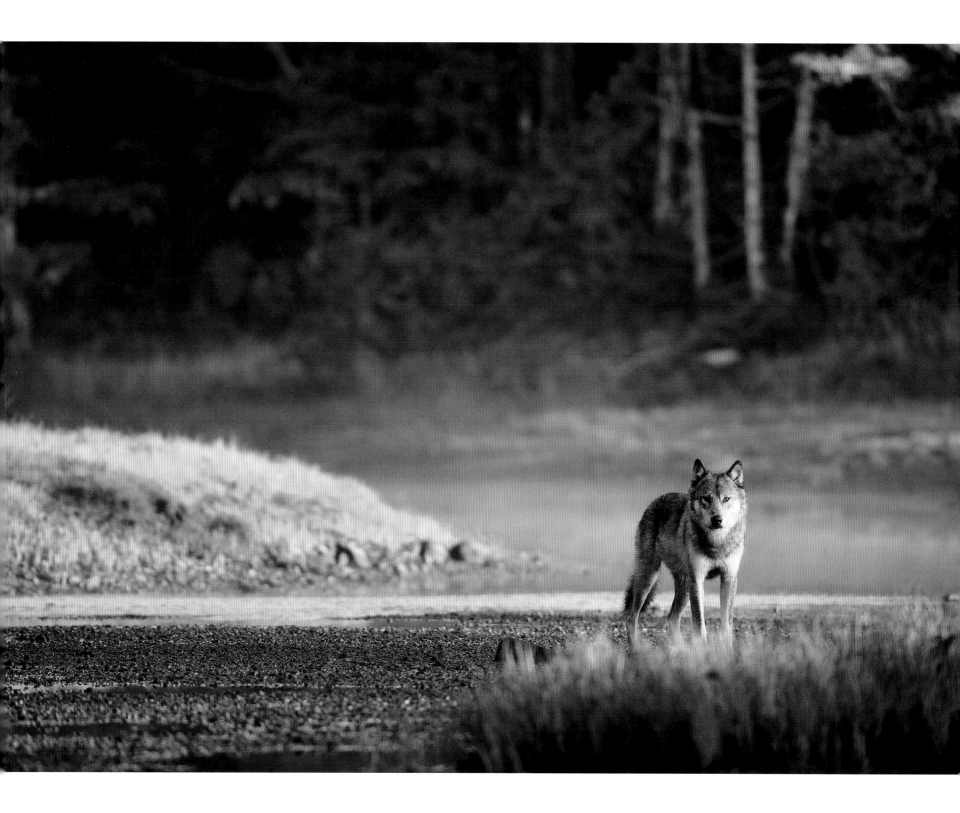

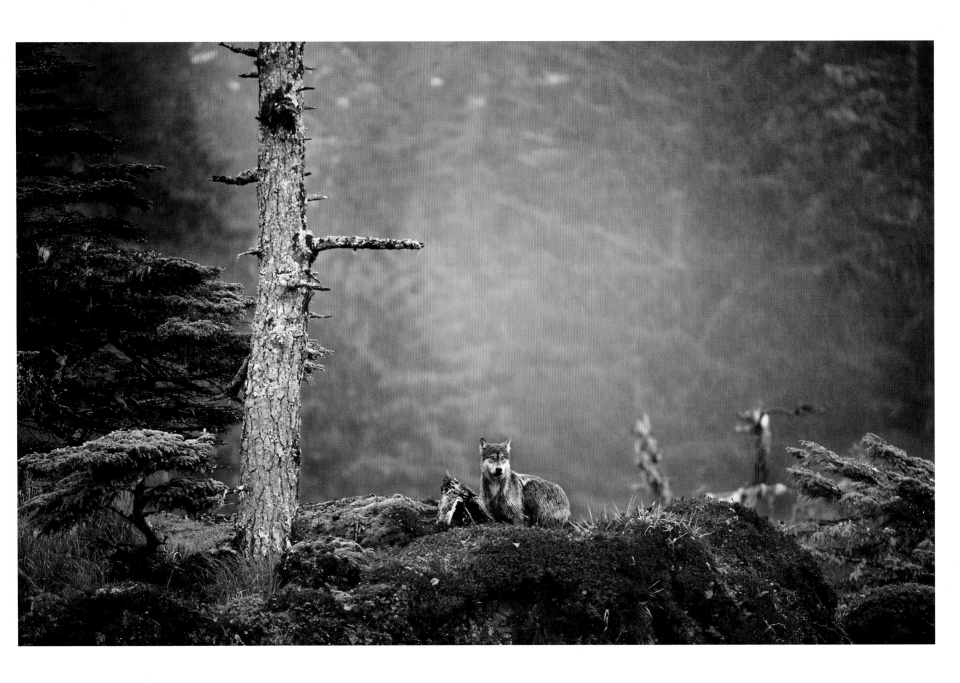

In daily transects of their island homes and perimeter walks of the shoreline, wolves guard their territory and encounter diverse marine-based prey.

main river. He does not know any other place. It must be terrifying for him to think of the swim across kilometers of open water, alone in the world for the first time, the strength and support that was his life having turned on him. The bonds between pack members are one of the strongest traits these animals possess.

Tough decisions make for good leaders and there is no easy way to do this, no easy way to send a family member across deep waters into uncertainty, probably death. Maybe the gray doesn't have it in him to make the swim; maybe he will attempt to forge a

marginal existence on the fringe of the island, trying to avoid the pack. That won't last long. Without the hunting efficiency of a pack he will die a slow death of starvation.

Wolves are forced by necessity to live within their means. Humans have not yet accepted this basic biological imperative for themselves.

LOOKING OUT ACROSS the strait I can see a faint blue outline etched along the horizon: the islands of Haida Gwaii. I have spent very little time across the Hecate Strait over the last few decades, which is surprising considering that the approximately 150 islands that make up the archipelago support twelve indigenous mammal species and more unique subspecies than any other similar-sized area in Canada. Haida Gwaii hosts genetically distinct mammals such as ermine and the largest black bear in North America, and their ten thousand–plus years of geographic isolation have earned the islands the title "Canada's Galapagos." But these islands, which have had so many humans coming and going over recent years, are also now home to ten introduced mammal species; if feral cattle, dogs, and cats are added to the list there are now more introduced than endemic species. Eighteen islands in the archipelago now have rats on them.

William Stolzenburg, in his book *Rat Island: Predators in Paradise and the World's Greatest Wildlife Rescue*, reports that islands account for less than 5 percent of the world's surface area but represent about three-quarters of the world's known extinctions since about 1600. Birds are usually the first to go, but the introduction of disease, invasive plants, and other non-native species continues to wreak havoc on these fragile island ecosystems.

Although the islands are just a day's sail across Hecate Strait from where I live in Heiltsuk territory, Haida Gwaii has remained largely a foreign and mythical land to me. As a teenager I was introduced to the islands from media reports and images of Haida elders standing their ground on Lyell Island in a confrontation with timber companies. They had had enough after watching approximately 80 billion cubic meters (2.8 trillion cubic feet) of ancient trees leave their territory.

The images showed elders in traditional regalia being arrested and hauled off to jail, as well as the beauty of the towering Sitka and cedar forests, the emerald islands, and the silver, aged totems standing sentry in front of ancient village sites. Seventy people were arrested by the time a truce was declared. By then Canada was being heralded as the "Brazil of the north" around the world for the brutality of its forest practices and its treatment of indigenous people.

But this was before my time. I remember Western Forest Products' chief forester Bill Dumont telling me in the early 1990s, as the campaign to protect the Great Bear Rainforest was beginning in earnest, "You people may have won in the Queen Charlottes, but it's not going to happen on the mainland coast." He was referring to the successful campaign the Haida Nation led to protect South Moresby, and "you people" apparently referred to anyone who wanted to protect ancient forests.

In 1988 Gwaii Haanas received national park status. It remains one of Canada's most celebrated protected areas with an unprecedented co-management agreement between the Haida and the federal government.

The big difference between these mainland-associated islands and Haida Gwaii is the presence—and absence—of large carnivores. Haida Gwaii is absent of wolves, grizzly bears, wolverines, cougars, and much of their ungulate prey, such as moose and mountain goats. When glaciers were still forming this coast like a jigsaw puzzle, the islands of Haida Gwaii broke off from the mainland and only a few terrestrial carnivores chose to stay with them. Evidence of grizzly bears has been found dating back to the late Pleistocene epoch, but it's unclear why they did not persist, unlike the Haida Gwaii black bear.

The other noticeable difference is the forest structure itself. Deer were introduced to the islands a century ago, and the gentle browsers, in the absence of any natural predators, have done more to impact Haida Gwaii's forest environment than the Haida people have managed to do in over ten thousand years. An entire succession of western red cedar and the associated thick understory of berry bushes are absent. Even the salal is over-browsed. It stands in amazing contrast to this side of Hecate Strait, where wolves would never allow such naive prey to go unchecked.

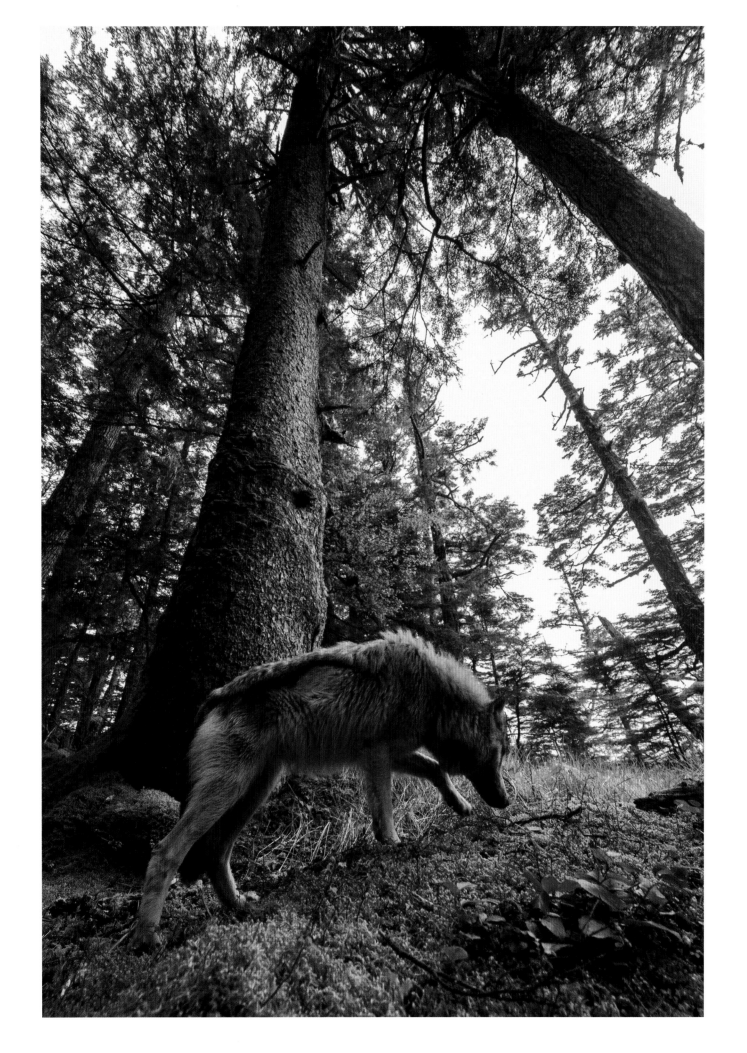

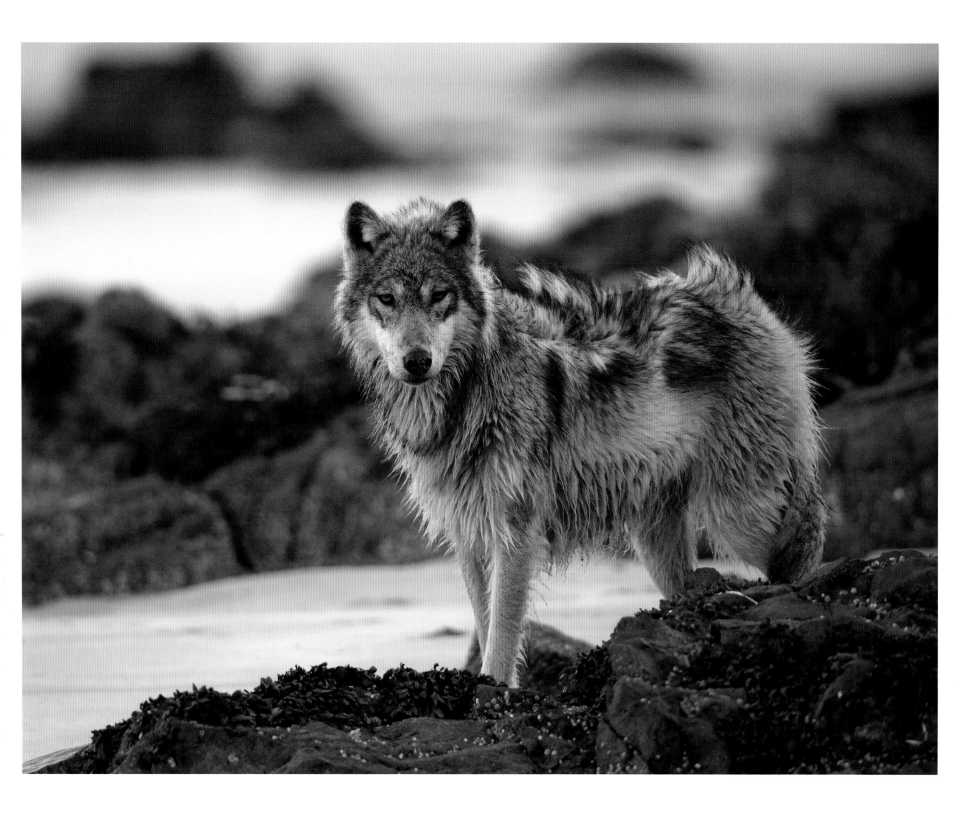

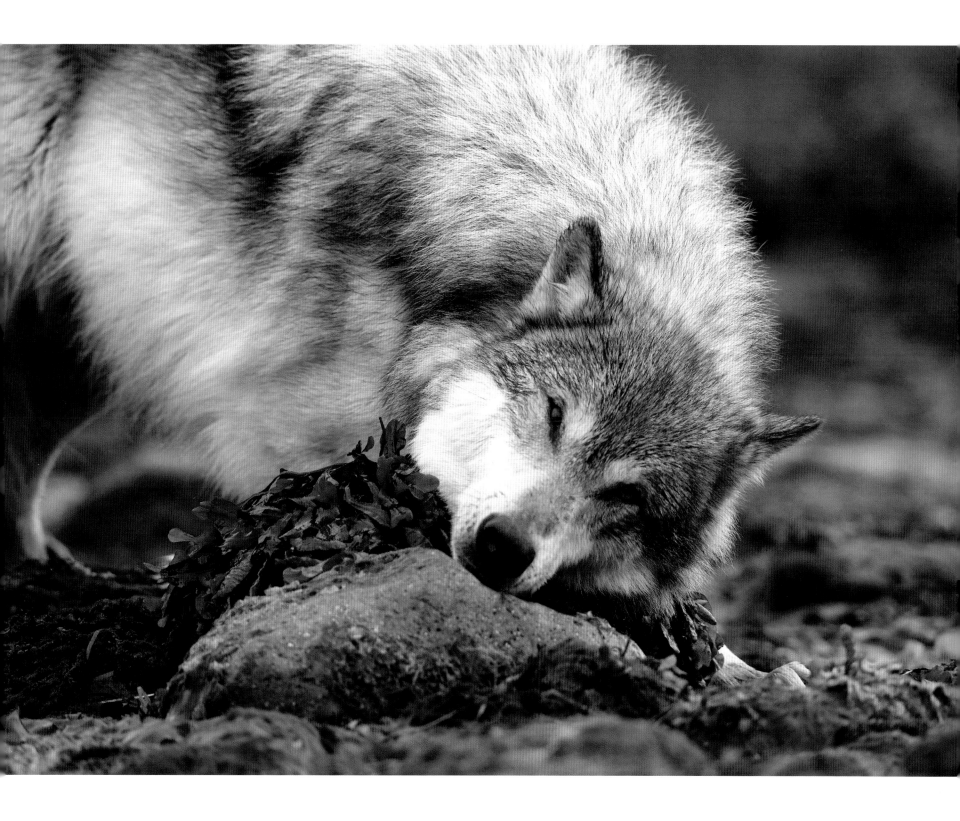

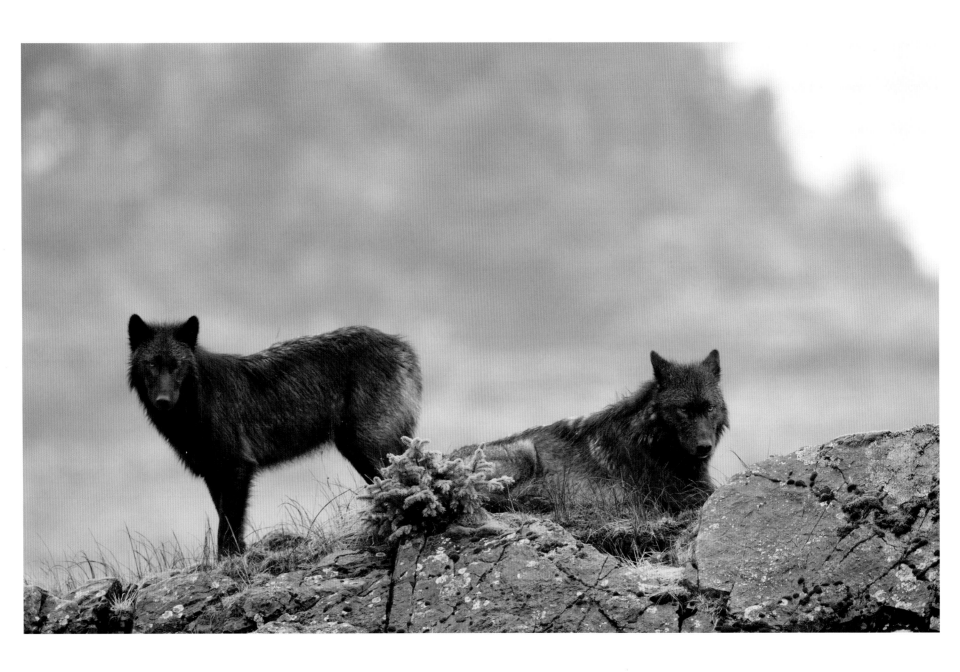

Now Haida Gwaii residents debate whether wolves should be introduced to the islands. I think wolves would do well there, and if humans would tolerate them, they might just allow a broken generation of cedar forests to return. But introducing a non-native species to combat non-native species is a tough sell after so many examples gone wrong.

FIFTEEN YEARS AGO, in an effort to address one of the larger knowledge gaps in coastal carnivore ecology, I helped recruit a young undergraduate student named Chris Dari-mont to help develop a coast-wide study on wolves. Soon other researchers joined the project and the unknown lives of these wolves emerged from the rainforest. This study was based not on direct observation but rather on what could be extracted from scat samples. A single scat sample can reveal DNA, diversity of diet, and stress patterns. The team collected so many of them that Chris became known locally as the poo boy.

One of the more interesting stories the research revealed was the evolutionary history of these wolves; they are genetically distinct from neighboring populations across the Coast Mountain range and in southeast Alaska. These coastal wolves had faded into the rainforest and offshore islands, successfully hiding from the guns, poison, steel traps, and government-sanctioned kill programs that reduced their continental kin to fragmented populations or, in many cases, total extirpation. It is estimated that North Americans killed over a million wolves during the 1800s, and their persecution continues today throughout the Holarctic. The first wave of European immigrants to this region came for sea otter furs and then whale oil, salmon, gold, and timber. Unlike on the open prairies, where settlers cleared land for agriculture, wolves here were able to retreat into the rainforest, avoiding conflict. The mild coastal climate also made for less desirable furs, which helped the wolves escape notice.

There are few places outside of this rainforest coast where wolves have been left to evolve naturally. That is why these coastal wolves may give us the best opportunity to study some of the last wild wolves on the planet.

Imagine what would happen to humans, from a genetic perspective, if they faced what wolves have over the last few hundred years, if human mortality exceeded 30 percent of our species' population—which for many wolf populations is a conservative annual mortality rate—year after year. Distinct races, hair colors, blood types, immunities, language groups, and countless other unique cultural attributes would decline or disappear altogether. The world's population would become bankrupt of culture and appear more homogeneous. Genetic diversity, the building blocks of life, would be eroded and our resiliency reduced as well. This is the legacy we have bestowed on one of the most socially evolved species on the planet.

What is true for wolves is also most likely true for other species on this coast whose genetics have yet to be studied. Years after this wolf study concluded I have remained preoccupied with the relationship that wolves have to the more remote environments in the Great Bear Rainforest. Wolves have fully penetrated the outer archipelago that lies scattered along the backbone of the Great Bear. While many islands are not large enough to support wolves on a year-round basis, they are each claimed and defended by dozens of different outer coastal packs. I have found signs of wolves on the loneliest guano-covered, treeless rocks, most often a trace of scat, usually dried and bleached by the wind, and on close inspection containing signs of harbor seal, sea lion, or river otter hair; the small bones of birds; and other outer coast prey. And frequently there are much fresher signs if the area supports a traditional haulout for pinnipeds.

On this winter day, once again the wolves have been on the outer haulouts. The seals and sea lions remain upset and I don't question why. I find dozens of fresh scat full of dark red blood, fine short hair, and black meat. They must have left the larger island sometime over the last few days when the tides were low during the night and winds turned to southeast. They know that the seals and sea lions, even on occasion sea otters, haul out higher when this kind of weather sets in. The dropping tide and a favorable wind to avoid detection give the wolves a distinct hunting advantage. Of course they must weigh the tough swim to the haulout against the likelihood of a successful hunt.

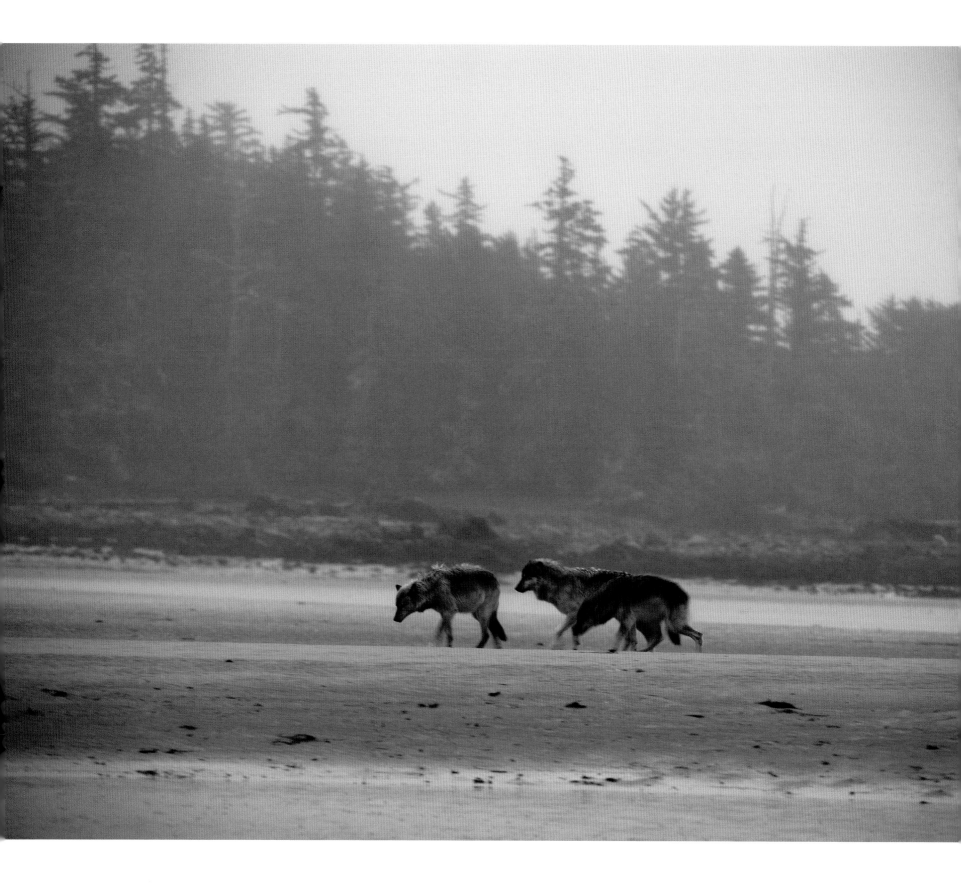

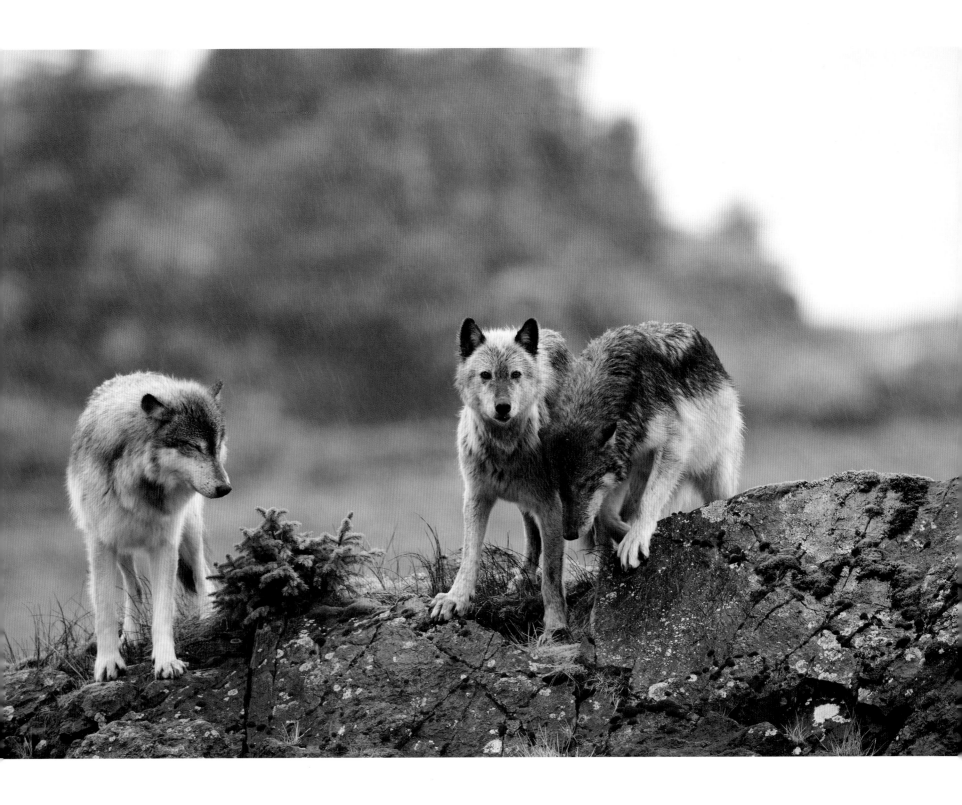

To swim these distances—often more than a few kilometers of open ocean and strong current—on a hunt is heroic, and they make the return trip with full bellies, ready to regurgitate for the pups at the den.

Seals and sea lions have an excellent sense of smell, and they are adept at detecting movement above water from many kilometers—an orca fin, a boat, a wolf. When I began studying wolves I found it hard to imagine how any number of them could immobilize and kill a healthy seal or sea lion, with their thick blubber and few appendages to grab. But a wolf in action has bone-breaking jaw strength, and multiple family members will latch on to their prey, pulling backward with uncanny strength to keep the animal away from the safety of water.

Once a kill occurs the first step is to lighten the carcass as quickly as possible so it can be dragged to higher ground away from the incoming tide or surf. The wolves start at the head and work their way down, tearing at the skin to expose more of the blubber. It is incredible to watch a forty-five-kilogram (one-hundred-pound) wolf tearing at a seal more than double its weight, and with each pull drag it upward across sharp rocks. The challenge of lightening the carcass is not exposing too much meat; otherwise the wolves will lose a considerable amount to ravens, eagles, and crows.

How do the wolves decide which place to hunt tomorrow? Do they decide beforehand to hit a haulout, or does it happen more randomly? Anyone who has traveled downwind of these haulouts knows what a stench they produce. This smell must travel for many kilometers across open water, covering neighboring islands like a blanket, and must weigh heavily on a hungry pack. Do they make a collective decision or does the alpha male set the direction, taking the first plunge into the water? They leave the den with the wind on their noses, as most hunters do. They know that deer will come down to forage in the intertidal zone for seaweed, so they make that part of their travel route. However they decide, their travels always seem to have purpose. If I had another life to live, coming back here as a wolf would not be my last choice.

THE STUDY OF the evolutionary history of species throughout the Great Bear Rainforest is fascinating and still new. Some species follow established rules of size, but others do not. For example, Foster's rule, first published by Dr. Bristol Foster in *Nature* in 1964, posits that on island systems smaller animals get larger in the absence of predators and larger animals become smaller with less predictable food sources. This seems to follow for some species in the Great Bear Rainforest; island wolves, deer, and even falcons are generally smaller than their interior relatives, most likely because of the warmer climate and more varied food supply.

But this coast was made for breaking rules. Signs of gigantism are everywhere—from twenty-story Sitka spruce trees to 450-kilogram (1,000-pound) grizzly bears. Fin whales, the second-largest animal ever to have inhabited the planet, are increasingly common here. The largest, the blue whale, I saw once off of Banks Island. In the marine invertebrate world, even the small things are giant—record-breaking chitons (a form of mollusk), the largest octopus, the largest sea slug, the heaviest starfish, and the biggest barnacle are here.

However, the real record holders had their day already. Imagine the now extinct saber-toothed salmon, which at over 1.8 meters (6 feet) long was the largest salmon to live on earth. There were also giant moose, elk, cats, beetles, mammoths, rhinos, hippos, and lions, and a 2.5-meter- (8-foot-) long beaver. Some of these extinct species, like mammoths, overlapped the first human migration across the northern land bridge that connected North America and the Russian Far East. Others went extinct millions of years earlier. It is difficult to imagine what this coastline was like when vast warm, grass-filled shallows hosted herds of tusked sirenians and fissipeds, toed animals that slowly submerged themselves to become our modern pinnipeds. Seals came from otters and sea lions from bears. I have sea lion and grizzly bear skulls side by side on my desk at home, and at first glance the two are difficult to tell apart.

Nevertheless, each year brings more insight into this coast's evolutionary history. Underwater sediment cores taken from Haida Gwaii revealed 16,000-year-old pollen and

associated seeds. This suggests larger ice-free refugia existed than is currently believed. Carbon isotope analysis of human bones from ten thousand years ago indicates that the First Nations diet here was derived from fish and marine mammals and not from the land, a diet that has changed little to the present day.

This coast has seen dramatic changes in sea level, which complicates our search into the history of life here. When the present-day city of Vancouver sat under two kilometers (over a mile) of solid ice—just over ten thousand years ago—small pockets off the west coast of Vancouver Island remained ice-free. The same goes for the northern BC coast. The weight of the vast ice fields along the mainland coast depressed the land, ripping offshore land masses like Haida Gwaii from their very foundation.

Yet miraculously, while this epic upheaval was busy sinking, lifting, and crushing evidence of people, animals, and plants that lived through the days of mammoths, equilibrium existed around the Hakai Passage region of the coast. Anthropologist Duncan McLaren from the University of Victoria, who has been part of an archaeological study at Hakai Passage, describes the region as a "coastal hinge," where the local sea level remained stable for at least thirteen thousand years. So while humans were dodging glaciers and their village sites were either being flooded, crushed by ice, or lost to the mountains, the small villages around Hakai remained inhabited for over eleven thousand years.

THERE ARE ONLY about a dozen breeding rookeries for Steller's sea lions on the BC coast. These are haulouts classified by DFO as producing about one hundred pups or more. The sheer biomass of so many sea lions, sometimes more than a thousand, attracts diverse life such as birds, fish, and whales. These wave-washed rocks are biodiversity hot spots and they tell us a lot about the productivity of the surrounding waters.

Now that birthing season is over the rocks are covered in juveniles, old ladies, and this year's chocolate-brown pups. The massive sea lion bulls, having done their job, are absent, out feeding constantly. They may go for months without eating during the summer, unable to leave the rookery for even a short time for fear of losing position and

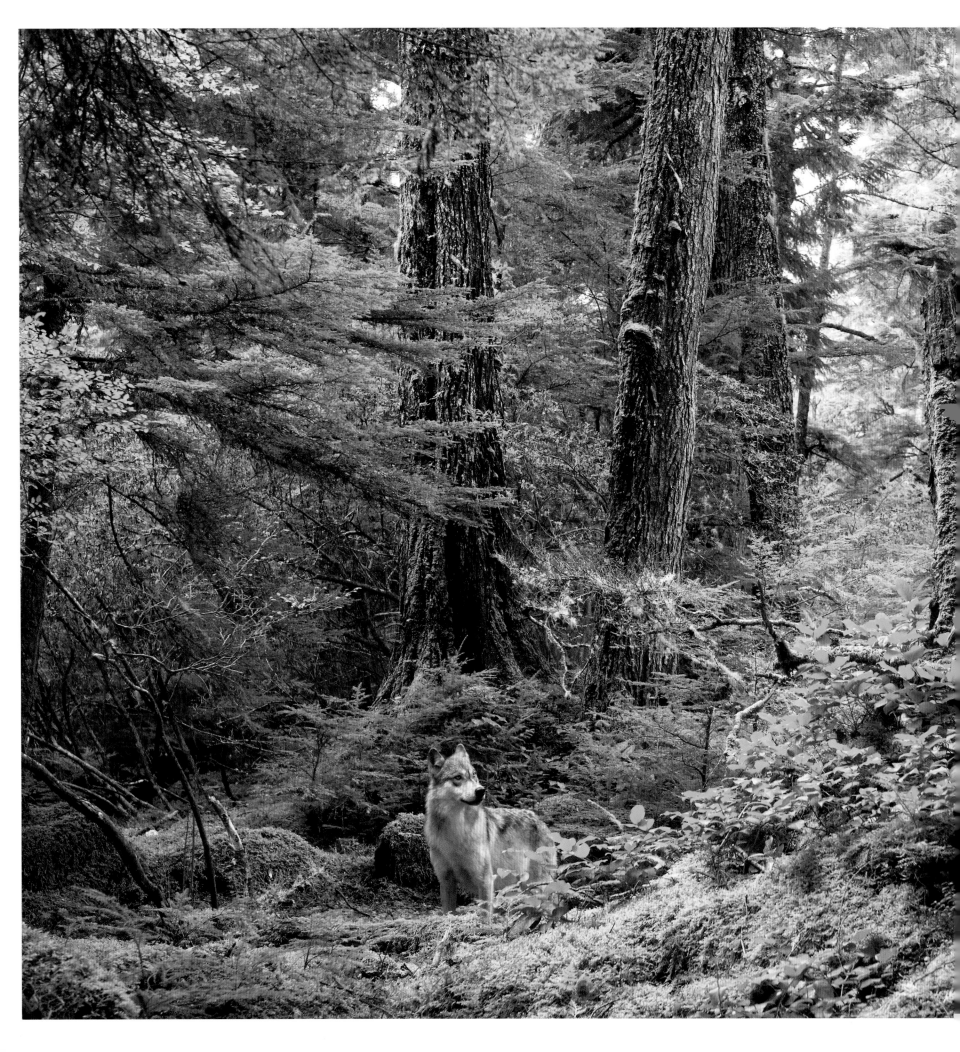

This wolf belongs to a genetically unique coastal population of wolves that avoided the persecution suffered by their continental kin. It is estimated that over a million wolves were slaughtered during the 1800s in North America.

status among other males. So the winter is their time to get as large as possible before the aggressive hierarchical battles begin anew. In the absence of large male sea lions to stir things up, the females and sub-adults are content to bask in the winter sun and watch our bubbles below.

Underwater they are fast and graceful. Their curiosity can bump a regulator out of your mouth, and occasionally one takes a bite; my neighbor is a commercial diver who had a Steller's sea lion dislocate his knee with a single bite. Yet the plentiful scat that rolls in the swells rarely reveals a bone or anything to indicate that they can prey on mammals. These sea lions must be eating relatively small fish, which their digestive systems reduce quickly. If there are over a thousand sea lions above me on this rock with an average conservative weight of 275 kilograms (600 pounds), then this reef and extended area support well over 275,000 kilograms (600,000 pounds) of large mammals throughout much of the year.

In recent decades Alaskan Steller's sea lion populations have declined over 80 percent, which many scientists attribute to changing ocean conditions and overfishing. As the oil-rich forage species of herring, sand lance, and anchovies have declined, the sea lions have been forced to eat the less nutritional pollock, leaving the animals full but still lacking the nutrition they need. Scientists call this the "junk food" hypothesis. As Canadian researcher Dr. Andrew Trites says of pollock, "It's like trying to survive on lettuce." But the BC coast is bucking these trends with a Steller's sea lion population increasing approximately 3.5 percent annually, nearing a coast-wide census of thirty thousand animals.

It is common for divers to be visited by gangs of these curious animals. I don't know of another place on earth today where a human can interact with so many large, wild carnivores and have a fair chance of emerging unscathed. Imagine being suddenly surrounded by twenty, thirty, or more sea lions, each weighing at least five times as much as a human. This is an animal whose closest land relative is the grizzly bear, but they are graceful and a joy to watch underwater as they come in tight, buoyed by

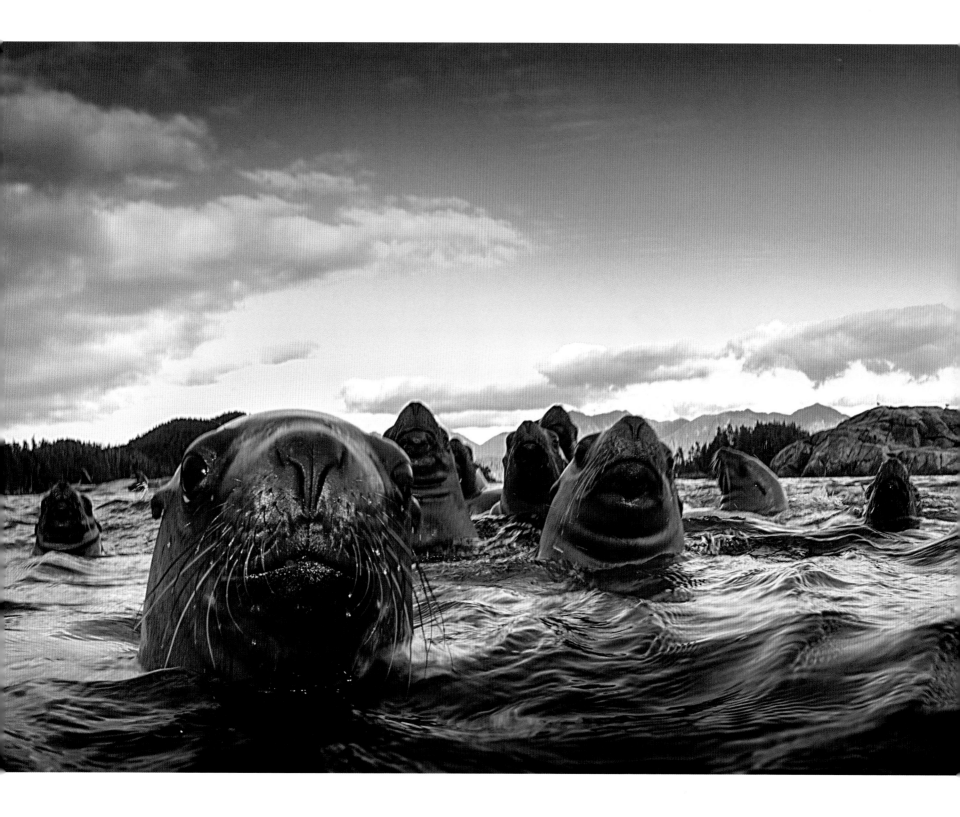

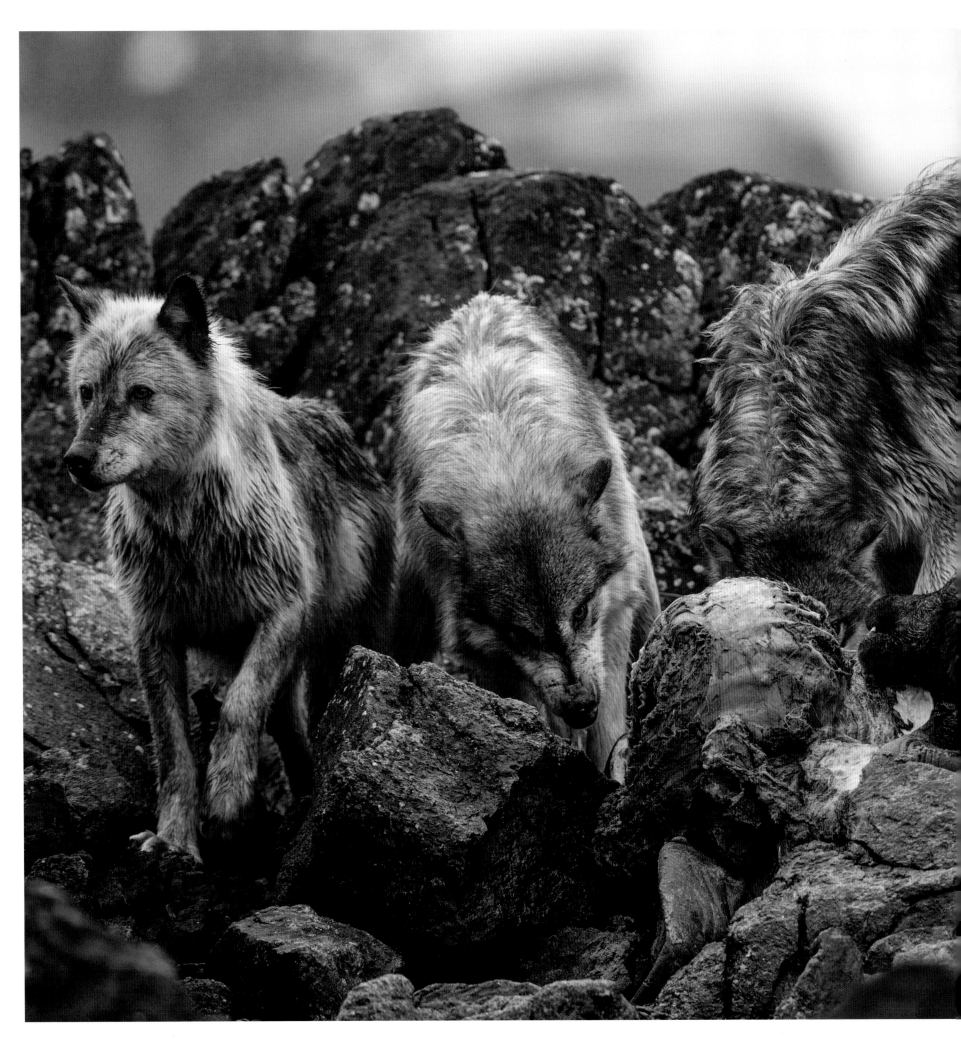

A wolf family can kill and consume a young sea lion in a matter of hours.

their numbers and their superiority navigating the underwater world. We humans are foreign, clumsy, and slow, and I can only be thankful that their diet comprises fish and not other mammals.

Being surrounded by sea lions underwater is nothing like interacting with a pack of wolves or one or two dozen bears congregating along a salmon river. Occasionally the sea lions may bark and clank their jaws at our presence. Exhaling bubbles can be a demonstration of anxiety or aggression to them, and unfortunately we do a lot of that with scuba, so I find myself holding my breath for as long as I can when they are around. What appears to be synchronized swimming, the constant diving and surfacing together, is actually feeding behavior. As long as everyone stays together they have equal access when they find prey. They are beautiful as they wrap themselves around one another suspended in blue water, like mermaids in an intricate ballet.

AT THE END of the day, anchoring in the lee of the low-lying Goose Islands, we are given a reprieve from the open swells of the past couple of weeks. *Skana*, the Vancouver Aquarium's small but trusty research vessel, is anchored here as well. On board is Lance Barrett-Lennard, a lead mammal researcher with the aquarium, and his partner, marine biologist Kathy Heise. We meet later on a nearby beach, huddled behind a rocky outcropping to avoid the strengthening northwesters that are picking up, and talk about the best—and unlikely—story to hit this part of the coast in many years: the return of sea otters.

"In 1968 the US Atomic Energy Commission made a cold call to DFO asking if we wanted some sea otters because they were about to detonate the largest nuclear test ever on US soil up in Amchitka," Lance tells me. About six thousand sea otters lived on the island target and they were not expected to survive. "Fortunately, marine researcher Ian MacAskie answered the phone and said yes, and just like that we had an unexpected boatload of sea otters heading our way."

So began the reintroduction of a critical species that had been absent from northwest coastal waters for over a hundred years. Quite a few did not survive the trip

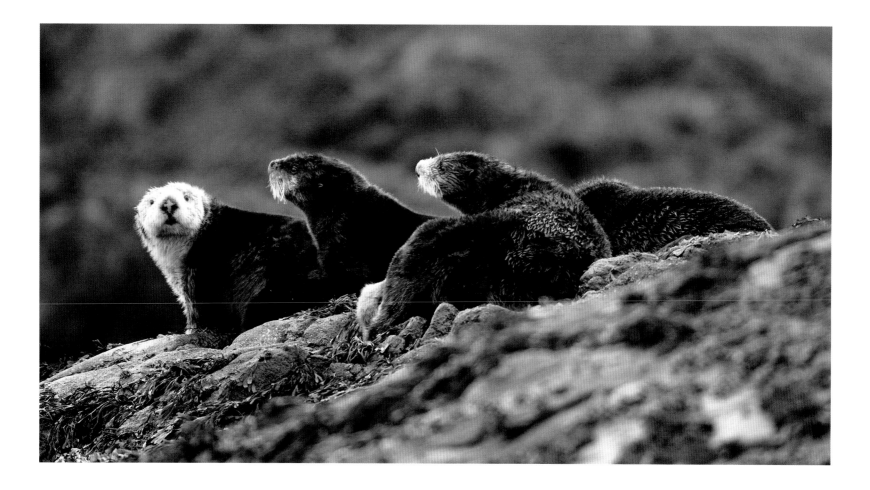

from various ailments; ironically, some died of seasickness. Bolstered by another ship-ment from Prince William Sound, a total of eighty-nine sea otters were released into the waters of northwest Vancouver Island. By 1990 the population had increased to six hundred.

"But little was heard of sea otters north of the island until the early nineties, when a large raft of them emerged around the Goose Islands," Lance says. "We thought that maybe this was a remnant population that somehow survived the fur trade, but after studying their genetics we found them related to the introduced Alaskan populations." This proved that the fur trade had decimated the sea otter population on the BC coast, but it also showed that they made a quick and long jump up the coast after being reintro-duced and remained hidden for over twenty years. Today sea otters are reoccupying their former haunts on the east side of Vancouver Island and north of the Goose Islands.

Sea otters resting on land are a welcome sight in the Great Bear. The recovery of this keystone species is helping bring back kelp forests and other critical habitat lost since the fur trade extirpated them from BC waters.

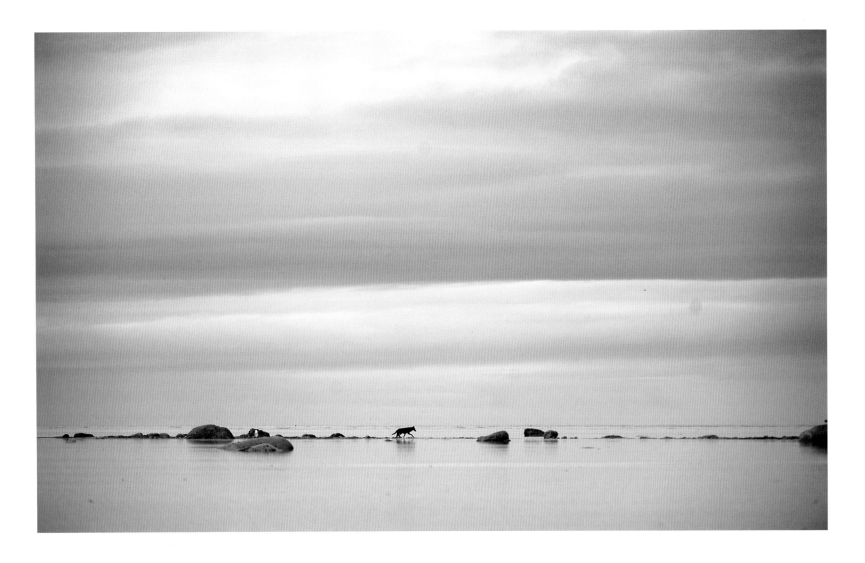

Island life for many coastal wolves involves swimming long distances to hunt seals and sea lions.

Like most large carnivores that have been fortunate enough to make their way back home, the return of the pink-nosed sea otter with his old man face has its supporters and its detractors. Some are now calling the outer BC coast the "otter coast" in recognition of the positive ecological role the species plays, but others are not so celebratory. This animal consumes up to 30 percent of its body weight every day, so its recovery is not going unnoticed. The lucrative sea urchin and geoduck fleets that have exploited the coast for years have had virtually no competition until now. Now in the bars and on the docks you hear grumbling about starting a sea otter cull because of the "indiscriminate" otters "wiping out" certain commercial species. But other fisheries are realizing new opportunities; as kelp beds return in the absence of the colorful yet destructive urchin grazers that some describe as underwater lawnmowers, they are providing new protective nurseries for many species of finfish. As sea otters continue to expand into their

former range, it is expected that the return of the kelp forests will bring greater abundance and diversity of life to the desolate urchin barrens.

Farther north, along western Alaska's shores, sea otters are not faring as well. In 2003 Alan Springer and colleagues proposed that the collapse of fin, sei, and sperm whales due to commercial whaling from the 1950s to 1970s caused a cascade of marine mammal declines. Referred to as the sequential megafaunal collapse theory, the idea is that the principal prey source for killer whales—other large whales and their calves—declined to the point that killer whales were forced to switch to smaller mammals, including sea lions, elephant seals, and finally sea otters. With the decline of sea otters, new trophic cascades are occurring, in particular the loss of kelp forests to the increasing urchin population.

However, a number of Canadian and American researchers have hotly debated this hypothesis, contending that BC waters witnessed the same whale slaughter, yet an actual increase in pinnipeds and other marine mammals followed at about the same time the decline was observed in Alaska. They also contend in their research paper, published in the science journal *Progress in Oceanography*, that the hypothesis does not take into account oceanic regime changes that may well be the major disruption to the marine food web and the cause of this decline.

Lance Barrett-Lennard supports the skeptics of the sequential theory in part because, similar to pollock and sea lions, sea otters are considered junk food for large killer whales. The latter simply can't get the nutrition they need from small, blubberless, and lean sea otters.

Perhaps it is a combination of these theories that accounts for what is happening in these waters, but scientists do agree that commercial whaling slaughtered the great whales to fractions of their former populations and that pinnipeds and most other marine mammals suffered similar mortality levels. Given the extent of global warming and changing oceanic regimes; nuclear, plastic, underwater noise, and other human-caused pollution; industrial fishing; and a host of other factors, it is difficult to imagine a return to the historic megafaunal diversity and abundance of these shores any time soon.

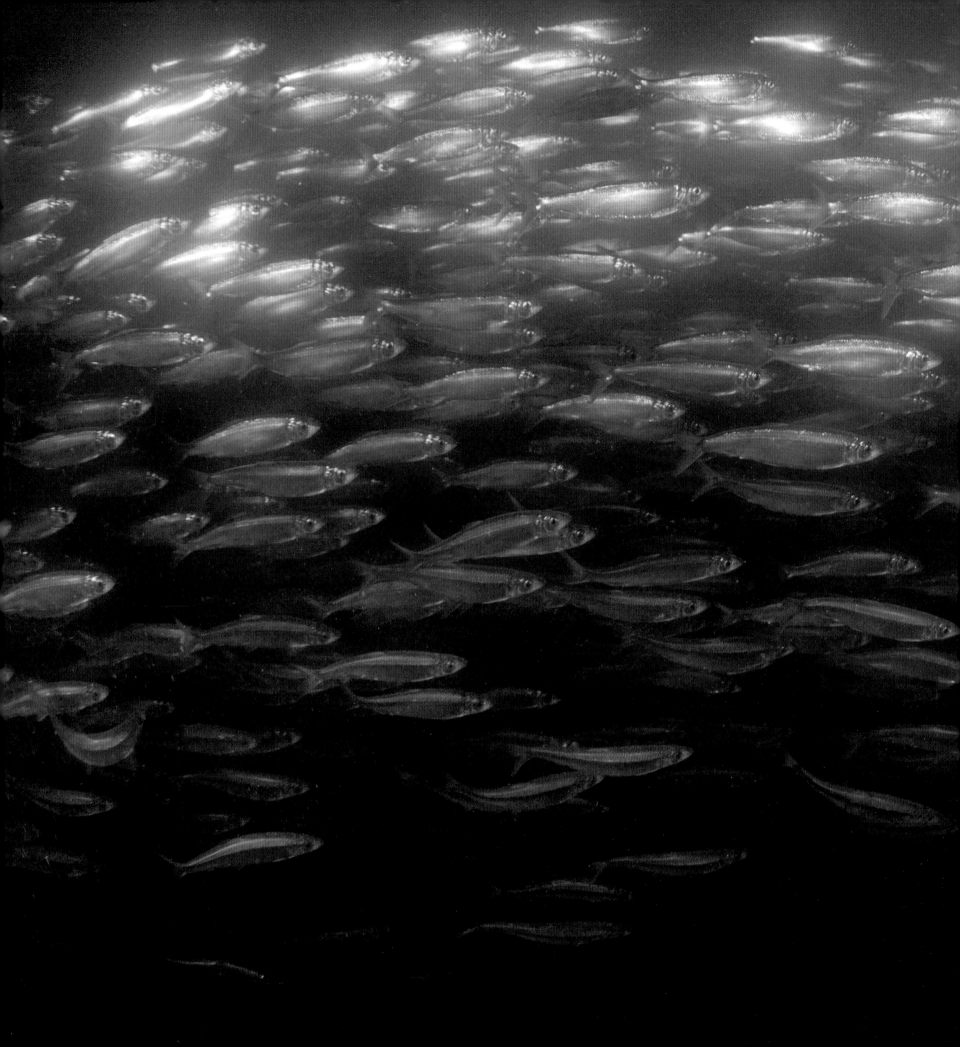

Archaeological records indicate that Pacific herring—a foundation of the marine food web—were consistently abundant along the north Pacific coast for ten thousand years. Only during the last century, since the beginning of the industrial fishery, did this critically important forage fish drastically decline.

WHEN THE MOON TIPS OVER

As the longer days of spring loosen winter's grip, the people of Bella Bella, Klemtu, Kitkatla, and other traditional herring-spawning territories on the north coast get focused on what locals call "herring weather." The tides, bird and mammal life, and air and water temperature indicate much about when the herring spawn will begin. People here follow the lunar cycle closely, and in Heiltsuk culture "when the moon tips over," it marks the beginning of one of the greatest and rarely observed natural events on the planet. This seasonal spawning event is so important, so vital and culturally revered, it marks the beginning of the traditional Heiltsuk New Year.

The connection between herring and people here is older than the cedar trees; historically herring may have been relied on more than salmon as a food source. Six-thousand-year-old herring bones were unearthed from a recent shoreline archaeological dig at Hakai Passage. Recently researchers from Simon Fraser University looked at 435,777 bone samples collected from 171 First Nations archaeological sites from Washington to Alaska, including 34 BC locations, and found that herring was the dominant fish species throughout the Holocene.

The consistency, abundance, and prevalence of herring over millennia in these sites could not be in greater contrast with the steady extirpation of stocks revealed since DFO began keeping records in 1928, a full fifty years after the start of the industrial herring fishery.

facing Spiller Inlet. The industrial herring fishery supported by the Canadian government indiscriminately takes male and female herring of all sizes. The female eggs are sold for export and their bodies are ground up into pet food, fertilizer, and bait.

Most fisheries on this coast have modernized with monofilament lines and nets, hydraulic winches, digital sounders—there are few, if any, places that fish can escape us and our efficient, technology-driven fisheries. But one fishery remains elegant and traditional—the spawn-on-kelp, or SOK fishery. Yes, canoes have been replaced with flat-bottomed, aluminum herring punts, but all other aspects of this traditional herring-spawn fishery have been carried out the exact same way for millennia.

Before the spawn, fishers harvest hemlock boughs from protected groves and kelp fronds and yaga—stringy seaweed—from the more exposed outer coastal beds. In the quiet coves and channels of the traditional spawning areas, the branches and seaweed are suspended from the floating, rock-anchored logs. These are site-specific, and the reason the herring choose them is known only to the herring themselves. First Nations families often choose multiple spawning locations to increase their odds of intercepting the spawn with their newly formed hanging gardens. Herring spawn is a valued resource and not all First Nations territories have such widespread herring-spawning grounds as the Heiltsuk.

Soon after the herring schools move inshore and the ocean turns milky with milt and sperm, the females discharge their eggs, twenty thousand per fish. Eventually 6 million eggs per square meter (about half a million eggs per square foot) will float with the tide, waiting to rest on seaweed, rock, or other substrate material. One out of every ten thousand eggs will produce an adult. With luck, the logs begin to dip under the weight of multiple layers of tiny eggs building up on the hanging garden below.

Herring are small and secretive, so their champions have been few. Canadians generally use them as bait or grind them up as pet food. First Nations, Japanese, and Chinese people are almost exclusive consumers of the eggs, so the rest of North Americans miss out on the cultural importance of roe.

As with First Nations on this coast, herring have had a troubled relationship with the colonial powers of the last hundred years. The herring have experienced one of the least publicized—yet tragic and unforgivable—examples of government mismanagement of a Pacific coast foundation species.

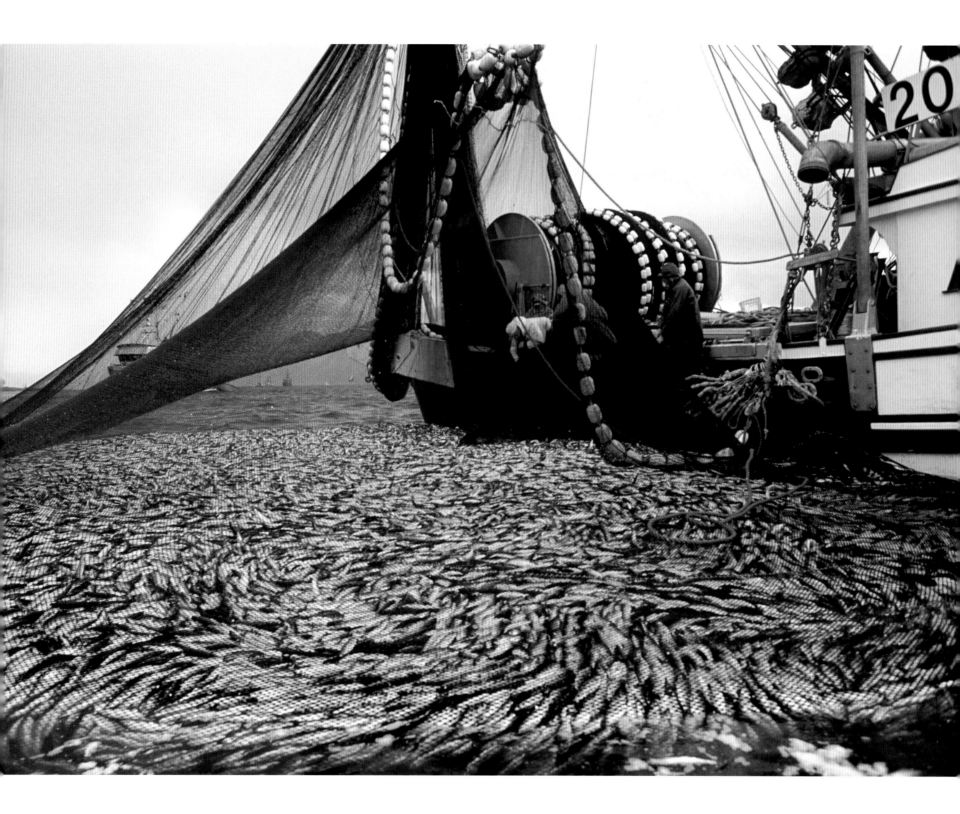

A Heiltsuk watchman totem pole stands sentry over traditional herring-spawning grounds.

In 1988 DFO charged two local Heiltsuk brothers, William and Donald Gladstone, under the Fisheries Act for harvesting and selling SOK without a commercial license. The brothers were forced to go to court to defend their traditional rights and to affirm their nation's relationship with herring. Five levels of court and judicial review, and eight years later, they walked out of the Supreme Court of Canada having won a precedent-setting case that recognized their traditional right not only to harvest SOK but to sell it commercially, as the Heiltsuk had been doing since well before European contact. The ruling put Heiltsuk commercial interests second only to conservation.

It is difficult to understand DFO. Logic would suggest that the agency would celebrate such a decision. It would allow them to focus on a community-based fishery that is infinitely more sustainable than current "kill fisheries" that scoop up thousands of metric tons of fish just so fishers can extract the roe; the rest of the fish ends up as fish meal, cat food, or bait. For a fish that can successfully spawn more than ten times in its life, this is a barbaric end to future spawning options and a sure way to reduce genetic diversity.

However, the sad irony is that by the time the Heiltsuk won their day in court, DFO had already managed the fishery into such decline that it effectively made the decision meaningless. The local commercial fishery has been closed for seven years, but the battle between the corporate-owned, DFO-supported herring "kill fishery," as it is known, and the conservation concerns of coastal First Nations continues without resolve. The kill fishery is an industrial insult to one of the most sensitive and important species in the north Pacific, but this has been the story of overexploiting forage fish for a long time. Sardines were the first to go in the 1940s, and when the nets turned toward herring it took only twenty years for that fishery to collapse, too. As soon as the stocks begin to recover, DFO opens the fishery again. The agency in charge of fisheries management in Canada rarely closes a fishery until biological extinction of a stock or a species is well under way.

In the spring of 2014 six RCMP patrol boats with more than two dozen officers arrived unexpectedly in our small community of Denny Island. Shortly thereafter the southern-based commercial herring fleet arrived. After a brief respite of seven spawning seasons

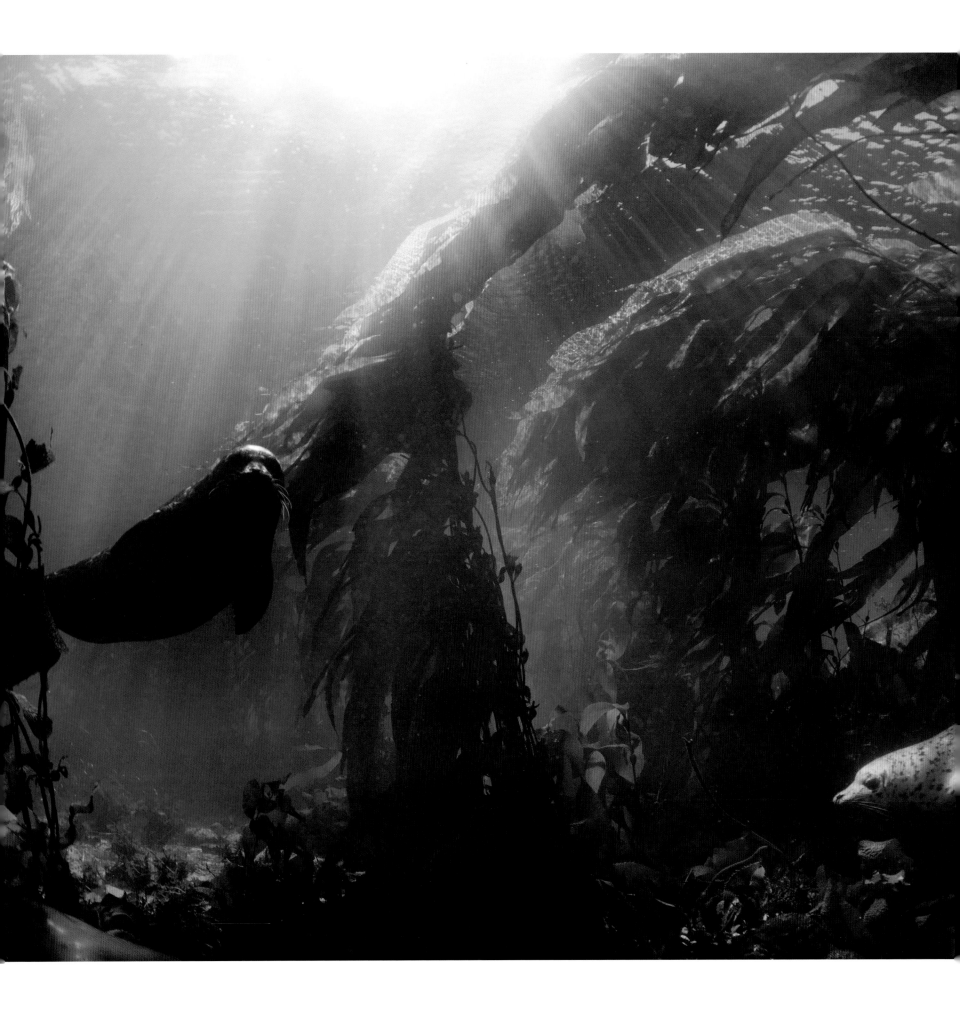

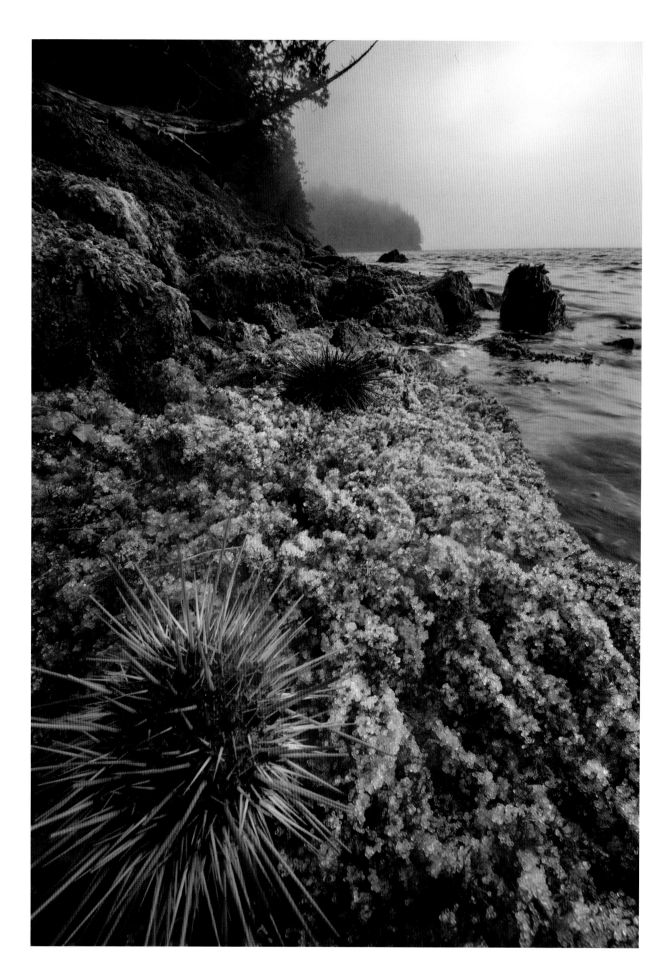

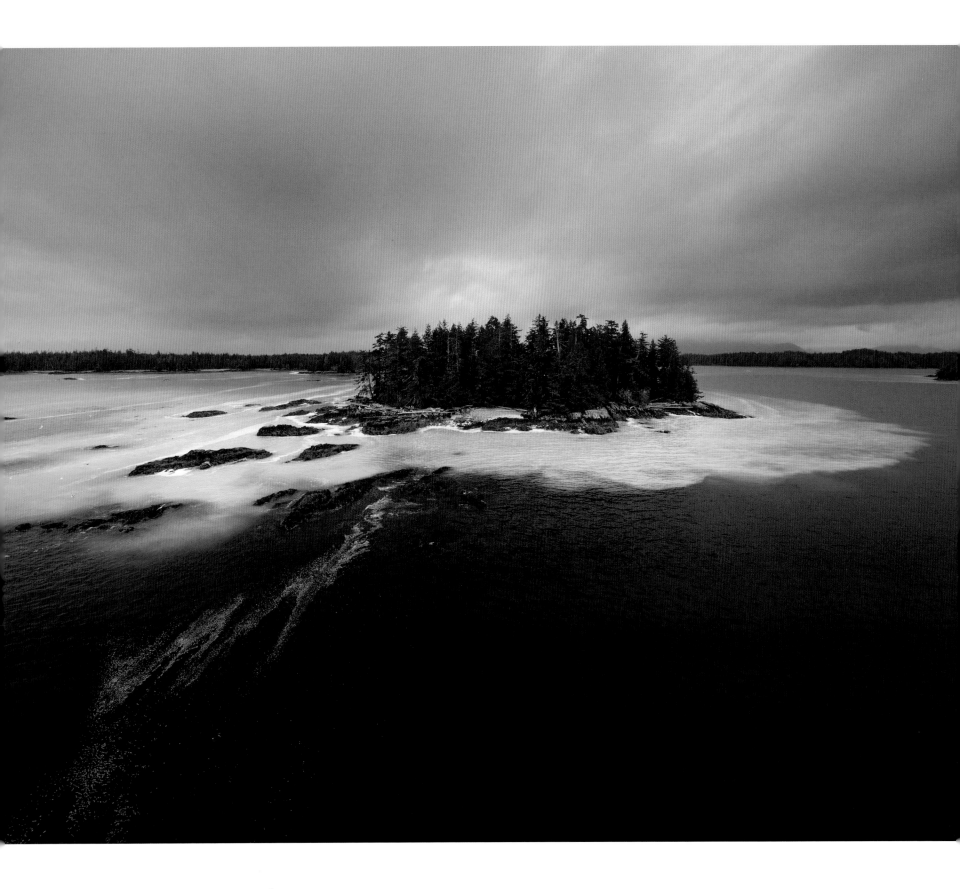

the fisheries minister, Gail Shea, overruled her own scientists' recommendation to maintain the commercial fishing closure and once again gave into corporate interests. When it takes such police presence to enforce an unsustainable fishery it is clear that the days of trust between DFO and local communities or Ernie Hill's "gentleman's fishery" have long since passed.

TODAY IS CALM, one of those early mornings when the fog hangs over the coast. The water in Seaforth Channel is covered in a thin layer of bubbles as the herring rise from the depths and expel air from their bladders. These curtains of bubbles are thought to confuse predators. As each herring expels air, a small acoustic blip can be heard like hard rain hitting the water. The late Heiltsuk elder Ed Martin told me that hunters used to carry small round pebbles in their canoes and gently toss them into the water to mimic the sound of herring; sea lions, dolphins, and other predators would come inshore attracted to the familiar sound.

Thousands of surf scoters rafted in large black mats are bobbing on the water's surface, the current, wind, and tide ensuring they are never in one spot for long. The males have large, distinctive bills—bright orange and white with a black gonydeal spot. They are breathtaking when they take off and gather momentum; like a wave gathering speed, the air is soon filled with the harmonic whistling of thousands of beating wings.

In a nearby cove a Heiltsuk family is leaning over the side of their herring punt, inspecting their lines. More boats are spread out along Spiller Channel. These boats travel slowly, keeping as quiet as possible. There is a dignified calmness on the herring grounds. People whisper. A paddle dropped in a boat can be loud enough to spook herring back down to the depths and ruin a potential spawn.

Generally the herring remain deep down in the daytime unless they start spawning. Today, though, the shoreline is revolving with rising schools. When caught in a seine net these fish are so powerful; working together they can pull a twenty-five-meter (eighty-foot) commercial boat over.

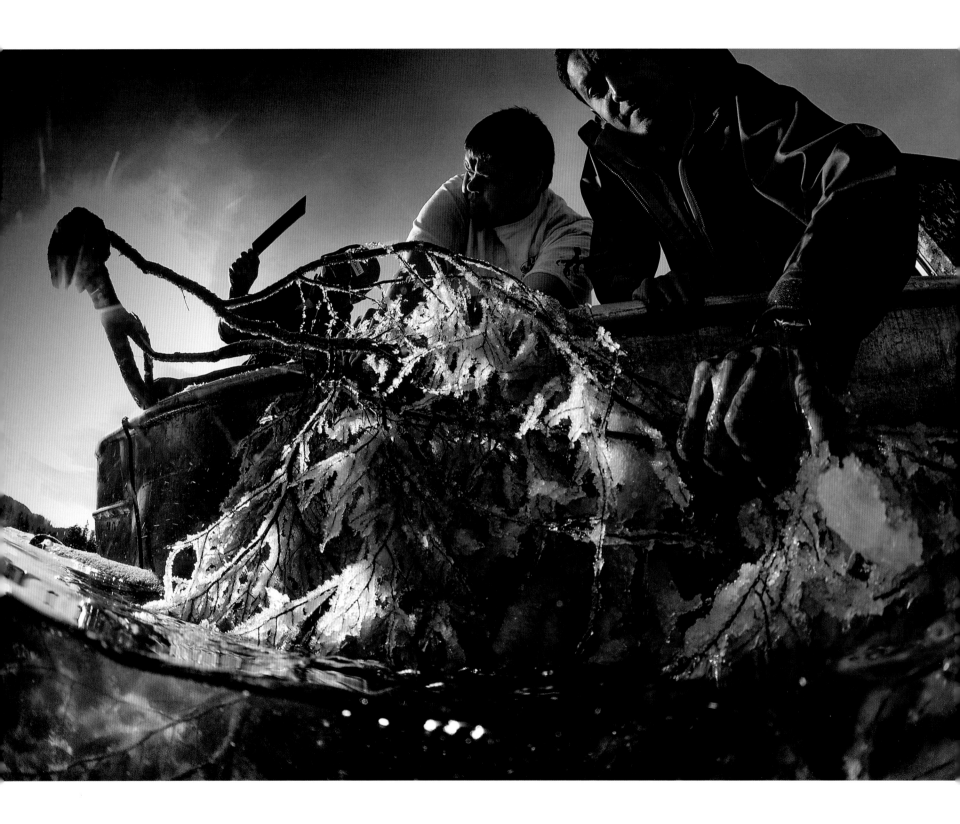

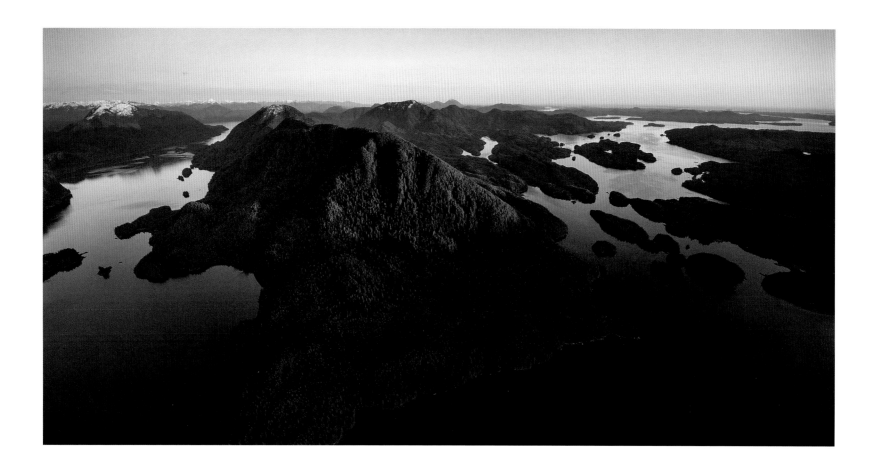

On shore the intertidal rockweed is exposed and covered with kilometers of shore-birds: black turnstones, spotted sandpipers, surfbirds. Chatting, chirping, and low rattling and rasping sounds fill the air as they devour the herring eggs attached to the rockweed. They know the tide is rising and they have only a couple of hours to feed. Well over a thousand eagles can be seen from any vantage point, and there are countless gulls, grebes, loons, ducks, oystercatchers, terns, murrelets, murres, brants, herons, scaups, and others—this avian drama is spectacular.

For many of these birds this nutritious, predictable, and easily accessible food source may mean the difference between nesting success and death, located as it is midway on their ten-thousand-kilometer (six-thousand-mile)—or more—migration from their wintering grounds of Mexico and Central America to the open Arctic.

Finally the chatter fades as the birds go off to rest on various islets and in quiet coves waiting for the next tide. Then the next major event unfolds as the surf scoters come

facing Heiltsuk fishers Jordan Wilson and William Housty show visiting scientist M. Sanjayan the traditional method of harvesting herring eggs on hemlock boughs.

above Herring-spawning grounds north of Bella Bella. The Heiltsuk and other First Nations continue to fight for an end to the corporate-controlled industrial herring fishery while promoting the more traditional and sustainable spawn-on-kelp method that allows the herring future spawning opportunities.

inshore. These black birds with their red, webbed feet can't go ashore, so they wait for high tide to dive for eggs, preferring the ones attached to eelgrass. I put on my dry suit and underwater gear, dive down about half a kilometer (a third of a mile) away from them, and slowly swim and drift with the current.

Schools of herring flash silver in the milky distance as I settle in about ten meters (thirty feet) of water. Soon the light dims as thousands of surf scoters begin paddling above me. I hold my breath, trying not to laugh at the comical sight. Soon birds are diving down all around me, lunging into the flowing eelgrass headfirst and, with a fast beat of their wings, propelling themselves back toward the surface, long fluorescent-green, egg-encrusted strands of eelgrass trailing in their beaks. They pull the delicate strands of eelgrass off the bottom easily, and it probably digests easily, too. Errant strands float gently back down to the ocean bottom. The sheer number of diving birds reduces the sight to bubbles, floating eelgrass and guano, and the flash of black feathers, orange feet, and bills.

On the next low tide I see a flock of shorebirds lift off suddenly. A pack of six wolves appears from the rainforest edge. They move to the shoreline and with heads down quickly begin to gorge on the herring eggs. Their intensity is born from a long winter in which food is harder to come by. A harbor seal rises through the milt with its face covered in sticky eggs. A mother orca and calf swim through soon afterward, their backs and dorsal fins covered with a translucent sheen—to be encased in herring eggs must be comforting. For five years in a row the same black bear has shown up along this stretch of spawning ground to eat eggs. Next to salmon season this is the only time that wolves and bears predictably show up along the shoreline.

Above the wolves I note many large bald eagle nests. Here on the traditional herring grounds the density of nests is far above average. In fact, the traditional herring-spawning grounds can be mapped by the density of these old nests, some more than a century old.

A fascinating attribute of herring ecology is how site-specific they are. Heiltsuk territory is a vast part of the BC coast comprising about thirty thousand square kilometers

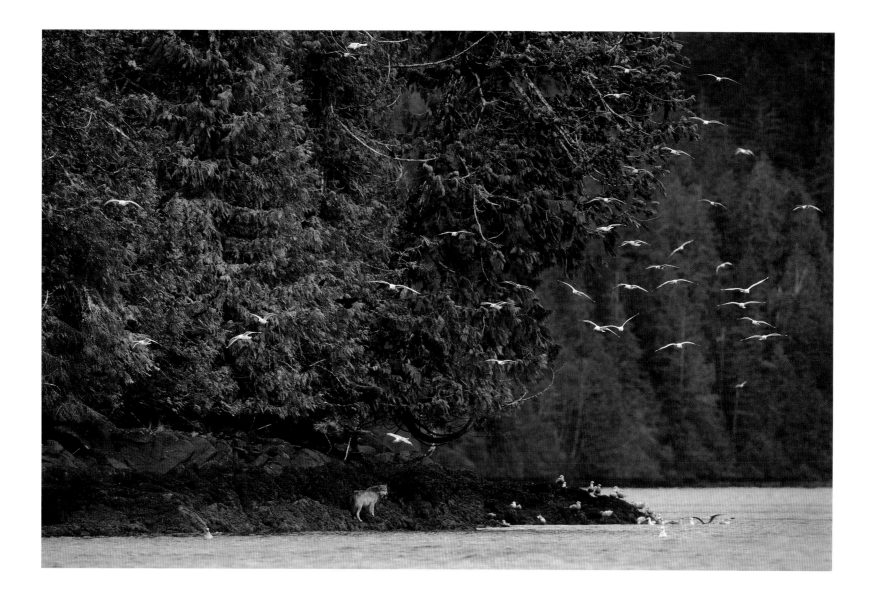

(twelve thousand square miles) of large fjords and countless islands, bays, lagoons, and archipelagos. It's the kind of wilderness that could take many lifetimes to explore fully. I have been working diligently at it for twenty-five years and still have a long list of places I have not been. Yet the herring choose to return to the same spawning areas year after year. Why do they spawn on one side of an inlet and not the other? Why one part of a bay or lagoon and not the other?

It is also hard to know why the herring abandon certain areas. Maybe they are spooked by predators; maybe they sense that the eggs are drifting out to deep water where there is nothing they can attach to. Or maybe they are young fish without the experience of previous spawns. Surely the herring must know if they are successful shortly after

During herring-spawning season, species from the rainforest and the ocean meet at the tide line to feast.

spawning. They would investigate whether the egg mass was getting thick and, if so, move on, job done. Back to running the daily gauntlet of predators until they return next year.

The herring have been showing the classic signs of overkill year after recent year. The fish are now smaller, meaning they are younger. And since it's the elder herring that lead the schools to these old spawning locations, that means they are not as culturally hardwired to return to their natal spawning grounds. The elder scouts have passed on survival skills for countless generations. Lose the elders and the lineage of knowledge dies with them.

The visibility clears and I am diving through a set of narrows that is quickly filling up with herring. I hover quietly in an eddy, watching the masses of herring come into sight and then exit upstream into the lagoon, moving against the current. Lifting my mask above the surface I can see their bubbles lying on top of the water. They don't seem to mind my presence, although they keep a distance of about a meter. And whenever I do anything remotely strange, such as exhale or bump my steel scuba tank on a rock, they quietly vanish, like they were never here.

Herring survive in numbers, and their intolerance to disturbance seems amplified by their mass. These fish spook like almost no other. Ordinarily a single exhale of air and a house-sized school of herring can vanish without a trace. But once they are in the throes of spawning, they are so focused that they tolerate the sea lions, whales, and birds attacking from every side.

I think of the industrial seine fleet that stretched along these traditional spawning areas for so many years, until in 2006 DFO closed the commercial fishery on the central coast—their clanking steel and aluminum, their whining hydraulic-driven winches, their shore boats belching smoke as they pulled their nets taut. Steel against steel. Main engines and generators going through the night. Boats constantly searching for fish with bright lights and sonar. It was like a city of lights on the herring grounds, with little thought given to the impact all that disturbance would have on these hyper-sensitive fish.

No wonder local First Nations fishers are so upset about this kill fishery. It is insulting on so many levels.

THIS HERRING SEASON I am helping a crew from *National Geographic* who would like to interview local SOK fishers. Three younger fishers are out—William Housty, Jordan Wilson, and Ian Reid—so I make my way over to them. I can tell they are not in the mood for interviews. They want to check their product, pull it up, and bring it home. William is still running on adrenaline from helping run an important potlatch in the community hall over the last few days. He has probably been awake for well over twenty-four hours.

"Everything will be fine," he says without looking up, "if you don't ask me any fucking questions."

The film crew looks at me for support.

I look away and find something to fix on my engine. William is an imposing man and one of the brightest and most culturally knowledgeable men I know. I figure if we wait a bit he will come around.

I watch as they methodically pull up hemlock branches, leaning far over the water. Each branch could weigh forty-five kilograms (one hundred pounds), and they pull them into the punt deftly. Ian pauses for a bit and looks up at the beach. A wolf is walking along the point, one of the pack that has been feasting on the eggs this past week. He smiles. "All these worlds trying to get by in amongst ours," he says and continues to pull up the branches and eggs like his ancestors did before him.

Jordan says the roe taste sweet and spicy. I eat a chunk of rich and fatty eggs that have fallen off the thick clumps now piled a meter (three feet) high on a blue tarp in the boat. Deep inside the catacomb of eggs I taste hemlock needles. It is the ocean and rainforest in one bite. At first the eggs taste almost acidic or bitter, but then the after-bite kicks in and spicy sweetness emerges. They are almost fruity. The eggs are a delicacy as fine as anything I have ever tried from the ocean.

facing These wolves arrive on the herring-spawning grounds in mid-March each year and may have access to nutritious herring eggs for over a month.

William tells me that some families dry the more thinly layered eggs in the wind. That is a personal preference. Japanese like kelp between their layered eggs; Heiltsuk like yaga, the stringy seaweed, or hemlock needles.

The local residents have all had a hard winter without a plentiful, predictable, and intensely nutritious food source. Herring season marks a new year that changes the fortunes of many on this coast. In fact some of British Columbia's wealthiest human residents can trace their first financial break to the herring days when the resource seemed limitless and stacks of cash—lots of cash—passed across the sides of boats from buyers to fishers. Some of these seasons were worth millions of dollars at today's value.

When I ask why they don't sell these eggs, given their value, William and Jordan explain, "We could take the money but then we would be back where we started."

I think about this concept of traditional economy and financial equality—or as my Heiltsuk neighbor Frank Brown calls it, this "modern duality" that First Nations live in today. Often successful entrepreneurs in these coastal villages are looked down on because an individual is seen to prosper at the expense of the nation. It is not easy being a capitalist in Indian country.

William tried to explain this to the government-appointed Joint Review Panel (JRP) that recently came through Bella Bella for the Enbridge pipeline public hearings. He explained that if he accumulated significant wealth he would give it away to his community, which would increase his economic stature among his people. The panel looked pained by the idea, given that their mandate was to find a way to approve oil transport projects through this coast.

Listening to these three men talking among themselves, interjecting the occasional Heiltsuk words, reminds me of the rest of William's fascinating presentation to the JRP.

According to Ecotrust, First Nations people along the coastal rainforest between western Alaska and San Francisco Bay spoke more than sixty distinct languages before European contact. Today only eight of these languages are spoken by more than one hundred individuals; forty-four of sixty-eight have gone extinct or are spoken by less than

ten people. In 2013 ninety-nine-year-old Violet Neasloss died in Klemtu. She spoke six
coastal languages, but with her passing a distinct southern Tsimshian dialect also died.
When one overlays a map showing where languages have gone extinct along the Pacific
coast with one that shows extinct salmon stocks, deforestation, and other widespread
environmental damage, the locations are the same. But why? Why does environmental
health affect language so strongly?

I didn't understand this connection until I heard William's testimony. He could have
chosen to speak about a great many things. He has a college degree in natural resource
management, has been leading a grizzly bear study in his territory for a number of years,
and has spent many years leading youth camps in Koeye River, among other things. He
could have spoken about any number of issues related to the impact of an oil spill, yet he
chose to discuss language.

He patiently described the meaning of various place names in Heiltsuk territory as
he had been taught by his parents and other elders. Each name told a rich layered story
of the place it represents—the sound of salmon moving over gravel or a meadow where
the grass stays green over winter. In Heiltsuk language there are hundreds and hundreds
of names that describe their home in the same intimate detail. He also described how
Heiltsuk people are actually Heiltsuk-speaking people, and that to be Heiltsuk is to act in
a certain way—with respect. He said that his elders, like David Gladstone and Ed Martin,
had taught him to protect their language at all costs. In the end he made the connection
that if an oil spill occurred it would fundamentally impact and change the environ-
ment so much that these words would no longer have meaning. The strongest link that
describes the history of people and their environment over ten thousand years would be
gone. In a culture that did not write its history down, these words are what connect the
past teachings, present day, and future.

USUALLY BY THE second week of April the end of the herring spawn is in sight. If fami-
lies have not harvested their eggs by now there will be noticeable stress in the village.

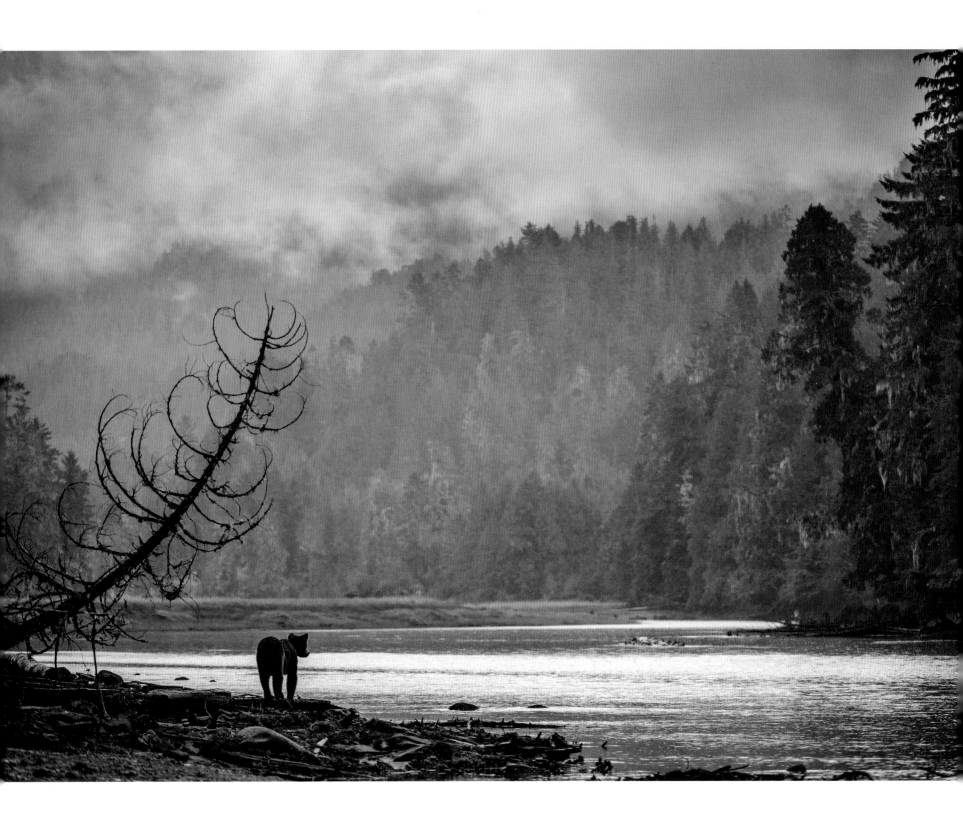

Fortunately, even though this year's spawn happened later than normal, most families did well and the mood on the docks and out on the water is light, because freezers are filling and backyards contain egg-covered branches slowly drying in the cool air.

In three days the shoreline has completely transformed. The number of eggs unveiled at low tide, as far as I can see down Spiller Channel, is staggering. It would take hours to count the eggs in one small spot of shoreline. So far there are over one hundred kilometers (sixty miles) of shoreline spawn—from the high tide line to eighteen meters (sixty feet) of depth—in Heiltsuk territory alone, and the spread is increasing as the herring move north of Reid Passage.

At this time of year the salmon creeks seem quiet, but they are silently disgorging millions of juvenile salmon. The first food they will encounter is vast underwater clouds of translucent baby herring the length of half a human fingernail. They will join the zooplankton for the early summer, and once they are more developed will part ways. The heavier salmon larvae will soon begin feasting on copepods.

The difference between salmon and herring is intensity. The herring spawn occurs over just a couple of weeks; salmon season spans months. The salmon spawn is the crescendo before winter sets in, and the herring spawn is one big opening act. The salmon's reproductive strategy is to bury their pea-sized eggs, protect their nests as long as possible, then die, leaving their offspring equipped with everything they will need in life. The herring approach is more shock and awe. At just the right time, one calculated by temperature, moon cycle, tides, salinity, and a host of variables we are still learning about, the herring rise from the depths in massive rotating balls. They spread so many eggs throughout the coast that they bank on the sheer abundance winning out.

And then as suddenly as it began it is over. The water is returning to its dark blue-gray, a few very fat seals lie on the surface bobbing like bloated corks. The din is gone, the calls and shrieks replaced by silence. The coast is already turning a season.

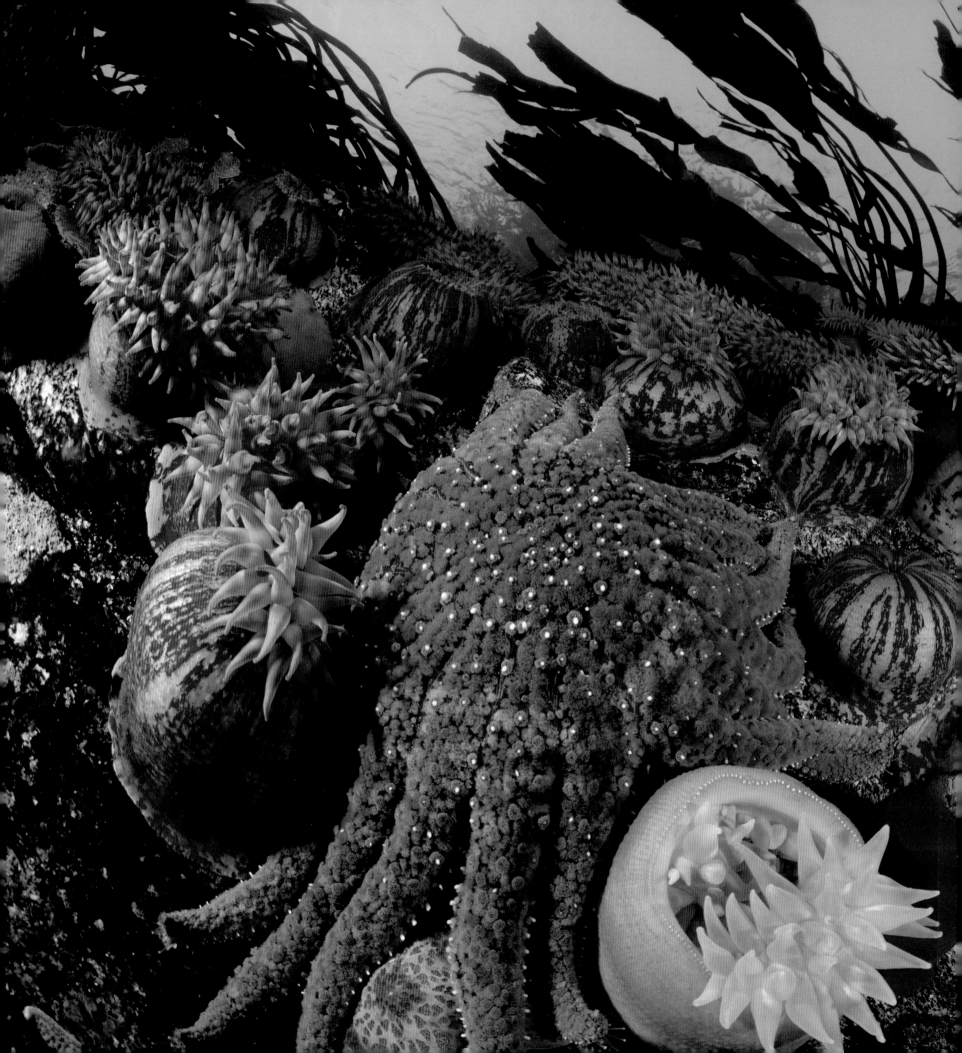

Anemones, starfish, and kelp.
A strong tidal current and nutrient-
rich and pollution-free waters
make the BC north coast one of the
best dive locations in the world.

A QUIET OCEAN

THE HYDROPHONE SITS unused on the deck. Normally it would play the sounds of the whales below, but today their vocalization is so strong it fills the air.

I am waiting for a break from the strong tidal current, even ten minutes of slack water that would allow me to get below and explore the nearby reef that drops off of Dupont Island.

Across Whale Channel the sun hovers above Princess Royal Island and the morning clouds have long burned off. But here above the sheer cliffs of Campania Island the mist persists, clinging to its granite peaks. Through it I see the island's thick moss and gullies full of yew trees, gnarled hemlock, and cedar. This island holds many stories for local Gitga'at people and it does for me, too. I proposed to Karen on its blustery peaks years ago. She accepted but insists she was under duress from the clouds of black flies. Since then we have returned with our children many times; in the summer of 2013 our seven-year-old, Lucy, managed to climb Mount Pender, the highest point on the island. Helen Clifton talks of the seagull eggs that used to be collected from the island's peaks; it was a test of prowess to bring intact eggs back to the community from the highest mountain—Laxk'ak'aas—or "place of seagull eggs" in the Sm'algyax language.

Around me, on the western edge of Caamaño Sound, the strong currents of the exposed ocean are rushing by the boat, causing a slow thumping noise as the chain bumps against the forward chain plate. It is like being parked in a massive river.

123

As I wait for the tide to turn I climb into my dry suit and prepare my camera housing and strobes. Soon enough the bull kelp are no longer bent over streaming their translucent brown, bulbous heads; things are calming down.

I slip into the ocean. My dry suit and body vibrate with the otherworldly sound of humpback song. I can actually feel the whales' song. I adjust my mask, check if the underwater housing is watertight, and begin peering around. I can see nothing except long columns of silver light reaching down into the abyss. The haziness and depth are disorienting. I will never get used to the feeling of being suspended above what seems like bottomless black water. Soon the reef face comes surging in, and suddenly with a push from the swell, bull kelp fronds embrace me for a moment. I find the anchor chain and follow it down to ensure that the steel hook is properly attached. It will hold for a while.

The ebb and flow of the surge bring me over to the more comforting rock. These outer coastal pinnacles are superbly divine in color, life, and wildness. A sheen of pink coral covers the rocks, decorated by sea slugs, spiders, giant white *Metridium* anemones, purple urchins, rock scallops, tube worms, and countless other species—truly countless. There is so much life here; any small section of this reef's bottom could be scrutinized for hours and yet more critters and species would emerge. Here on this reef are exotic and diverse species writhing in iridescent colors and alien shapes. This view would easily astound any human being, but too often we behave like it doesn't exist.

I am getting cartwheeled by the surge and current that is still running at a few knots. It feels like space travel over a new planet below: worlds of life are streaming past, nothing resting for long. There are over four hundred species of fish on the BC coast, and many of them are present here. So often when I descend, especially in the winter, to over thirty meters (one hundred feet), things are just starting to get interesting. There are fields of cod slowly moving back and forth in the deep-water surge; many of these species appear to be in a state of dormancy from the cold water and lack of food.

The famed underwater explorer Sylvia Earle estimates that we have mapped only 5 percent of the world's ocean environments; we know more about the solar system.

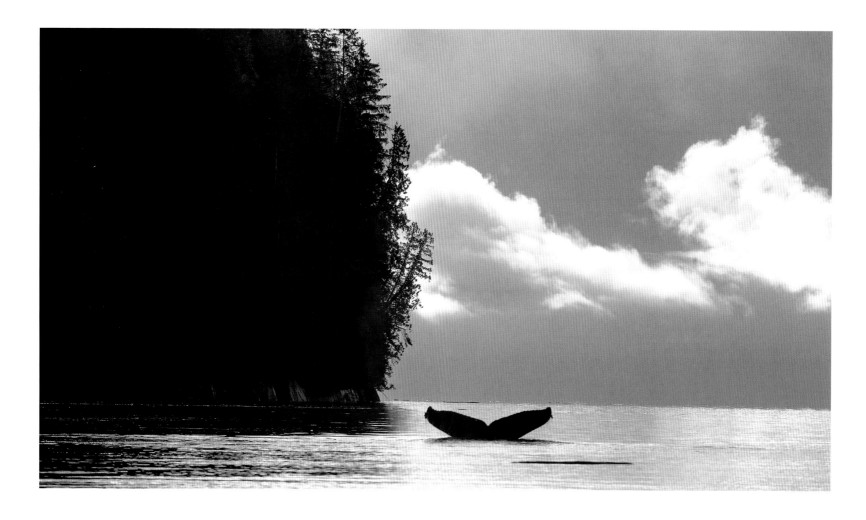

Thomas Peschak refers to the ocean—and our lack of understanding of it—as a mirror. We stare from above into the silvery waters and just see our reflections. It is an apt metaphor because the harm we are doing to the oceans ultimately harms our own species. Somehow we have to break through the surface sheen and understand, or at least respect, what this underwater world is about.

While I adjust my camera settings I notice the humpback whale vocalizations getting louder. If I knew more about the humpback's complex language I might rearrange my future plans. Like an orchestra of giants, the long calls resonate between galactic groans and something akin to the music of wind and brass instruments. The sounds are delivered with clarity and purpose, but are utterly foreign. They run over and through me, then bounce off the rock wall and back again—louder and louder. I listen to the echoes: one,

Squally Channel. The return of northern humpback and fin whales to the BC coast is being celebrated at the same time that their critical habitat around Caamaño Sound is part of the proposed route for what would be one of the largest increases in shipping traffic in the world.

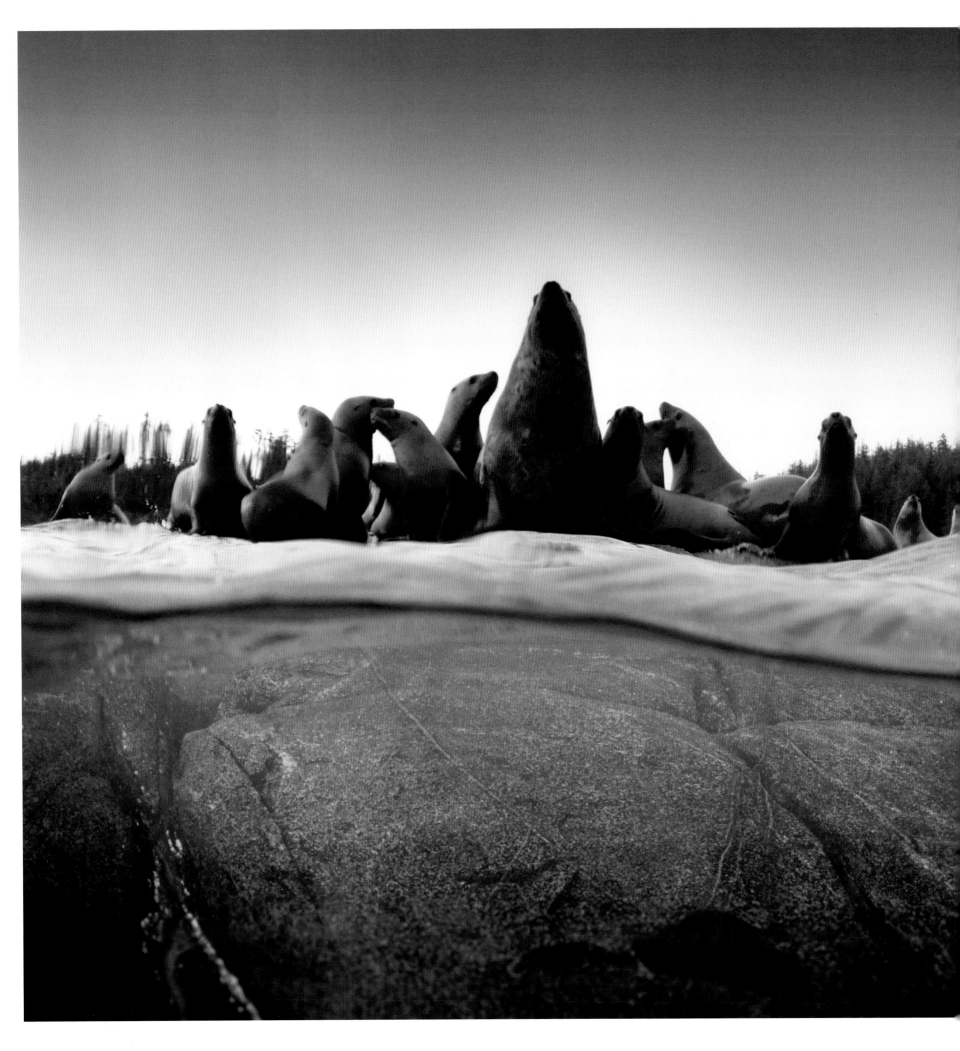

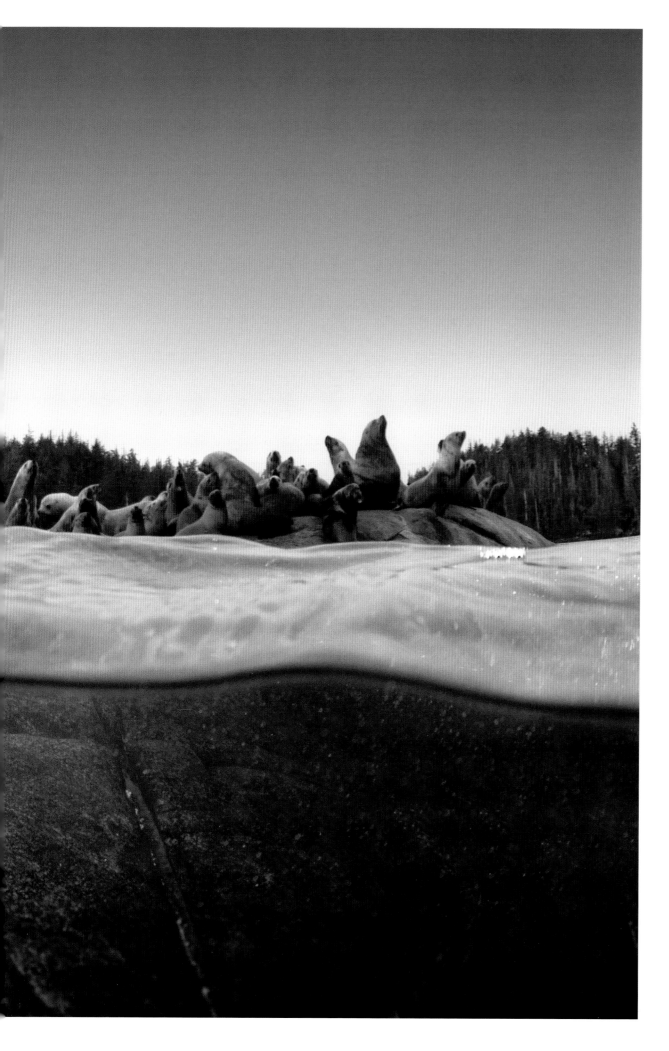

Sea lions of Ashdown Island watch over Whale Channel.

two, three, four, then five, before the sound is picked up and started anew. A disoriented school of herring streams past and we compare notes on who is more scared. The calls are turning into the vocalization associated with bubble-net feeding behavior.

The calls are pushing a mass of shiny blue and silver pilchards, bigger than the herring that just passed by. Looking down I can see the black balls moving like slow-running ink as they rotate in a synchronized pattern. One would think scattering would be a better defense strategy against this gang of whales—given what is coming—but each one of these little forage fish clearly feels that safety will be found deep in the confusion of a homemade fish ball, increasing in size by the second. It is mesmerizing.

I am already feeling disoriented and the pilchards' frenzy does not help. Noting the direction of the silver stream of bubbles exhaled from my regulator is all that keeps me upright. The calls get louder and the pilchards cling together in a tighter and tighter revolving ball, circling and circling.

I see a whale moving slowly facedown below me, then another off to my left. I forget to breathe: it is so beautiful. I have to keep thinking about the current, which is picking up. It is becoming work to stay in the lee of the reef, but this is no time to swim away. The pilchard ball is revolving like a planetary orb, spinning one way but traveling the other. A picture might be in the works.

As I look through the viewfinder, my suit suddenly feels like it is being ripped open, or maybe as though a failed high-pressure hose is coming off my tank. I am engulfed in a wall of bubbles pushing me to the surface. I hold the camera tightly and swim through them to the side. The bubbles are coming from the whales deep below. I am being hit by a massive net of air designed to trap the mass of pilchards. I am staring into the open jaws of a group of whales—each one about the weight of five hundred people.

I push hard toward the rock wall, pulling on kelp as I emerge through the surface. Off to my right the whales also surface, jaws massively agape with writhing little silver pilchards, glittering like shards of glass. The wake from the surfacing whales covers me; I have seen enough.

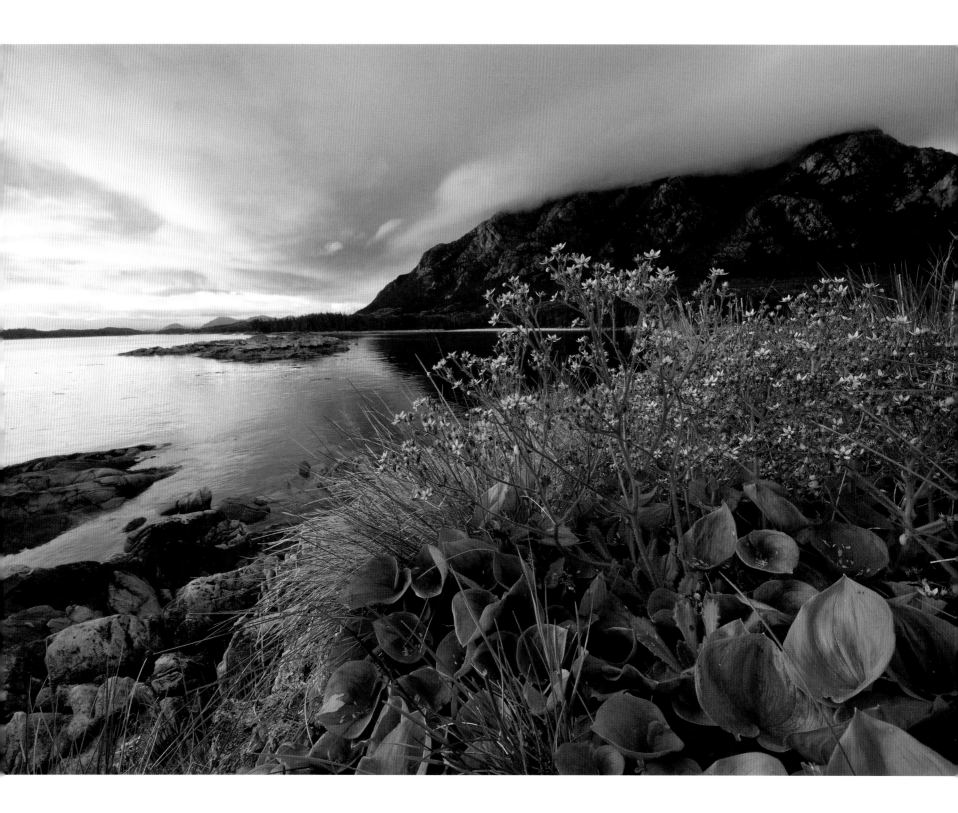

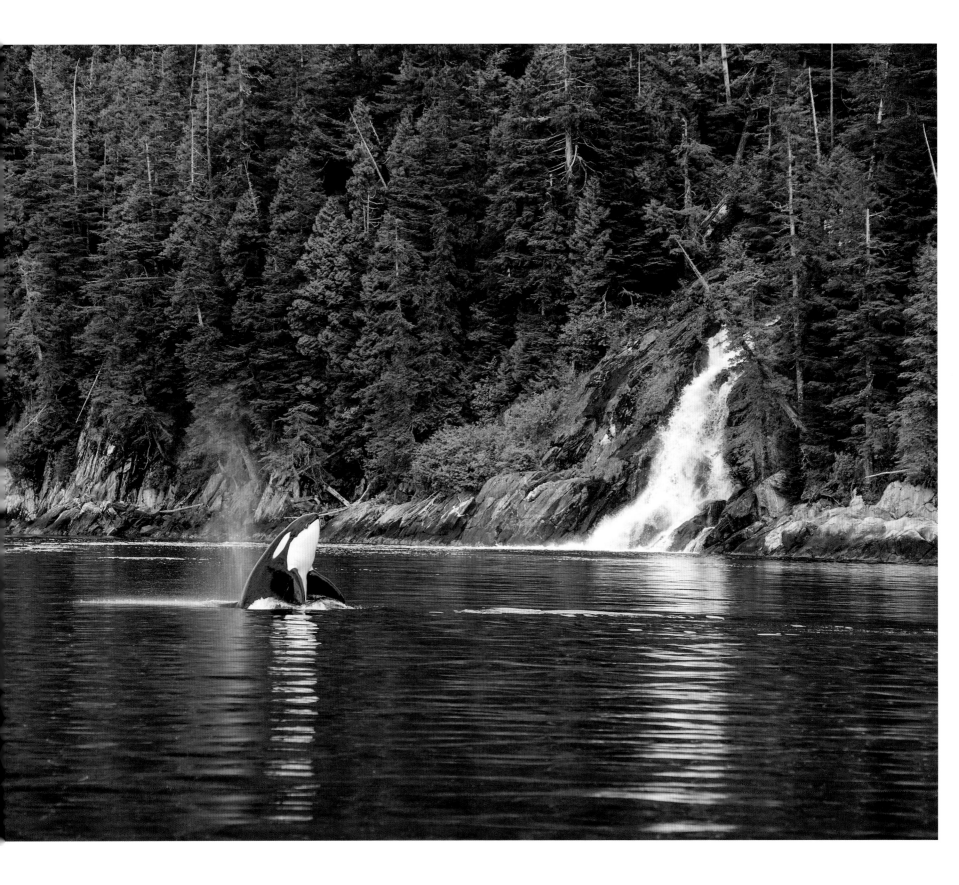

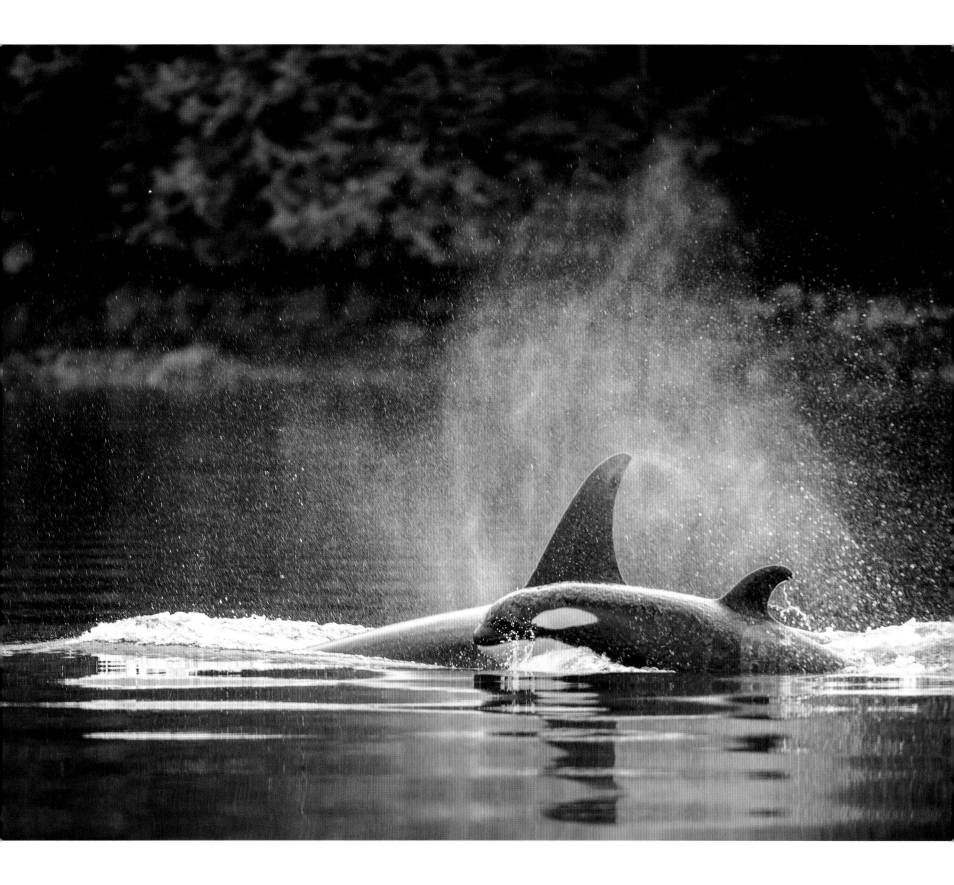

THE BC COAST has attracted prospectors of all types over the last few centuries, from the early fur traders, whalers, gold miners, timber barons, cannery executives, and collectors of native art, to today's fish farmers, hydro developers, and CEOs from oil and wind farm companies. The origin of these industries can usually be traced to a prospector who initially evaluated the resource and exploitation potential. If it was favorable, a flood of ships, equipment, workers, and others would soon follow.

Humpback whales also appear to employ prospectors when they forage for fish in the eastern Pacific. The BC and Alaska coastlines are so immense with their long fjords and countless islands and bays that humpback whales could spend a good portion of their short feeding season in search of forage fish instead of actually feeding—and today forage fish are anything but predictable. Overfishing, indiscriminate bycatch, ocean survival, water temperature, and a host of other factors have reduced pilchards, oolichans, sand lance, herring, and other prey fish to historic lows, so whales need an efficient strategy to increase their chances of finding—and staying—with them.

In March, following the herring migration to their natal spawning territory, humpback whales disperse across the BC coast fresh from their overwintering grounds of Hawaii and Mexico. And similar to bears at this time of year, they are hungry from not having fed since late fall. To carry them over the coming winter and their long migration they must attain all their nutrition in the all-too-short spring and summer months.

If a humpback prospector intercepts fish it is not long before more whales join in, but how exactly they communicate their findings is unknown. We know only that somehow communication occurs between whales over many underwater kilometers. Perhaps one day scientists will discover a separate vocalization pattern specific to prospectors, a call that contains the necessary information for whales to evaluate food stocks.

The return of humpbacks to BC waters is a rare success story in a long list of collapse, extirpation, and overexploitation of the marine world. Twenty years ago if I saw a single humpback whale it was a notable event. No one alive today on this coast remembers back to when humpbacks were plentiful in the quiet waters of the Great Bear, but the historic

kill records from the whaling fleets that once plied these waters tell a bloody story of former abundance. From 1908 to 1967, at least 24,862 whales were killed and processed by BC coastal whaling stations, not including wounded and unrecovered whales, nor gray whales, which by 1900 were commercially extinct. Of the seven species included in the kill estimate—fin, sei, blue, sperm, right, Baird's beaked, and humpback—only the last, and to a much smaller degree the first, have come back in significant numbers.

It can be difficult to determine when a species has returned from the brink of extinction when we have limited understanding of the historic population in the first place. For example, Pacific gray whales are considered one of the great success stories of a species that has "recovered" from near extinction. Its current population is estimated at 22,000; however, researchers at Stanford University and the University of Washington, through genetic analysis, estimate historic numbers may have been three to five times as high, closer to 100,000. If true, this example reveals how fragile the current population is and how diminished the world's oceans have become.

Acoustic pollution or masking from shipping traffic is causing significant concern for whale researchers throughout the world's oceans. At the same time that we are beginning to understand the importance of the acoustic environment for cetaceans we are witnessing a doubling of the world's shipping fleets—and the underwater noise that they produce—every decade.

Coastal elders remember whaling ships equipped with harpoon guns mounted on their bows plying the Douglas Channel, searching out the last of the great whales. The whale hunts happened as recently as fifty years ago. We soon extirpated nearly all species of these leviathans and were preparing to machine-gun the leaner killer whales because they were competing with "our" salmon stocks. Generations of British Columbians would live their lives assuming that whales were naturally rare to witness, one of those once-in-a-lifetime experiences.

Looking out across Whale Channel, twenty kilometers (twelve miles) south of Hartley Bay, I find it difficult to imagine what these waters were like when the whaling ships

Steller's sea lions move effortlessly through the offshore kelp forest.

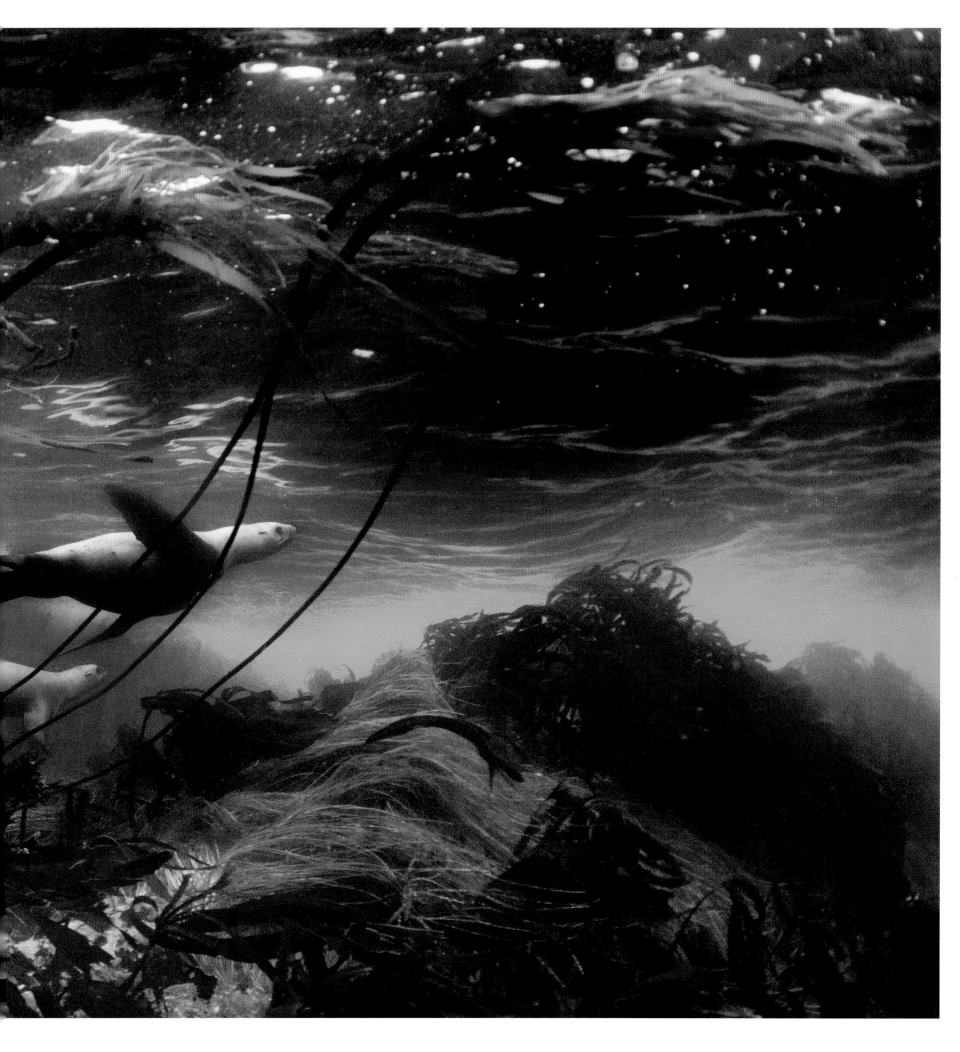

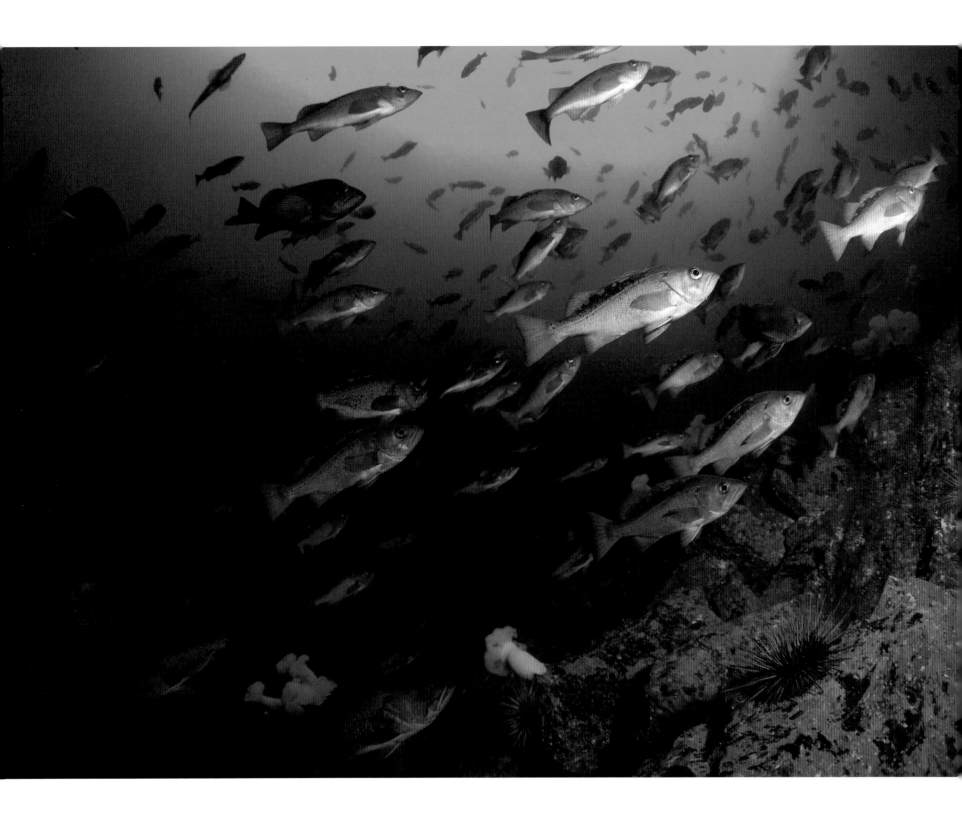

worked them. Ernie Hill, one of the hereditary chiefs of the Gitga'at Nation, recounts a story of those days: "I started fishing when I was twelve years old, back when it was a gentleman's fishery. We would travel from my father's fishing grounds, ones that he had rights to out on the west coast of Banks Island, and then we would slowly work our way around trolling for coho, waiting for other species to turn up."

Ernie is describing what so many of the old-timers feel on this coast. Those were the days when fishing was a way of life, when family was part of the crew and spending six months pursuing salmon was not just a job, but a lifestyle. Nowadays fishermen complain that they can't make enough money to survive on a three-week fishery, never mind pay for a crew, fuel, groceries, insurance, and maintenance.

Ernie relaxes thinking of those days before he faced the daily pressures of being a hereditary chief while also serving as one of the longest-standing principals in British Columbia at the Hartley Bay School. Since 1968 he has overseen the education of countless Gitga'at students while also building and upgrading a beautiful school.

One day we were making our way up Squally Channel and we saw a whaling ship, the *Tahsis Chief*. It was moving down the inlet, so we decided to follow it, and before the day was out we witnessed the entire hunt. They would kill a whale with a grenade-like device. Then they winched the whale back alongside the ship and detonated another explosive into the whale to kill it. After that they would then pump it full of air, put a flag on it, and go search for another whale to kill. Once they had about seven or so they would tow them down to the Winter Harbour whale station.

Ernie still remembers, back in the 1950s, when the seine boats would be rafted together in Barnard Harbour on the northwest side of Princess Royal Island, and among them would sometimes be whaling ships with dead fin whales tied up alongside.

This coast supports more than its share of diversity of long-lived species, from cedar trees that grow for over two thousand years to rockfish, killer whales, fin whales, and

geoduck clams that may live to a hundred years or more. Seals and bears live to thirty years of age. Perhaps a collective species memory explains why it is taking so long for whales to begin to reestablish themselves here in the Great Bear.

But now we are seeing the first sign of a page turning in our relationship with whales, because each spring brings more and more humpbacks back to the BC coast. In 2013 two separate sightings of a North Pacific right whale were recorded on the BC coast—the first time in sixty-two years since the last one was killed by whalers. Fin whales, the second-largest whales in the world, are also rebounding, albeit much more slowly than humpbacks. Over seven thousand of these fast whales were slaughtered in British Columbia during modern whaling days, as technological advances in sonar and vessel speed caught up to nearly the last of their kind in local waters. Twenty years ago it was rare to see a humpback whale, but a fin whale was almost unheard of. Today humpbacks have become common sightings and fin whales are increasing their presence each year.

Are the whales returning because they are slowly regaining a trust in us since the barbaric days of whaling? Are there more prey fish available? Is this one of the last quiet refuges where they can communicate without shipping traffic and other anthropogenic noise? Or perhaps it's a combination of these things.

THOMAS PESCHAK FLIES in to Hartley Bay today with his girlfriend, Sunnye Collins. We are planning some dives together over the coming weeks. I expect they will be tired as Sunnye has come from the eastern United States and Thomas all the way from South Africa.

After storing too many Pelican cases of camera gear we depart the dock and make our way to Grenville Channel. Sitting in the wheelhouse discussing the merits of the many approaches to marine protection, I realize that Thomas's story is a familiar one in the world of photographers and filmmakers. "I started out as a marine biologist but soon became disillusioned with how science and research were routinely ignored and corporate interests seemed to win out at every turn," he says. "The beauty and diversity of the

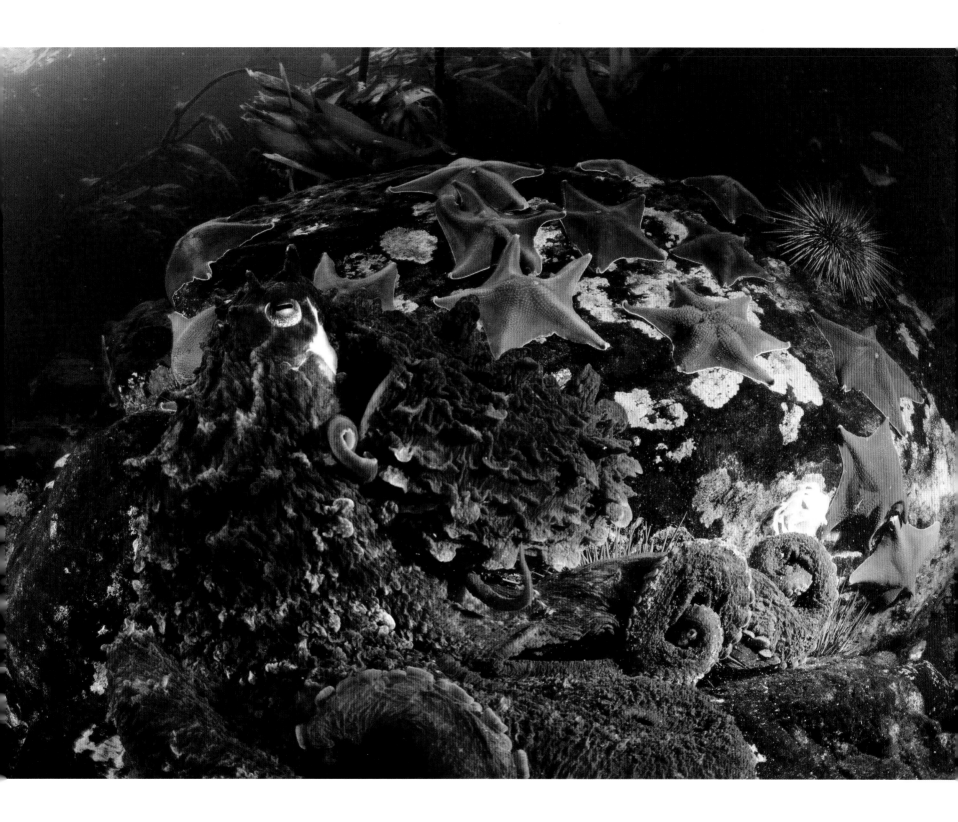

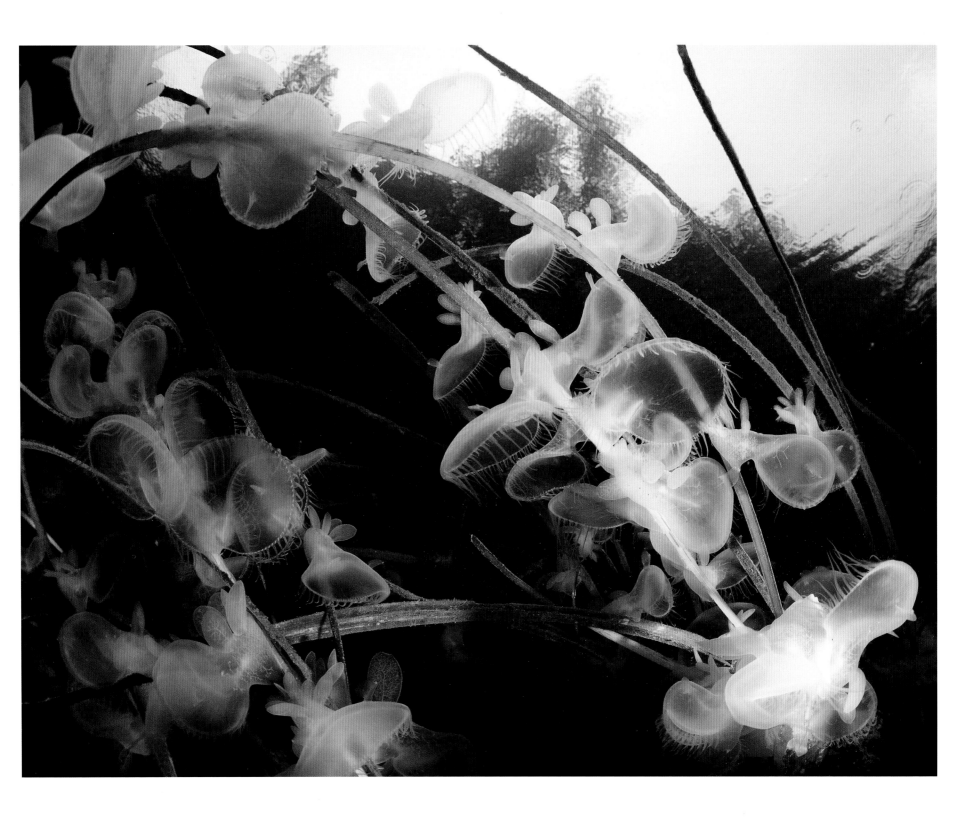

world's oceans must be seen, and no amount of research papers will inspire the kind of change that is needed in the time that we have left."

Sunnye tells me she is excited to be here as she has never seen a salmon before and whales are pretty new to her as well. I am glad that she is taking her first trip in the Great Bear during such a calm day. I have the autopilot steering us and we are doing about six knots, the three of us sitting in the forward nets taking in the amazing long, finger-like formation of Grenville Channel and the Inside Passage. Suddenly we are startled by a loud exhale. In seconds we are covered in rotten fish–smelling whale breath as an adult humpback surfaces only meters in front of the boat. Before I can run back to the wheelhouse and throw the boat into reverse, the startled whale quickly dives, but to do that it has to throw up its tail. Too late. The tail rises above us and comes directly down on the deck, just in front of Sunnye. She has no time to jump back, and when the tail lands the boat abruptly stops, throwing us all forward in a tumble.

Whale skin is smeared all over the deck. When I look over at Sunnye's petrified face I can't help myself: "That's the third time this week."

Less than a few kilometers away Gil Island spreads itself down the western flank of the Inside Passage. This is the island that helped put Hartley Bay on the map one late rainy night in March 2006. After three decades of weekly transits of the Inside Passage the 125-meter (410-foot) BC Ferry *Queen of the North* did not alter course, but continued perilously southbound past Wright Sound, crashing into Gil Island head-on. Just over an hour later the ferry sank with two passengers entombed inside.

Within minutes of the collision the nearby residents of Hartley Bay were awake and scrambling for their boats. It did not take long for the emergency Mayday announcement on the VHF marine radio to reach media outlets around the world. Children left behind in the village while their parents were helping with the rescue found themselves answering phones and giving live interviews and updates to CNN and other outlets.

I was on the last northbound voyage the *Queen of the North* ever took, and to this day I find it hard to believe that such disaster could occur to a BC Ferry in such familiar

waters during a routine voyage. The *Queen* was a source of pride and comfort for coastal communities, and its sinking seemed unimaginable. I suppose that is a common sentiment when a large shipping disaster occurs. But the *Queen* was not a foreign vessel, operating under a flag of convenience and owned by a numbered company. This was the flagship of the BC Ferries system, arguably the best-maintained vessel supporting the best-trained crew in the world. We may never know exactly what happened, but we do know human error caused the disaster.

Now, years later, Enbridge and the Canadian government act like the sinking never happened as they point to improved shipping standards in an attempt to offset concern that an oil tanker could also crash into Gil or other islands. But what is lost on them is that all of the safety standards in the world can't mitigate unpredictable human behavior.

Hartley Bay residents are still unable to harvest clams, seaweed, and other marine products from the waters around the oil-leaking vessel. We look at the government's response to the disaster, including its refusal to clean up the contaminants, as a sign of what the community could expect in the event of future shipping disasters.

"This ship passed by Hartley Bay a couple times a week for thirty years before it sank," Thomas says. "And now between the Enbridge, LNG, and condensate tanker proposals coming out of Kitimat there will be a major tanker ship passing by Hartley Bay every two to four hours—not weekly—yet in the same breath they are telling us that the likelihood of an accident will never happen in my lifetime."

AS YOU TRAVEL north from Bella Bella, the open VHF channels are usually pretty quiet. You might hear occasional chatter from the bear-viewing boats coming out of Klemtu, or a weather update or reported navigation hazard from Comox Coast Guard Radio. But around Caamaño Sound and the Gil Island area, the radio chatter usually picks up, and it's all about whales.

Local sport fishermen, Gitga'at Guardian Watchmen, charter boat operators, and others diligently report their whale observations back to Whale Point, the home and research

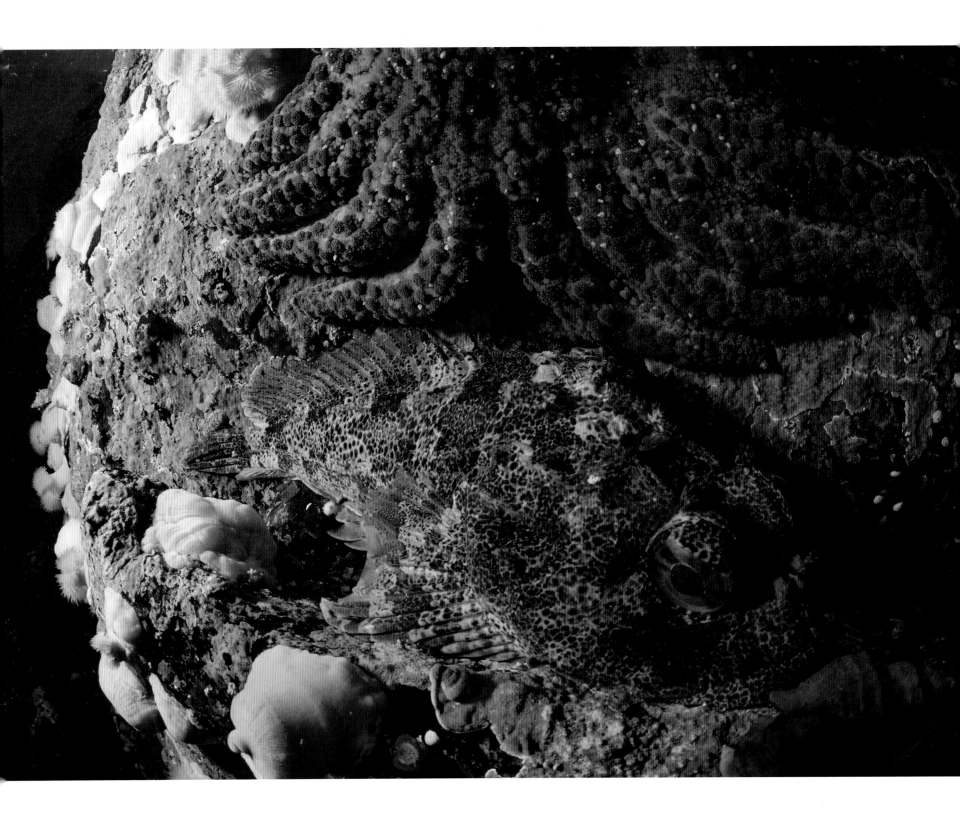

facing A red Irish lord. These
sculpins are so confident in their
camouflage that divers can pick them
up in their hands. The ability of many
species of fish to change color is
thought to be their best expression
of communication and emotion.

center for Janie Wray and Hermann Meuter. As the reports come in, Janie or Hermann—
and sometimes both—usually respond asking for specifics. Which way are the whales
traveling? How fast? Did you get a photo ID? At the least they send a hearty thanks for the
report as they continue running one of the most dedicated whale research initiatives on
the BC north and central coast.

Dropping in to Whale Point has become part of the routine of traveling through this
coastline. No one else has a better understanding of the status of whales in the region, and
their enthusiasm for anything whale-like is infectious.

Today I pull my sailboat into Taylor Bight just around the corner from their research
station and make plans over the radio to meet up in the morning. Janie intended to go
out early for a whale transect, but Hermann would paddle over for breakfast. I set the
anchor and look at the lab perched on pilings over the intertidal zone. It appears quiet, but
streams of hydrophone signals are being received from around Gitga'at territory and whale
observers are inside diligently recording sightings throughout the day.

A brief rain falls around three o'clock in the morning. I have gear strewn all over the
deck and most of the hatches are open. Soon everything is soaked. On my way back down
below I glance over at Whale Point and am surprised to see most of the lights on. Curious,
given that the research station and house all operate on power charged by an assortment
of small-scale wind, hydro, and solar generation. Electricity is precious and used sparingly.
One of the many volunteers and interns working with them must have left the lights on,
or maybe they are having a party and I wasn't invited. I go back to sleep.

A few hours later, just after sunrise, Hermann paddles over. Hermann is a big bear of a
man, and with his Viking resemblance he looks a bit out of place in such a tiny canoe. He
pulls up alongside and before he can extract himself from the craft and climb on board, he
is already answering my question about the electricity.

"A36s, part of A1 pod of the northern resident killer whales, came through late last night
and they were very vocal, and the ocean conditions were just right for perfect recordings. It
was such a treat." Hermann is exceptionally excited about this particular family of whales,

and I am keen to find out why. (All killer whales in British Columbia are cataloged by letters and numbers signifying clan structure and identifying individuals.)

Hermann and his research partner, Janie, have been tethered to hydrophones for nearly twenty years. The network of underwater microphones they have installed around Gil Island have become extensions of their own personal sensory world. They sleep— always—next to a speaker amplifying the sound of the underwater environment. They prepare meals to the gurgling static. They chop wood next to a small speaker that hangs from the outside eaves trough of their cedar-encased home (the wood cut mostly by hand with a chainsaw mill). The speakers combine multiple hydrophone audio channels from different locations around Gitga'at territory. From as far away as Money Point near Hartley Bay to the north end of Aristazabal Island, whenever a whale or sound of interest comes live they are able, through a mixing board, to isolate the particular hydrophone and general location of the vocalization.

When at Whale Point, visitors should know that they will rarely have the undivided attention of Janie and Hermann, because they are forever listening, almost subconsciously, to the twenty-four-hour sounds of the deep. To the untrained ear much of it sounds like background static, but upon closer scrutiny, horn sounds, pings, and squeals can often be heard. Even when whales are not vocalizing, an orchestra of shrimp, rock cod, waves, and even shifting gravel fills the speakers around Whale Point. The simplicity and non-invasive nature of this type of acoustic research, augmented with direct observation techniques, has provided one of the most important data sets for whales on the entire north coast.

(Pacific Northwesterners, as it turns out, have a globally unique interest in listening to the underwater world. At a recent acoustic conference hosted by the World Wildlife Fund in Vancouver, many of the international experts in marine acoustics were astounded by the acoustic monitoring that has occurred in the Pacific Northwest over the past four decades.)

Humpback song is one of the most beautiful and haunting sounds on earth. It is not random: the songs are orchestrated in a disciplined fashion. But it remains mysterious

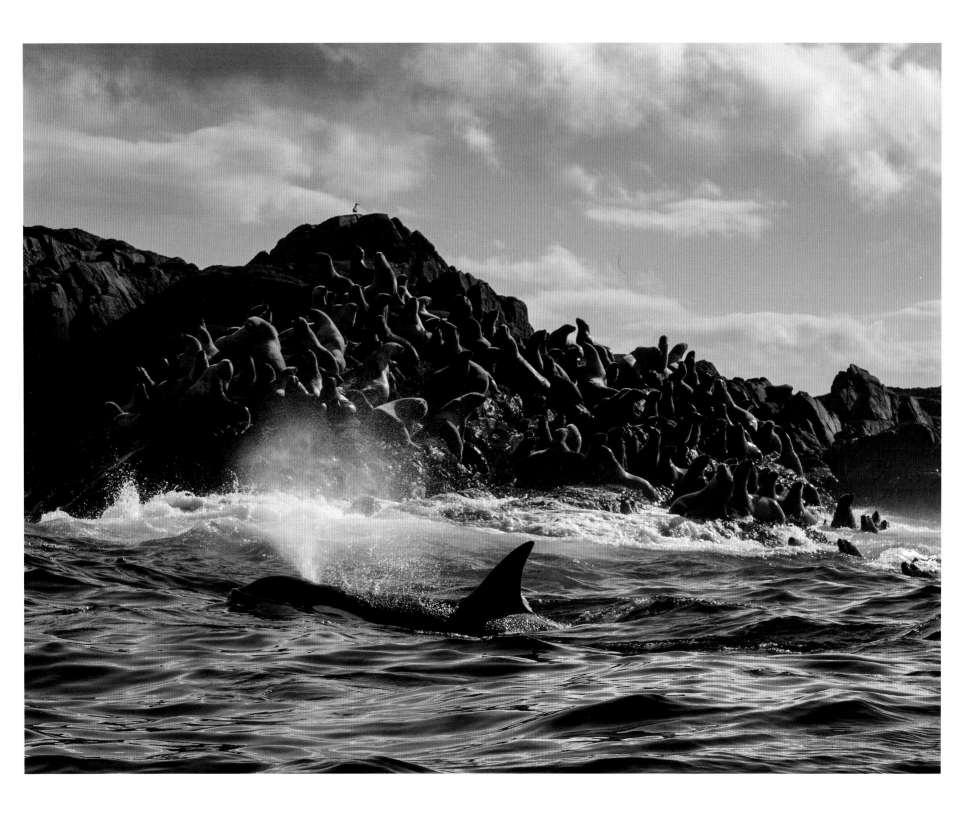

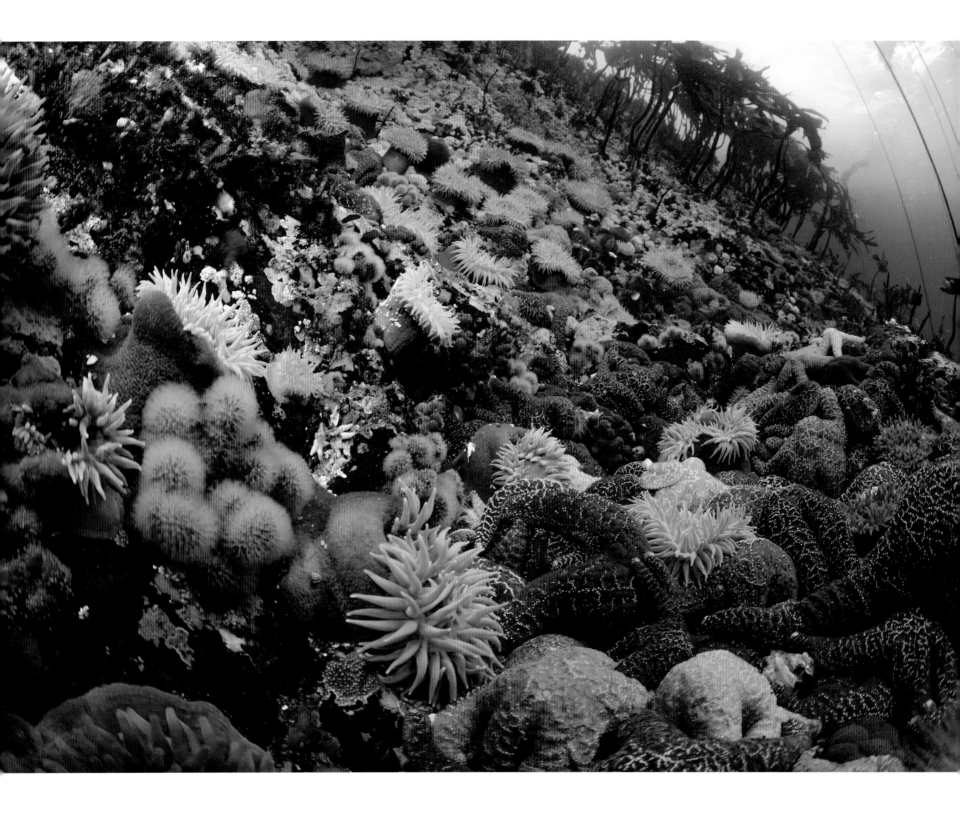

and complex. Our own species' love of music is perhaps one of the strongest bonds that we share with these ancient animals.

Acousticians, musicians, and many other scientists have studied humpback whale song, and while the structure is better understood now, its meaning is not. We know that when a song is created it will be repeated, like notes from a sheet, over and over again, each verse or theme being sung by the males. The song will be repeated over multiple years, sometimes with subtle changes, sometimes with new songs altogether. What we don't know is the reason for the changes, who makes them up, and why they are accepted by the greater population. The songs may originate in the calving grounds of Hawaii or Mexico, and they are presumably sung on the long migrations to the feeding grounds, so the general assumption is that they signify sexual preference.

The brightest minds and the most powerful computers have not yet broken the humpback whale code. But as Roger Payne says in his book *Among Whales*, "Whales have had their most advanced brains for almost 30 million years. Our species have existed for about one thousandth of that time." It is going to take a lot more work, and respect for these animals, for us to truly hear them.

Over breakfast and strong coffee I ask Hermann why the killer whales from last night had special meaning. He sits back and smiles.

Funny enough, as we were listening to the A36s we were reflecting on life's twists and turns that brought us here. I first came to Canada to see killer whales. I just had it in my head that I wanted to see them in the wild, and when I got to Johnstone Strait this was the first family I ever laid eyes on. There was no turning back when whale researcher Paul Spong invited me to volunteer at OrcaLab. Once I started to listen to the hydrophones that Paul Spong had set up, it didn't take long to get hooked on listening to the underwater world.

These underwater microphones are connected to a submerged cable that runs through the intertidal zone and is connected to an FM transmitter that sends the signal kilometers

facing Princess Royal Island. Tavish Campbell explores the vast underwater wilderness of the Great Bear sea.

away. The hydrophones are situated in some of the most exposed areas around Gil Island and Caamaño Sound. The deeper they are placed, the better, but at about twenty-five meters (eighty feet), it's easy for scuba divers to reach them for routine maintenance.

Hermann glances at a picture of three orcas that I took twenty-three years ago and immediately tells me what family they came from. I barely know my own cousins, yet he can describe the extended family and their history, dialect, and movement patterns just by glancing at a saddle patch on the back of a dorsal fin. Janie has the same abilities, which come from a lifetime's devotion.

The big research question for those studying killer whales here in the early days was where exactly did they go once they left Johnstone Strait?

"It was this question that got Janie and me looking north to set up our own research effort," Hermann continues.

The other motivation was that we were simply getting tired of listening to tugboats, cruise ships, and other shipping traffic instead of whales. There had to be a quieter place on the BC coast where whales were found. When we went north past Cape Caution we had no idea where we would end up, but once we got to Caamaño Sound we knew this was the place. The huge expanse of inlets, fjords, and access to Hecate Strait—all in a part of the coast almost entirely free of shipping traffic. We went to Hartley Bay to meet the Gitga'at and see if a research effort here would be possible.

Helen Clifton often talks about this chance meeting when the "whale watchers" first arrived in Hartley Bay. As Janie and Hermann described the kind of research they had been conducting to the south and how they proposed to study the whales here, the conversation turned to killer whale social structure, which is matrilineal. This brought Helen forward in her chair. "Why, that's just how we do it as well!" A bond was formed and Johnny Clifton began thinking of where the whale watchers might set up a research camp.

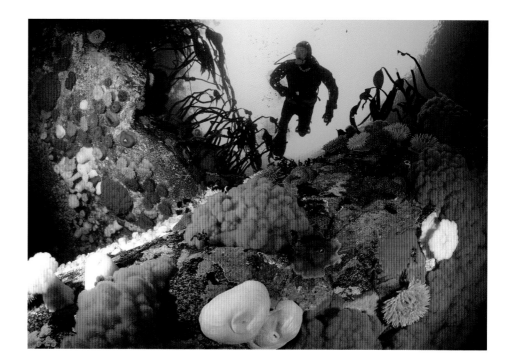

Glancing at the newly constructed research observation post overlooking Taylor Bight from Campania Island, with the sheer granite backdrop of Mount Pender, I ask Hermann, "Why here?" It seems a strange place for a permanent research station, with its lack of protected anchorage and exposed shoreline.

Hermann reflects: "The protection from winter outflows and even southeast winds is reasonable enough, while we have great access and view of the surrounding area. It's also the epicenter of whale activity for the entire area."

Later in the evening I join Hermann, Janie, and four newly arrived volunteers for a meal of fresh fried geoduck burgers, salmon, and potatoes. The various countries represented around the rough-hewn cedar table include England, Switzerland, New Zealand, the United States, and Germany—such diversity in the deep coastal wilderness.

Looking about the beautiful home and research station on Whale Point, I think of the hard work that Hermann and Janie have put in to this place while maintaining a rigorous research schedule. Imagine the skills necessary to run a research station far from any stores or supplies of any sort; they require an understanding of micro-hydro, solar, and wind energy, not to mention batteries and hydrophones. One must be able to scuba dive, chop wood, and, most importantly, operate and fix boat engines.

THE NEXT MORNING Janie and Hermann and the rest of the crew at Whale Point have a busy day ahead of them, so I leave the relative protection of Gil Island and sail across Squally Channel. With the hydrophones listening and with seasonal boaters and the Whale Point crew searching for fins and spouts, not much is missed during the height of the whale research season here. When this research effort began over ten years ago, fewer than forty-five humpback whales were documented, but by 2011 that number had

increased to more than three hundred. Janie and Hermann recorded about fifty hours of whale song in 2006 and over five hundred hours in 2010.

Crossing the entrance to Caamaño Sound, which is deep-blue and calm, I sail over to a small plywood structure perched on driftwood pilings at Ulric Point, the northern extreme of Aristazabal Island. This is an outpost where volunteers from Whale Point cycle in two-week shifts, maintaining a hydrophone station while observing whales daily. The outpost is well situated with an open view of the northern part of Laredo Channel, a good part of Squally Channel, and the entrance to Caamaño Sound. This is the heart of what DFO proposes to call critical habitat for humpback whales under the Species at Risk Act (SARA).

Lagging behind other countries, including the United States, Canada finally passed SARA in 2002, and for the first time there was some legal protection for species threatened with extinction or local extirpation. One of the first groups of animals to be declared endangered was the southern resident orca population.

John Ford, a long-standing and respected marine mammal scientist with DFO who specializes in BC whales, was charged with the job of recommending areas of critical habitat for whales. In 2009 he made four recommendations for the BC coast. For humpbacks, a threatened species, Dr. Ford recommended the waters surrounding Gil Island, almost a perfect overlay of Janie and Hermann's research area and the proposed Northern Gateway oil tanker route.

Pulling into a small cove around the corner from the station, I drop the hook and run the dinghy over. Fields of shiny brown bull kelp cover the rocky shoreline. Even on one of the calmest days of the year a small swell rolls in from Hecate Strait. The waves explain why this whale outpost is closed in the winter months. It is just too difficult and dangerous to service it. Also, it is exposed to brutally cold outflow winds.

I am greeted by Eric Keen, a return volunteer and graduate student from the Scripps Institution of Oceanography in California, and Lucy van Oosterom, a new recruit from New Zealand. I pass a fresh coho salmon to them that I caught along the way

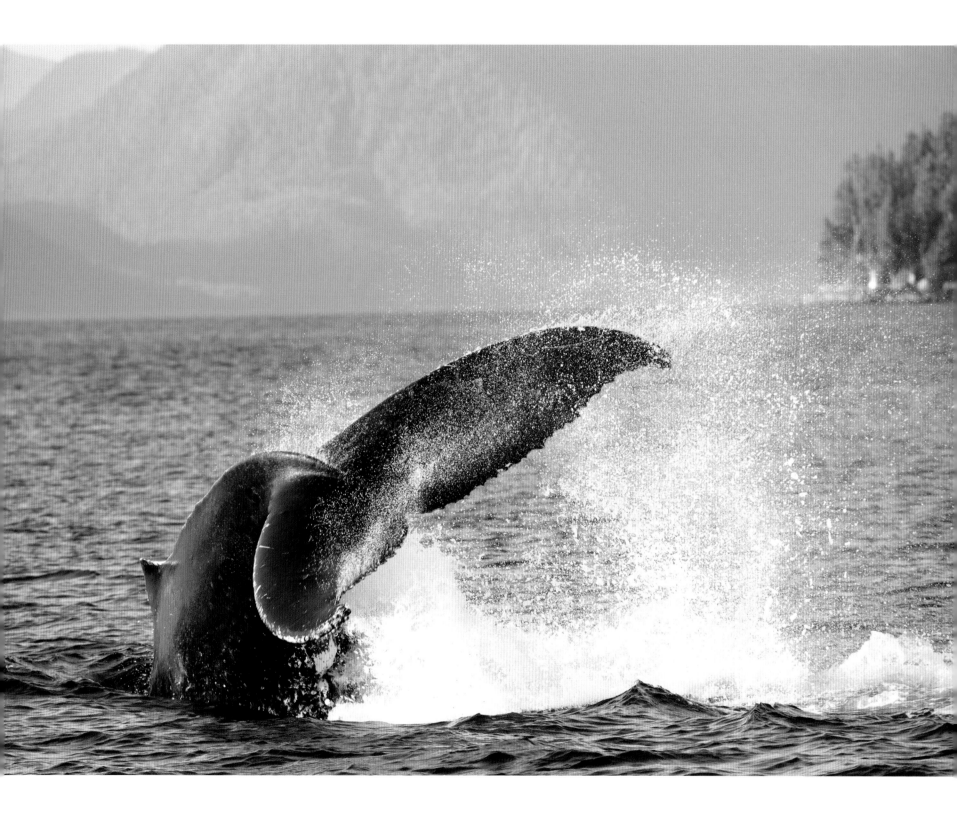

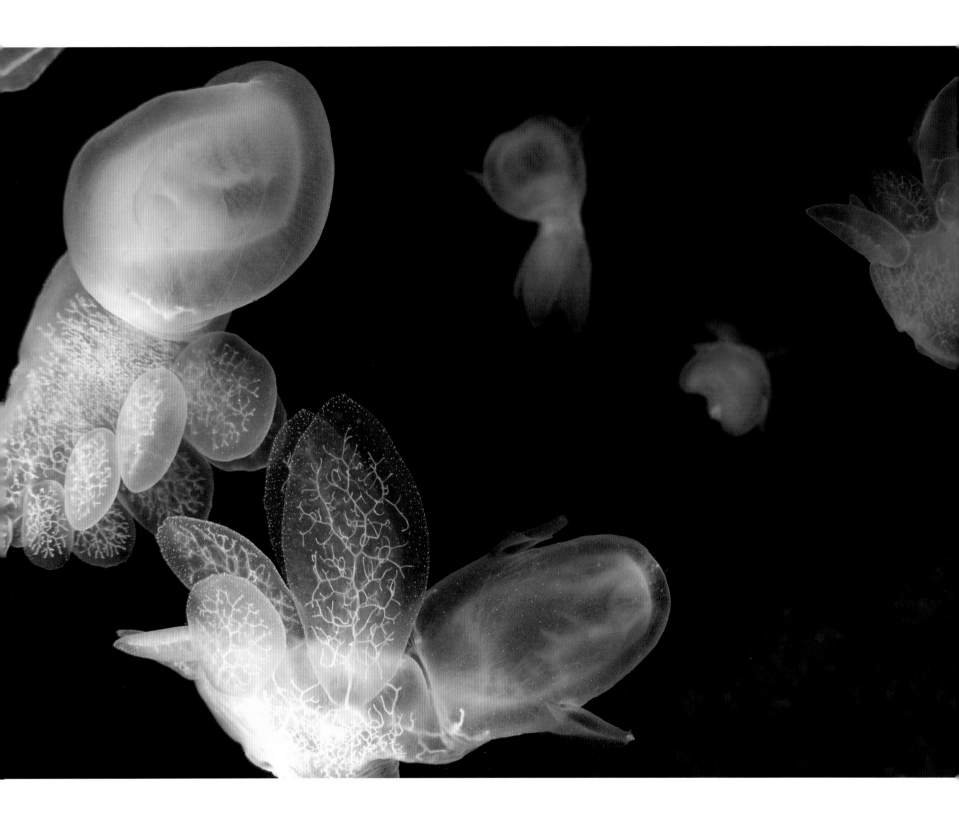

and scramble up to the rustic shelter. It is built like a roadside fruit stand, fully open to the north for unobstructed viewing. The roof is covered with a simple solar panel, just enough to power a VHF radio and a hydrophone. The researchers sleep in tents pitched out back under towering spruce and cedar trees.

The two of them are busy searching for whales. Life is simple out here, but the whale-observation tasks are well structured. Daily visual transects are conducted at timed intervals and all observations are recorded, and over time trends and cycles can be deduced. On the wall beside me is a large map of the area surrounding the station, with markings on it like a spoked wheel. Each segment corresponds to a number and each shape gets a defined amount of observation.

I look across the water at the spectacular view and ask Eric what interests him about this place. "It's uncommon to find research that is so topical and relevant," he says, "and to be able to see whales in a wild environment, without harassment, is becoming a global rarity."

Lucy adds, "Yesterday we had two fin whales and eighteen humpbacks—not a bad day's work. We also had resident orca whales, A35s, come through in two groups, and they were very vocal. Our recordings are really clear."

The wind has died down to a whisper, and whale tails can be seen fifteen kilometers (almost ten miles) away. It is smart, however, to close this outpost over the winter, because these waters can turn into hell's fury at breakneck speeds. I have seen it too many times to be complacent. Environment Canada classifies these waters as the fourth-most dangerous in the world. During a storm in October 1969 the exploratory drilling rig Sedco 135F just east of Haida Gwaii recorded a wave over thirty meters (one hundred feet) high and wind gusts of 160 kilometers (100 miles) an hour. In 2011 McInnes Island Lightstation just to the south recorded gusts reaching 230 kilometers (145 miles) an hour.

Expecting hundreds of tankers to travel through these waters without incident every year is foolish. It is here on this reef that an oil tanker is most likely to grind itself onto rock. This part of the coast can simply not be tamed that way. In April 2014, just two

facing Seeing the forest through
an ocean lens. Ninety-five percent
of British Columbia's marine species
are invertebrates, including sixty-
eight species of starfish, seventy-five
species of sea anemones, nearly
five hundred species of sea worms,
and over a hundred species of nudi-
branchs. The number of the much
more celebrated vertebrate species
of marine mammals, birds, and fish
hasn't yet topped six hundred.

months before an expected federal government announcement to support Enbridge's Northern Gateway proposal, the DFO suddenly announced the delisting of northern humpback whales from "threatened" to "special concern" under SARA. There is now no legal requirement to protect critical habitat for these whales.

ONE WOULD THINK that a pod of Bigg's (formerly known as transient) killer whales would station themselves near one of the main sea lion haulouts and claim it for the prized food source that it is, but the mammal-hunting whales prefer to keep moving, using stealth and surprise as a hunting technique. Pacific Wild researcher Diana Chan, who helped initiate the acoustic project with the Heiltsuk Integrated Resource Management Department, has observed this firsthand from one of the coast's hydrophone stations, located by a sea lion haulout near Bella Bella. "We usually pick up vocalization of Bigg's on one of our adjacent hydrophone stations first, but as they move toward the sea lion hydrophone station they go into stealth—silent mode," she tells me.

On the other hand the fish-eating "resident" killer whales are much more vocal and active when fishing, so much so that researchers believe that neighboring pods of whales eavesdrop on them to find out where the best fishing is happening on the coast. But transients will move on if the hunt is unsuccessful, preferring to travel many kilometers to the next rookery or seal haulout, hoping for a surprise attack rather than risking injury from wary and prepared prey. A seal or sea lion can gouge an eye or otherwise wound the whales. Killer whales, which can live up to a century, practice discipline, caution, and patience over reckless chance.

CANADIANS LOVE TO talk about the weather, but divers prefer to talk about visibility. Mostly it is the clarity of the ocean that takes me underwater in winter. In spring the longer and warmer days trigger the growth of diatoms, a form of algae and a foundation of the oceanic food web. They begin reproducing at a rate of a million offspring every

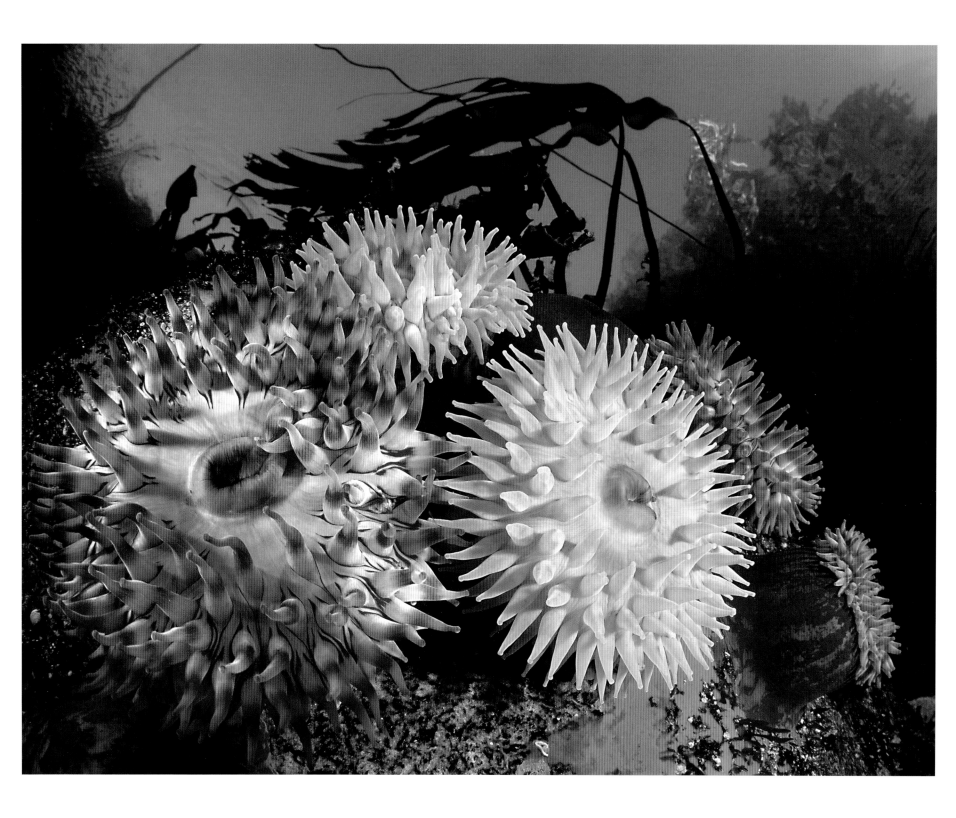

twenty days; add another month or two and the ocean has transformed into plankton soup. Seeing the front of your mask can be a challenge at those times, and photography becomes hopeless with all the backscatter. Besides, after a season of salmon, rainforest, and river valleys, the crystal-clear, vibrant, cold waters of the Great Bear provide a spectacular new dimension to explore.

Today is one of those few days that allow for some clarity in the underwater world. I put on my diving gear and slip beneath the boat. I am joined by friend and dive partner Tavish Campbell, and we both stare, mesmerized, as a giant *Mola mola* appears in the distance. The gargantuan fish, almost all head and tail with little in between, looks to be at least 450 kilograms (1,000 pounds). Tavish swims by the great fish, a specialist at preying on jellyfish, before it slowly moves off to deeper water.

The reef diversity changes abruptly in the Great Bear Rainforest, unlike anything on land. Going slowly and focusing on this smaller world, I'm reminded of how globally exceptional the diversity of our marine environment is. On one side of an islet a steep wall can be encrusted with life, so much that it would take a sledgehammer to break through the homes of hundreds of separate species to find it. British Columbia has approximately seven thousand known marine species, a number that could double if we started looking seriously. The lion's share of these, about 95 percent, are invertebrates, including sixty-eight species of starfish, seventy-five species of sea anemones, nearly five hundred species of polychaete sea worms, and over a hundred species of nudibranchs, a type of mollusk. The number of the much more celebrated vertebrate species of marine mammals, birds, and fish hasn't yet topped six hundred.

But then travel another twenty meters (sixty-five feet) and the amount and type of life transform the reef again. The steep rock face has a dusting of feather stars and a few rock scallops, and a resident candy-striped shrimp scampers about in the embrace of a crimson anemone as a lumbering teacup-sized orange nudibranch forages on soft purple coral. Off to the side a great school of quillback and gray-black rockfish swim uphill against the surge.

The broken shell substrate in the underwater alcoves is marked by occasional orange sea pens and long strands of frondless bull kelp, weather-beaten and left over from the vast fields that occupied this exposed reef only weeks ago, before the first storms uprooted the poorly anchored ones. Now they are covered in hooded nudibranchs, a translucent predatory sea slug that I can watch for hours. They are beautiful and graceful as their bodies wave back and forth while their rows of stout paddle-like feet propel them. They open half their bodies up like a sail to catch tiny unsuspecting prey as it passes by, like an aquatic Venus flytrap. Fields of them make a heavenly backdrop. Farther along, massive waves of opossum shrimp ride the current and surge, sometimes so thick they black out the light from above.

Another twenty meters (sixty-five feet) on the horizontal plane and the scene changes again. The same is true for the vertical plane: drop through a succession of atmospheres—and darker, colder water—and an incalculable new set of species, life cycles, and evolutionary adaptations present themselves. A decorated warbonnet swims against schools of glimmering anchovies, and a rougheye rockfish sits suspended at the base of the cliff. This small mandarin-colored fish can live over two hundred years and could well have been defending this same small patch of rock when Lincoln gave the Gettysburg Address and Canada was still working on Confederation. It could also have been alive half a century before the first barrel of oil was ever pulled from the ground in Texas.

Forty meters (130 feet) or so below, conventional scuba equipment reaches its limit. Below this dark frontier, undiscovered species lie waiting in the vast abyss.

From estuary to headwater above, each watershed is unique but relatively easy to map. But the underwater world rarely has defined physical boundaries. Life is given and nourished by an unbridled interplay of changing tidal and deep-water currents, upwellings, and transitional thermoclines.

I always presumed that the greatest animal migration on this coast traveled along the surface—salmon, humpback whales, oolichans, and herring heading for their spawning or feeding grounds—but there is another less known and less understood migration so large

that it changes the ocean's chemistry daily. Like a heart that pumps only once a day, as the sun fades, marine organisms rise up from their dark, predator-free resting places in the mesopelagic zone at depths of over six hundred meters (two thousand feet) to feed in the food-rich surface waters. This mass migration, known as a diel vertical migration, contains so much biomass and is so widespread that scientists now believe the daily exchange of oxygen helps facilitate breathing in the world's oceans. And it's not just a few species; as McGill University scientist and researcher Daniele Bianchi notes in *Princeton Journal Watch*, "Chances are that if it swims, it does this kind of migration."

After our dive, southeast winds are called for as we sail into the open ocean. The open waters of Hecate Strait and beyond, where we are heading, remain one of the planet's great ecological frontiers.

The longest annual mammal migration to pass through our waters each year (in fact, one of the longest in the world) sees twenty thousand gray whales hug the coast between their calving grounds in Mexico's sheltered lagoons and their summer feeding grounds in the Bering Sea. Researchers used to think this long stream of whales swam along the west coast of Vancouver Island and then jumped up to the west coast of Haida Gwaii; however, marine mammal researcher Dr. John Ford and his colleagues recently found a different story after tagging five whales off the west coast of Vancouver Island with satellite transmitters in addition to stationing observers at Bonilla and Langara Point Lightstations. They found that the whales did not continue north, but turned east into Hecate Strait, continuing northward along the eastern waters of Haida Gwaii. Perhaps there are better foraging opportunities on the wide, shallow banks of the inside waters, or perhaps the shallow water confuses killer whales' echolocation, making it a safer place for gray whales to travel.

Gray whales are slower than most whales and are considered highly susceptible to ship strikes. This recent information has come at an important time, given that their spectacular migration happens right in the pathway of proposed tanker traffic coming out of Kitimat and Prince Rupert. If we have only just learned the migration pattern of these thirty-metric-ton (thirty-three-US-ton) animals, what else must we be missing?

As the sun falls below the western horizon we are met by a large gang of white-sided dolphins. The curious and gregarious visitors hitch a ride on our bow, staying with us well into the night. Shearwaters glide along the large, rolling swells, and we periodically see whale spouts, likely humpback. This offshore continental shelf still supports large commercial fisheries, but looking back at the whaling industry's impact in this area, it is hard not to feel impoverishment.

In the early 1990s Edward Gregr analyzed historic whaling records for these waters as part of his master's thesis at Simon Fraser University. The maps produced the kill locations of over 8,000 whales out of a total of over 24,000 sei, humpback, sperm, fin, and blue whales that were commercially hunted in the first half of the last century, the industry's final days. The dots on the map that correspond with each known kill location black out huge stretches of ocean, the same waters we are sailing through now. This was the epicenter of the killing fields for coastal whales. The data showed a seasonal migration pattern of sei and blue whales along the BC coast. It also showed that sperm whales may have used these waters as a breeding ground, mating in the spring and calving in later summer; many pregnant whales were killed and recorded.

The end of whaling's dark chapter on our coast was marked by the International Whaling Commission banning commercial whaling in our waters. But the impact of hunting overkill was evident in all whale species that were commercially hunted. Whales were smaller, hunting success was more challenging, species that once were plentiful were rarely part of the catch records, and pregnant sei, fin, and blue whales were nearly absent. It would be nice to think that we had finally banned the killing of whales because of empathy or changing societal values, but the cold fact is that they were simply done and it was the only choice left.

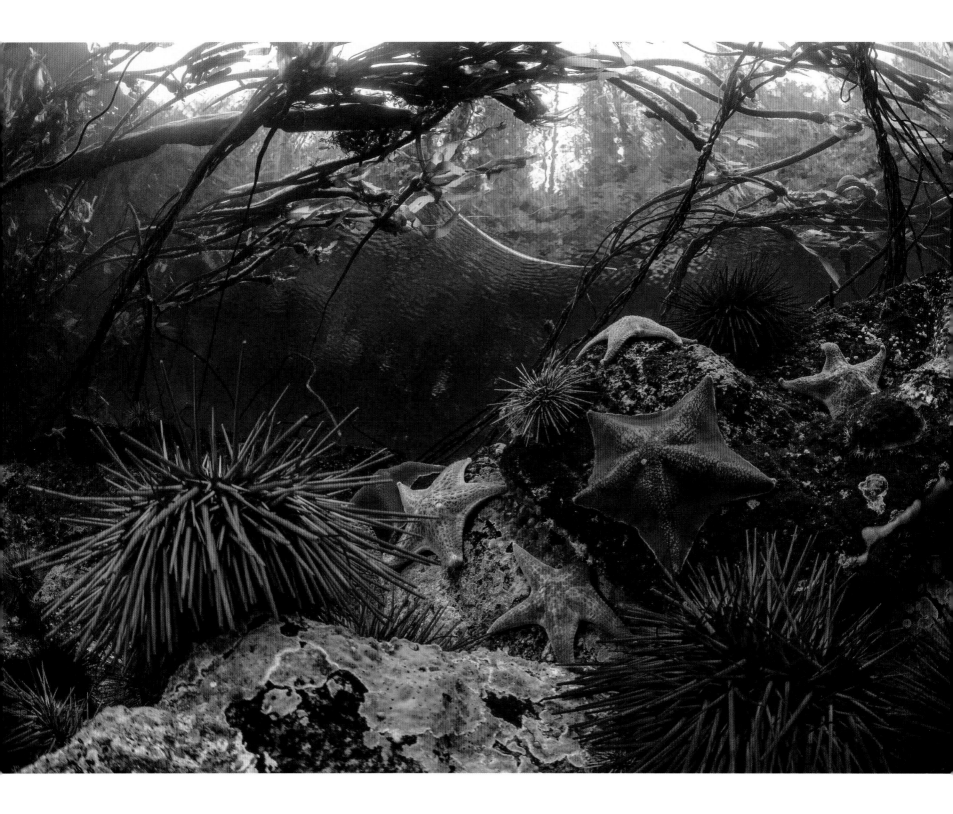

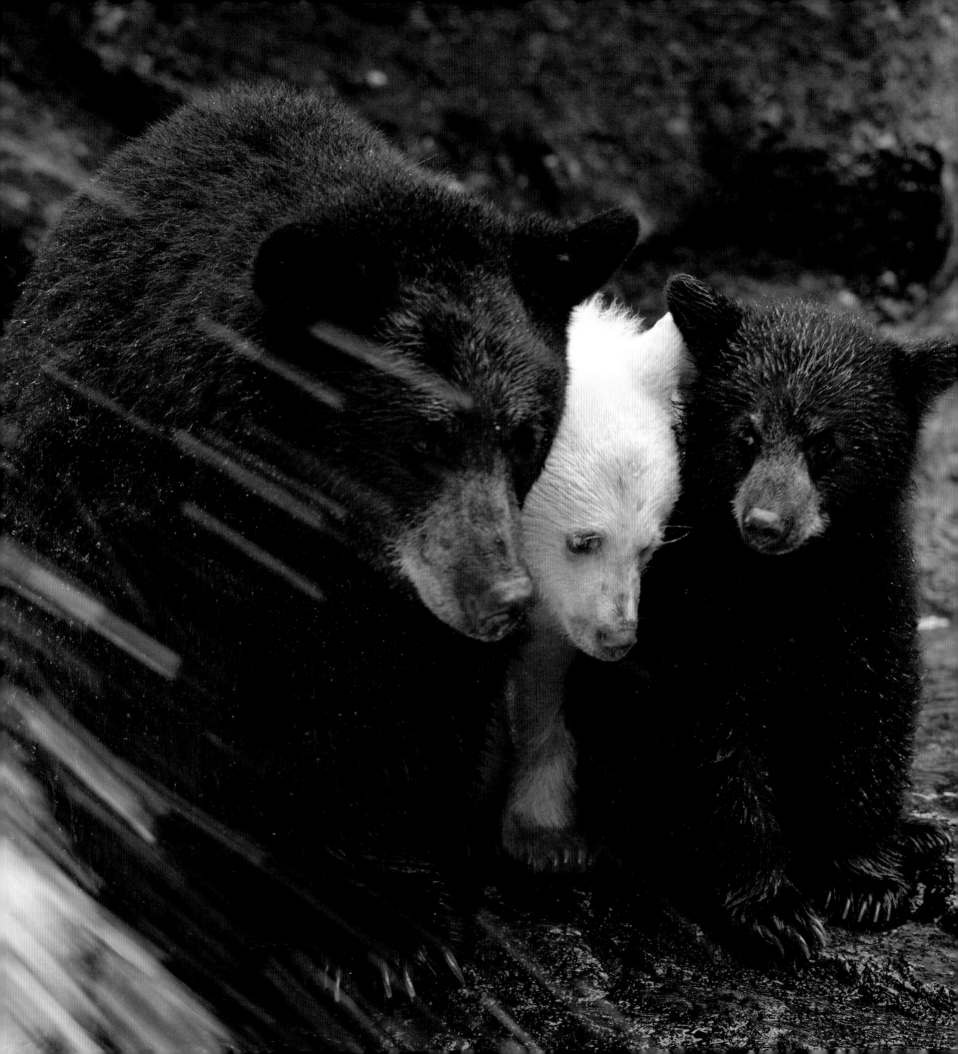

Spirit bears remain an iconic
symbol of the fragility, uniqueness,
and uncertainty facing Canada's
northern rainforest.

THE GUARDIAN

"WHAT ARE THEY going to do, stop an oil tanker every time a whale swims by?" Helen Clifton asks before introductions are complete. She gets comfortable in her favorite chair, taking the time to make eye contact with each person as they find a seat around her small but comfortable living room. "One of those ships could not travel five minutes without having to pull over." Her statement ends in a deep laugh, eyes sparkling with wit and wisdom as she leans back in her chair. Her voice rolls like a gentle wave from deep in her chest. "Next they are going to propose intersections with traffic lights for the whales."

Helen Clifton is a force and, without question, one of a kind. Her ability to stare the most serious issue in the face and still find humor is a gift. She is bright, endlessly engaging, articulate, organized, and fearless. I have watched her disarm the most cynical, even hardened, individuals.

She was responding to Enbridge's latest explanation of how the company would minimize the number of whales that would be directly killed by ship strikes along the proposed Northern Gateway tanker route. Enbridge said it would employ whale observers to help maneuver tankers around the whales. A three hundred–meter (one thousand–foot) tanker weighing a quarter-million deadweight tons maneuvering around whales in the Inside Passage—Helen's laughter is the only appropriate response.

At eighty-five, with eighteen grandchildren, thirty-four great-grandchildren, and her first great-great-grandchild in 2013, Helen has a full life. She could be relaxing in her later years. But nothing is further from Helen's mind as she wakes up every day pondering her community's future since it has been dragged into the oil age. She, like so many other coastal people, is now transfixed on the threat and uncertainty that oil and LNG have brought to their doorsteps. Helen recently cancelled her traditional food-gathering trip to keep abreast of Enbridge developments. Each day she researches the latest tar sands news, even following the business reports on Enbridge coming out of Alberta and Toronto. Whenever I have been out on the boat for a while, I go to Helen's to get caught up on current affairs from around the world. She keeps a binder under her chair that is twenty-five centimeters (ten inches) thick and steadily growing on clippings related to Enbridge.

Helen is my link to world affairs, particularly on the latest developments on the energy front. She is well connected with friends and relatives up and down the coast who keep her informed—the moccasin telegraph she calls it. Her son-in-law, Art Sterritt, runs the Coastal First Nations consortium, the political arm of the coastal nations, so she gets a lot of political information close to the source.

In 2010 I was fortunate to be an acting liaison, of sorts, between the Gitga'at leadership, Helen, and the stream of journalists, documentary filmmakers, politicians, and others who had descended upon Hartley Bay in response to Enbridge's formal application to the National Energy Board. Media wanted to hear what the First Nations band sitting in the oil tankers' path had to say about the proposed pipeline. They came on the invitation of the Gitga'at and the International League of Conservation Photographers to cover the RAVE (Rapid Assessment Visual Expedition) and to hear community members' perspective on oil tankers entering their territory. In a RAVE, these top photographers capture threatened environments and cultures around the world, producing a visual showcase of what the planet stands to lose. It's a compromise between revealing the last secrets of the planet and ensuring human cultures and ecosystems are not destroyed without a record.

Helen was frequently the go-to person for media in Hartley Bay as combination matriarch and spokesperson. I sat in on many of the interviews that she would eventually agree to over the coming months. These interviews usually took place in her living room surrounded by pictures of relatives and her late husband, the revered Gitga'at chief Johnny Clifton, and various art and intimate images of spirit bears taken by her grandson-in-law and bear-viewing guide Marven Robinson.

Helen was running a daily media marathon engaged in long interviews with international and local television networks, print journalists, radio programs, online media, and documentary film crews. The usually quiet docks of Hartley Bay were buzzing with foreigners ladened with microphones and cameras. The community was characteristically patient with the endless questions and intrusions.

Helen's house is often Grand Central Station in Hartley Bay, situated at the center of town between the dock, community center, band council office, elders' building, and school. The back door is usually closing while the front door is opening to someone new looking for advice, a meeting, or a meal, which usually consists of dried seaweed, salmon egg soup, halibut, smoked salmon, smoked oolichan, Dungeness crab, and strong coffee. Helen waits for visitors to get settled before discussing the Gitga'at world.

Her stories, without fail, come around to the oil and LNG tankers proposed for the territory, but always in the context of what it means to be Gitga'at, the seasons that mark the different food-gathering activities, the weather, their economy, and the generations that follow her. "What will they have?" she is forever asking. "Will they still go to Kiel?"— the Gitga'at's traditional spring food-processing camp—and Quaal, or Old Town, one of the traditional salmon-processing camps and historic village site farther up the Douglas Channel?

Helen frequently refers to her late husband, Johnny, from his days of trolling for salmon, hunting, trapping, and living off the rich Gitga'at lands and waters. Johnny Clifton was a coastal legend—a man who crossed between traditional and modern ways with ease. A decade after his death Hartley Bay still mourns the loss of their great leader.

A submerged petroglyph along the proposed tanker route. Gitga'at territory contains some of the greatest displays of ancient rock art on the Pacific coast.

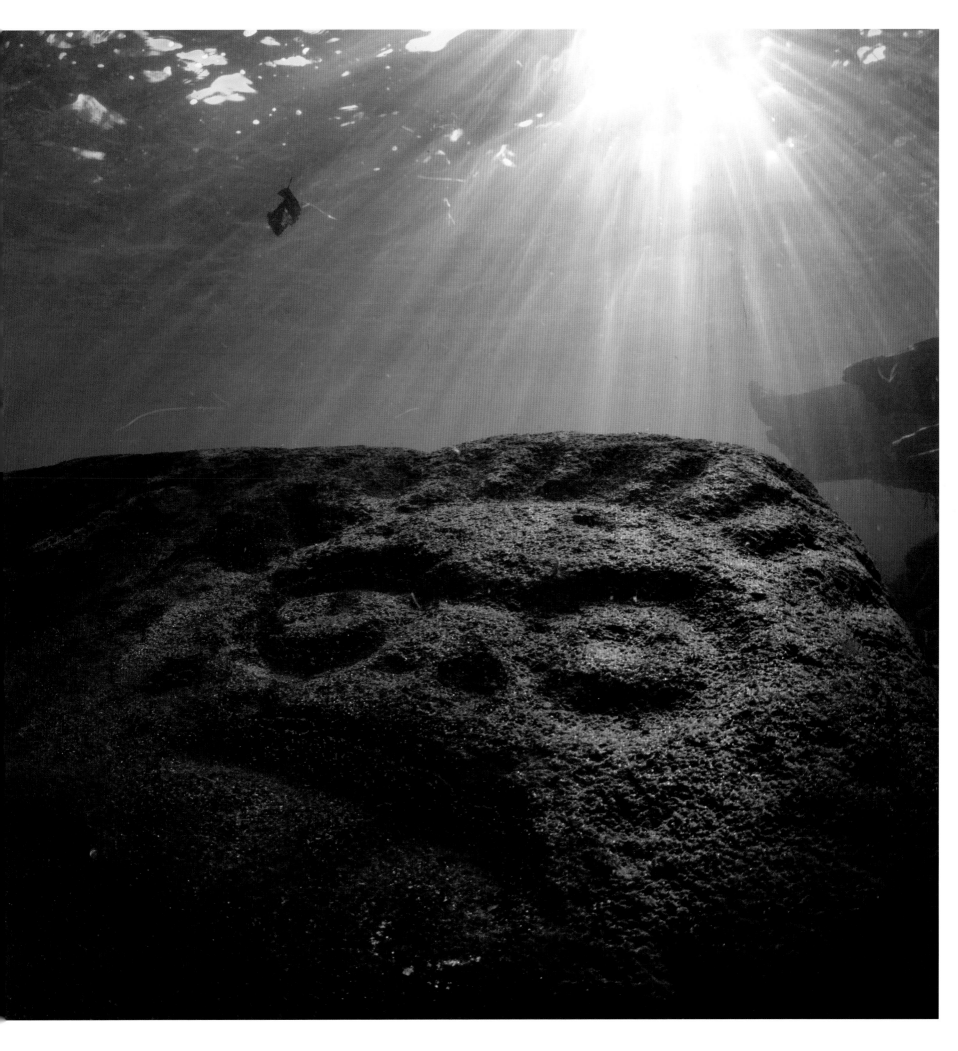

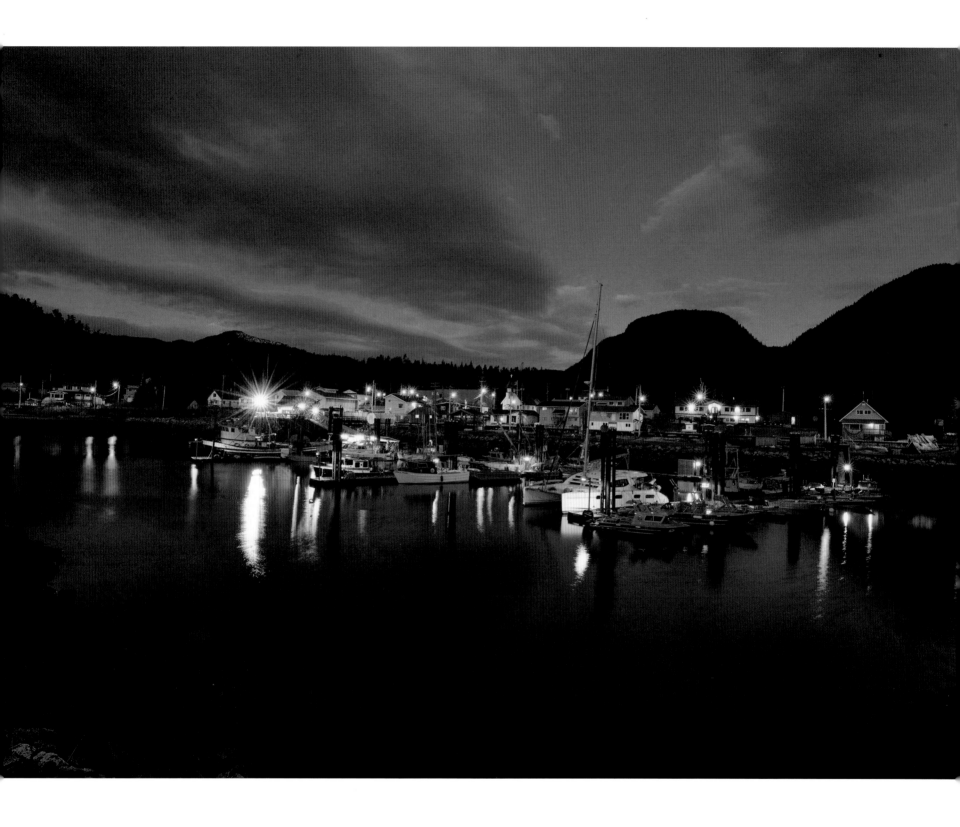

Today, in 2014, the National Energy Board has recommended the Northern Gateway
be approved, and the journalists keep coming. Representing an entire community, and
frequently a diverse community, is difficult work, but Helen does it as naturally as picking
cockles out of a sandy basin. She has to ensure that protocols are followed, that questions
she is not responsible for are transferred to the appropriate person, and that she does not
share information that could be used against the Gitga'at Nation in future legal action
brought on by Hartley Bay, the Canadian government, Enbridge—or all three. The courts
have already become the next battlefield for the Gitga'at.

It is exhausting work, and I can see it weigh on Helen. But she won't take a break,
knowing this is her and her community's chance to tell people who the Gitga'at are and
the nightmare they have been forced into. "People need to know who we are and what we
are responsible for," she says. For a community of 160 people in such isolation from the
rest of Canada, with no roads and a marginal ferry system, the opportunities to reach the
world are few and far between.

When Helen gets going there is no changing course; she commands attention because
of her considerable knowledge but also because she knows that time is precious and the
stories are long. I know how cynical some of these seasoned journalists are, but Helen
never seems interested in what media outlet they work for. She treats everyone the same.
She gives the same thought and time to an upstart online volunteer journalist as she does
a network film crew with a broadcast audience of tens of millions of people. Over the
last few years I have seen the powerful opposition Helen and so many other Gitga'at feel
toward the idea of tankers in their territory. The tankers are as personal a threat as can be
made against an individual, their family, and by extension the entire First Nation.

Sometimes Helen slows down for a moment, tired after hours of questions, and looks
up at the pictures of Johnny on the wall, wishing, I think, that he was still here to help
lead this fight. Looking out the window across Douglas Channel, knowing what she must
do, she says quietly, "I cancelled Old Town this fall, first time in forty years." This was a big
decision given the importance of all those jars of salmon for her family. I think she was

facing Black bears of the Great Bear Rainforest are a unique coastal population that diverged from their continental relatives 360,000 years ago.

worrying that, at her age, cancelling her seasonal migration to Old Town to smoke salmon might be the beginning of the end of this ritual—that she wouldn't continue to show the younger people in Hartley Bay its importance. But then her steely, bright eyes narrow and her smile comes back. "I need to save my strength for what is to come."

RECENTLY, UP AT the top end of Douglas Channel in the Haisla First Nation community of Kitamaat Village, the Gitga'at and the Haisla hosted what they described as a Gathering of Nations Feast. Government and industry were not getting the message about the First Nations position on Northern Gateway, and these two communities felt it was time to host a feast to show their determination and solidarity.

The BC coast was abuzz about the event as people from the far interior and coastal towns up and down the Great Bear Rainforest began migrating toward Kitamaat Village. There was so much talk about pipelines and tankers in the media that it was time for people to gather, and it was particularly important for the two coastal host communities, arguably with the most to lose in the event of a spill, to publicly go on record and show that they are working together.

I was joined by a group of friends from Bella Coola, and as we made our way down the spectacular Douglas Channel escorted by a small group of Bigg's killer whales, we watched a mother teach her calf how to hunt a Dall's porpoise. The wounded animal would make a break for open water, then the mother orca would burst forward, quickly grabbing the animal and flinging it into the air back toward her calf, or she would delicately grab a fin and push it out of the water, half-submerged, half-struggling, toward her small calf, who would then take small bites. It was a memorable experience on a historic day and a fresh reminder for all of us who witnessed it of how rich Douglas Channel is.

Upon arriving at the dock I could see that this was going to be a big event, a historic event. Already hundreds and hundreds of people were walking the roads on their way to the large community hall. The RCMP had set up roadblocks and were checking people's identification, creating an intimidating presence on a peaceful day. I was amazed by the diversity of indigenous people from the interior and up and down the coast. The

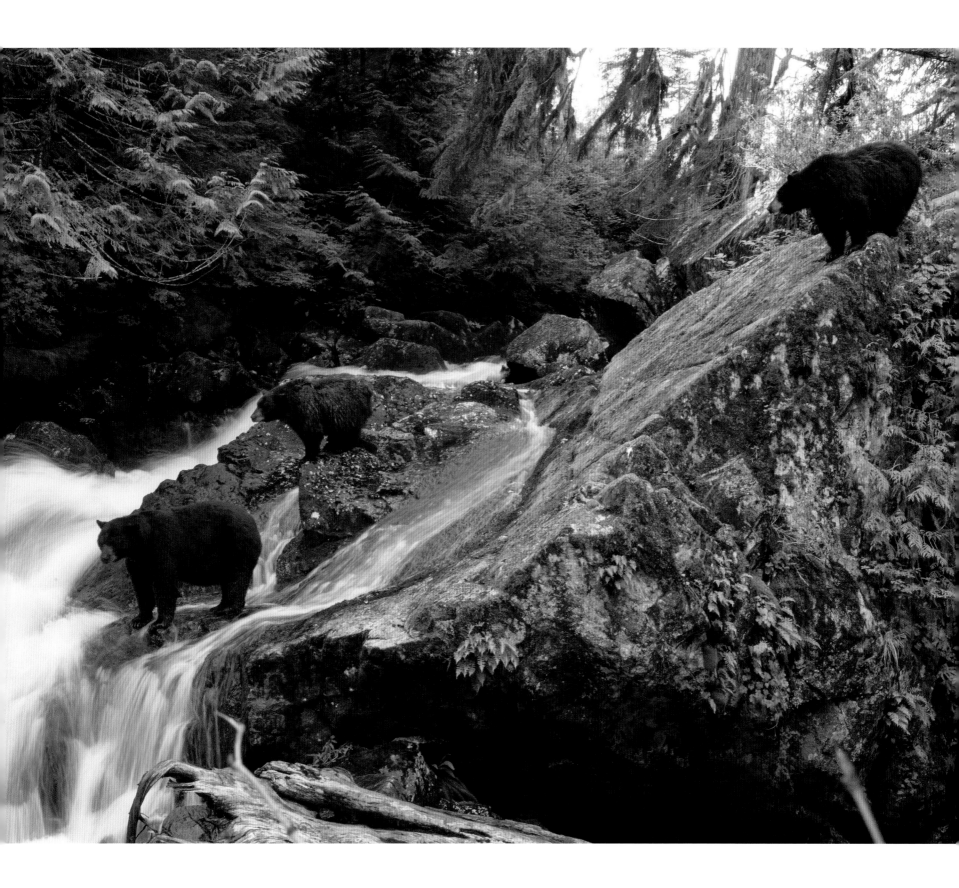

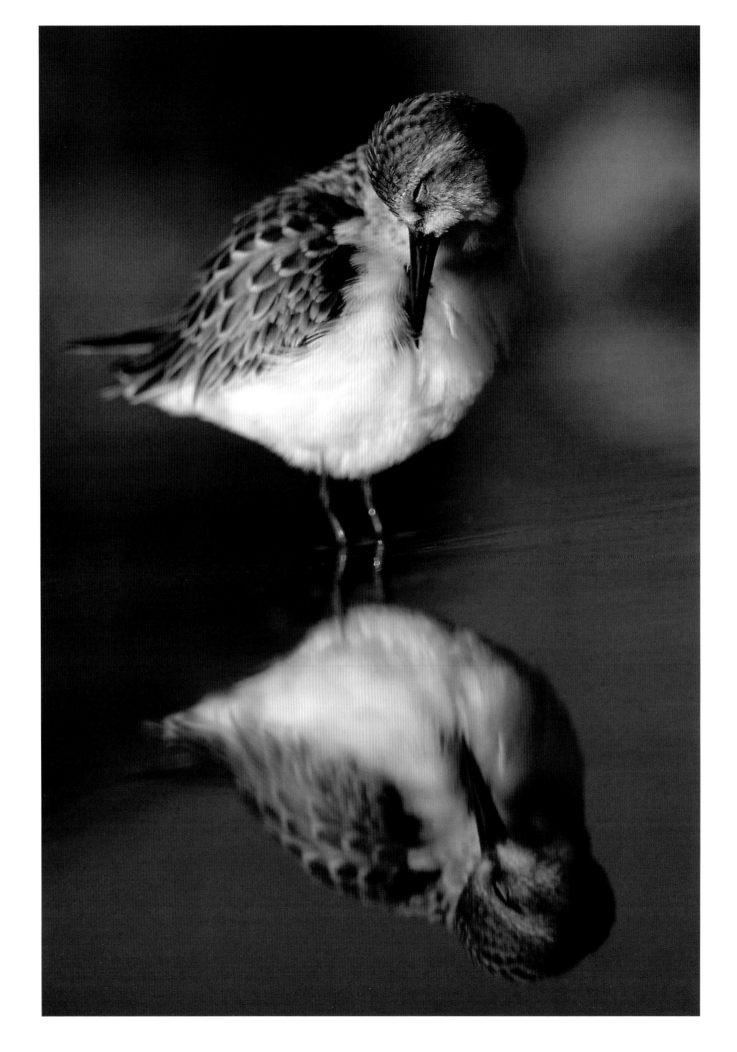

facing A western sandpiper. The Great Bear Rainforest provides critical habitat for nesting and migratory birds.

overleaf left I have watched this male grizzly grow from a tiny cub to a healthy adult. If not hunted and with protected habitat, it may live to over thirty years of age.

overleaf right A wolf having a stretch after a long afternoon nap. Like sharks, wolves continue to suffer from an undeserved reputation of being ruthless and indiscriminate.

differences in physical appearance, regalia, songs, language, drumming, customs, and traditions were remarkable—as was the number of non-native people in attendance. The large hall was packed and full of goodwill, spontaneous dancing, drumming, and celebration. Everyone knew why they were there.

I wandered around the upper bleachers of the hall looking for a way to photograph such a huge audience as speeches were made by dignitaries, chiefs, and elders. I ended up in one of the upper rooms where a group of people were busy around a table cutting up a large copper into tiny pieces.

Coppers, shaped like a shield and pounded out of burnished bronze metal, were traditionally the most valuable representation of wealth on the coast. An individual copper could represent lands, waters, and other valuable resources—canoes, stories, and slaves. For a chief to purposefully destroy a copper at a potlatch would elevate the chief beyond repayment. In the First Nations traditional economy that made him the wealthiest of men. And here was one being cut into tiny shards soon beyond recognition.

Later, there was the largest feast display I have ever witnessed. Table after table of Dungeness crab, oolichans, halibut, and salmon prepared in dozens of ways; countless clam chowders; sea lion, seal, deer, and many other types of meat; sea cucumbers; and wind- and sun-dried seaweed. Well over a thousand people were being fed from the lands and water around Hartley Bay and Kitamaat Village.

What I remember most from all the dances, feasts, and declarations from that day, and what I carry with me still, was when Ernie Hill, *Simoogit Sinaxeed*, held up a large bag containing the many pieces of the copper, which was named Guardian, or *Hayetsk* in the Sm'algyax language; the translation means to watch over and guard the ocean and land. Soon small pieces of it were being distributed to the guests in the hall with the responsibility that each person should carry this symbol of coastal wealth with them on the difficult journey ahead. When the BC north coast is protected from oil tankers once and for all, another feast will be held and these pieces returned to their proper place. Then the Guardian, and all it represents, will be made whole again.

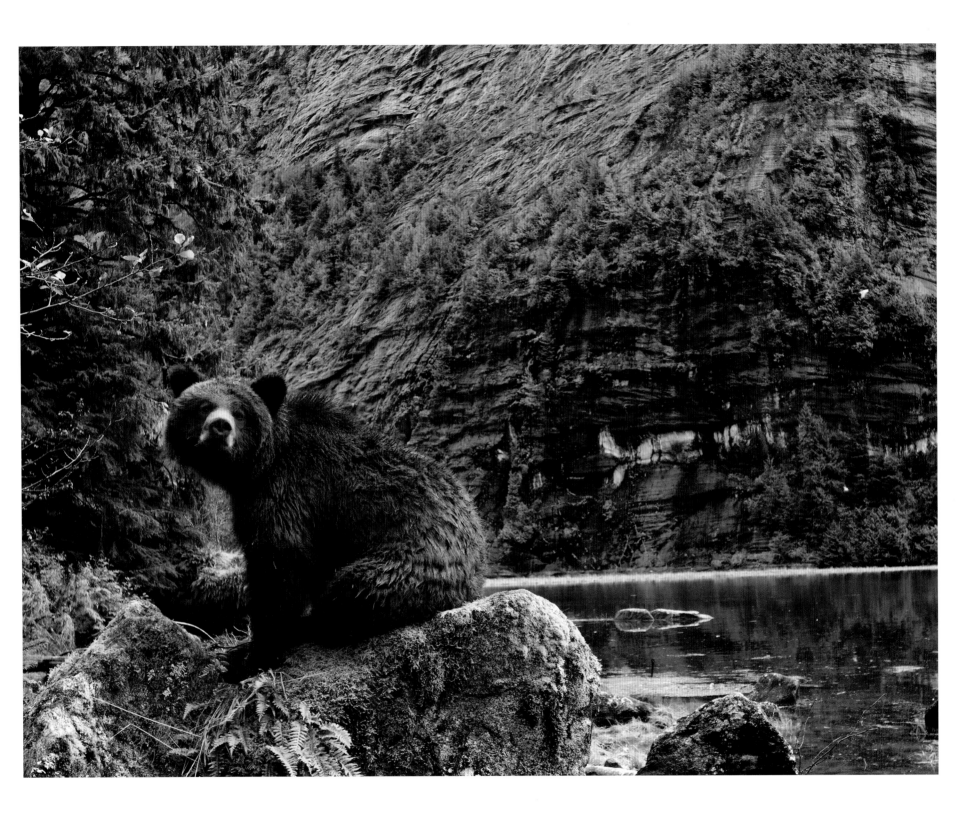

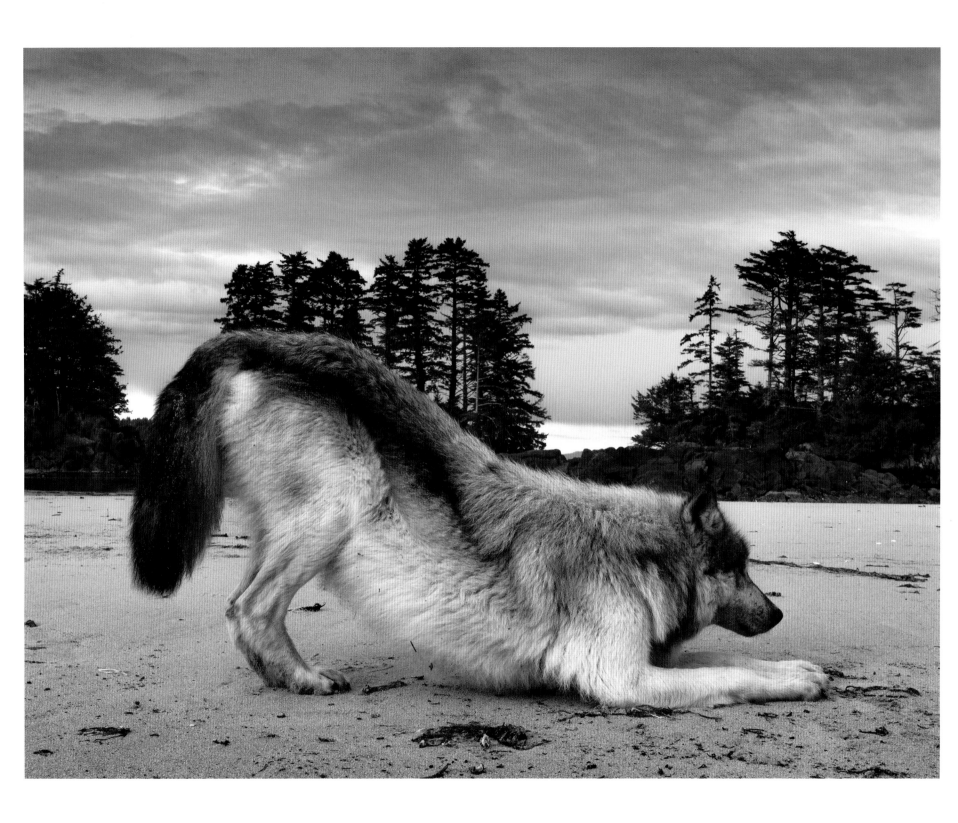

Until there is a legislated ban on tankers in the Great Bear Rainforest, the future of this coastal paradise remains uncertain.

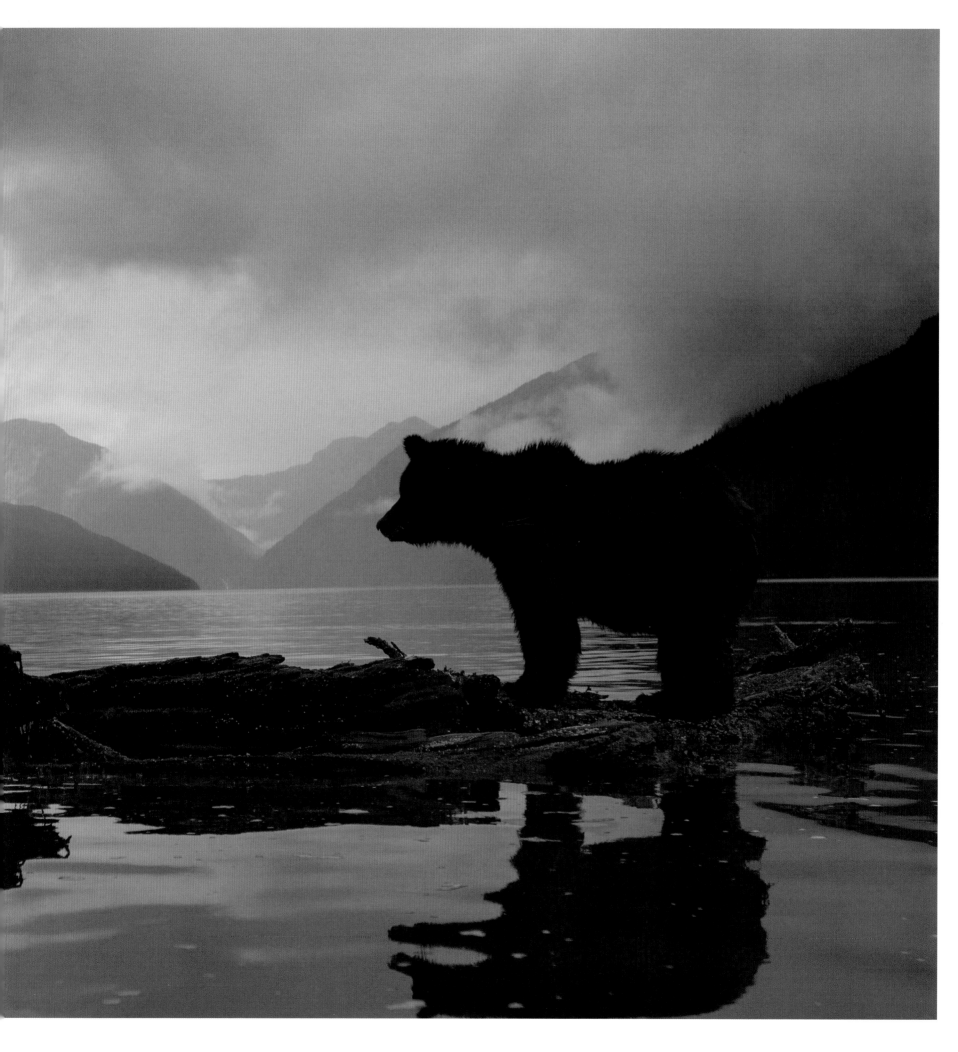

ACKNOWLEDGMENTS

Over the last few decades of conservation efforts on this coast, communities seem to have been constantly battling government-supported, industrial-sized projects that would harm the Great Bear Rainforest: open net–cage salmon farms, industrial logging, seismic testing, and unsustainable fisheries, among others. But no one could have predicted the current situation in which this one stretch of rainforest paradise faces many profoundly large, globally significant proposals at once.

The threat of these projects has extracted a heavy social, economic, and cultural price from the people of this coast. This is especially tragic, because most of these multi-billion-dollar fossil fuel transport schemes, including refineries and liquefaction plant proposals, are so ill-conceived and economically, culturally, and environmentally flawed that they should be discounted outright. Instead our provincial and federal governments continue to trip over themselves offering greater public subsidies and cheap foreign labor while systematically eliminating our few environmental and labor law safeguards. They continue to make decisions that support foreign-owned oil and gas companies over the wishes of the Canadian public.

It has often been said over the last few years that the only positive role that oil and gas companies have played in the Great Bear Rainforest is as catalyst to unite people with a shared voice. And I would agree. It is the deep fear of what could happen to this coast—to this planet—that has drawn out incredible passion and unwavering commitment as people work together to protect their rainforest home.

These same communities lie on the front line of hope. I share with many of my coastal neighbors a deep and sincere gratitude to those who have taken the necessary and often creative steps to make their voices heard.

I want to express my deepest appreciation for the thousands of testimonies that were given during the National Energy Board hearings and now remain part of the public record. If ever there is a question of the level of commitment to protecting this coast, I urge the reading of these transcripts. They are part of Canadian history, and I can only hope that years from now this will be the record we are judged by.

It is hard to know where to begin or end thanking people, and to the many I miss, please accept my apology.

To Karen and our children, Callum and Lucy. You three are simply the best. To my amazing siblings and parents, thank you for everything.

This book could not have been created without the friendship, encouragement, and support of Andrew Kotaska and Christine Scott, John Taylor, Richard Jeo, Rob Fleming, and Louise Wilson-Hayes; a heartfelt thanks to all of you.

To the courageous community of Hartley Bay: your patience and dignity in the face of the unimaginable threats to your home and culture are as astounding as they are inspiring. Thank you especially to Kyle Clifton, Marven and Teri Robinson, Albert Clifton, Wally Bolton, Nicole Robinson, Archie "Bunker" Dundas, Bruce Reece, and the late Margaret Reece. To the Hill family, especially Cam, Eva, Ernie, and Lynne, thank you for your endless hospitality and commitment to your community. And, with great respect, thank you to Helen Clifton; you make the world a better place.

In Bella Bella, special thanks to Jordan Wilson; Mary and "Bear Guy" Vickers; Ian Reid; Martin Campbell; Frank and Kathy Brown; Harvey and Brenda Humchitt; Chester "Lone Wolf" Starr; William, Jess, and Marge Housty; Larry Jorgenson; Gary Housty Sr.; Marilyn Slett; and the Heiltsuk Integrated Resource Management Department.

I am fortunate to have met so many champions of their traditional territories and cultures, but I want to give particular thanks to Douglas Neasloss and Vernon Brown from Klemtu; Jason Moody and Meghan Moody in Bella Coola; Gerald Amos and Cecil Paul in Haisla territory; all of the members of the Coastal Guardian Watchmen; and Art Sterritt and Garry Wouters at the Coastal First Nations consortium.

So many elders—Ed Martin, Qwatsinas, Jasper Vickers, Margaret Reece, and George Housty—have passed as the future of tankers on this coast has been debated. I know the uncertain future facing their communities weighed heavily on their minds.

For aerial support, thank you to Julian MacQueen, Don Arney, Werner Friesen, Gerry Friesen, and LightHawk.

Special thank you to various people who read parts or all of this manuscript: Michael Reid, Hermann Meuter, Jane McAllister, and Kathy Heise. Of course any errors or omissions are mine alone.

Thank you to Greystone Books publisher Rob Sanders, Nancy Flight, the talented editors Trena White and Lana Okerlund, designers Peter Cocking and Jessica Sullivan, and production editor Jennifer Croll.

I am thankful for the inspiration, advice, and friendship from fellow photographers, many of them also members of the International League of Conservation Photographers. Thank you to Thomas Peschak and Save Our Seas Foundation, Paul Nicklen, Cristina Mittermeier, Murray O'Neill, Brad Hill, and John Marriott.

I am fortunate to have colleagues with Pacific Wild who are some of the hardest-working and most coastal-loving people I know: Diana Chan, Max Bakken, Rob MacKenzie, Sarah Stoner, Krista Roessingh, Colette Heneghan, and Geoffrey Campbell. Thank you all for your incredible dedication to your work.

Year-round conservation work on this coast would not be possible but for our reliance on competent mariners. Tavish Campbell, I can't thank you enough for all of your help on marine logistics over the years and for the many fun days above and below the water. Thanks also to Desmond Roessingh, Ashley Stocks, Jordan Wilson, and Frieda Humphreys.

There are also many people who have supported me personally, my family, and the work of Pacific Wild: Jim and Jean Allan; Leanne Allison and Karsten Heuer; Ellen Archer; Kiff Archer; Elli Blaine; Jenny Brown; Loren Clark-Moe; Lorna Crozier and Patrick Lane; Paul Dean; Orin and Charlene Edson; Jim and Tammy Erickson; Andrew Findlay; Pat and Marsha Freeny; Barrie Gilbert; Ian Gill; Damien Gillis; Jane Goodall; Kim Gray; Norm Hann; Kim Hardy; Mike and Maureen Heffring; Mark Hume; Robert F. Kennedy Jr.; Ingmar Lee; Jan and Robbie MacFarlane; Susan Mackey-Jamieson; Michael Mayzel; Wayne McCrory; Bill McDowell; Neil McGeachy; Bob and Brenda McGill; Susan McGrath; Peter and Rosalin Miles; Harald and Birgit Mischke; Faisal Moola; Alexandra Morton; Linda and Gerd Mueller; Barb and Patrick Murray; Andrew Nikiforuk; Navindra Patel; Chris Picard; Larry Pynn; Nicholas Read; Michael Reid; Mike Richter; Twyla Roscovich and Paul Ross; Chuck Rumsey; Gerald Scoville; Paul and Helena Spong; Carol Tattersall; Ellen Torng; Jeff, Sue, Chelsea, and Logan Turner; Marianne and Jim Welch; Grant and Claudia Wierzba; Julie Wrigley; and Dean and Kathy Wyatt.

A hearty and special thank you to Jane Sievert and the fine people at Patagonia for your long-time support.

To the inspiring and dedicated whale people: Hermann Meuter and Janie Wray, Lance Barrett-Lennard, Graeme Ellis, John Ford, Rob Williams, and Kathy Heise. To the creekwalkers who care deeply about their rivers: Doug and Carol Stewart, Stan and Karen Hutchings, and Ralph Nelson. And to the many dedicated ENGOs and conservationists working for this coast: Natural Resources Defense Council, the Nature Conservancy,

Bruce Hill and Friends of Wild Salmon, Brian Huntington at Skeena Watershed Conservation Coalition, Greg Brown, Caitlyn Vernon with the Sierra Club, and the membership of the Commercial Bear Viewing Association. Thank you all for your dedication.

To the charter boat operators, this coast is fortunate to have such passionate wilderness ambassadors: the Campbell clan—Ross, Fern, Farlyn, Theo, Miray—and Luke Hyatt on *Columbia III*; Dave Lutz and Emerald Isle Sailing Charters; Tom Ellison, Jenn Broom, and Chris Tulloch on *Ocean Light II*; and Eric and Trish Boyum on *Great Bear II*. Thanks also to Bluewater Adventures, Maple Leaf Adventures, Shearwater Marine, Spirit Bear Lodge, King Pacific Lodge, Hakai Beach Institute and Jean Marc LeGuerrier on *Til Sup*, and Colin Griffinson and *Pacific Yellowfin*.

PACIFIC WILD is a non-profit public charity and a leading voice for wildlife protection in the Great Bear Rainforest. Innovative research, habitat protection, and public education remain cornerstones of Pacific Wild's approach to lasting environmental protection.

For more information on the Great Bear Rainforest or to learn how to support Pacific Wild's conservation work, please contact us at:

PACIFIC WILD
PO Box 26
Denny Island BC Canada V0T 1B0

Email: info@pacificwild.org
www.pacificwild.org
www.facebook.com/Pacificwild.org

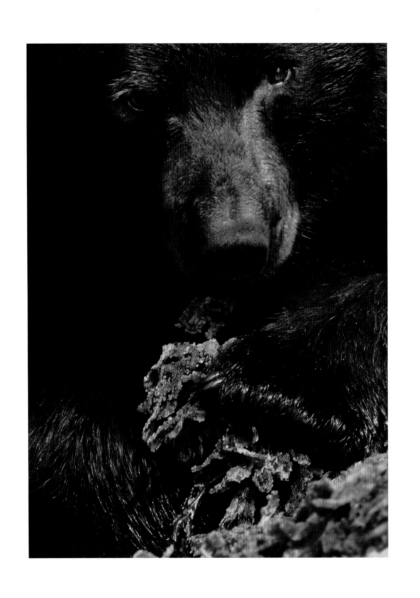